THE NEW CHINESE PAINTING

1949-1986

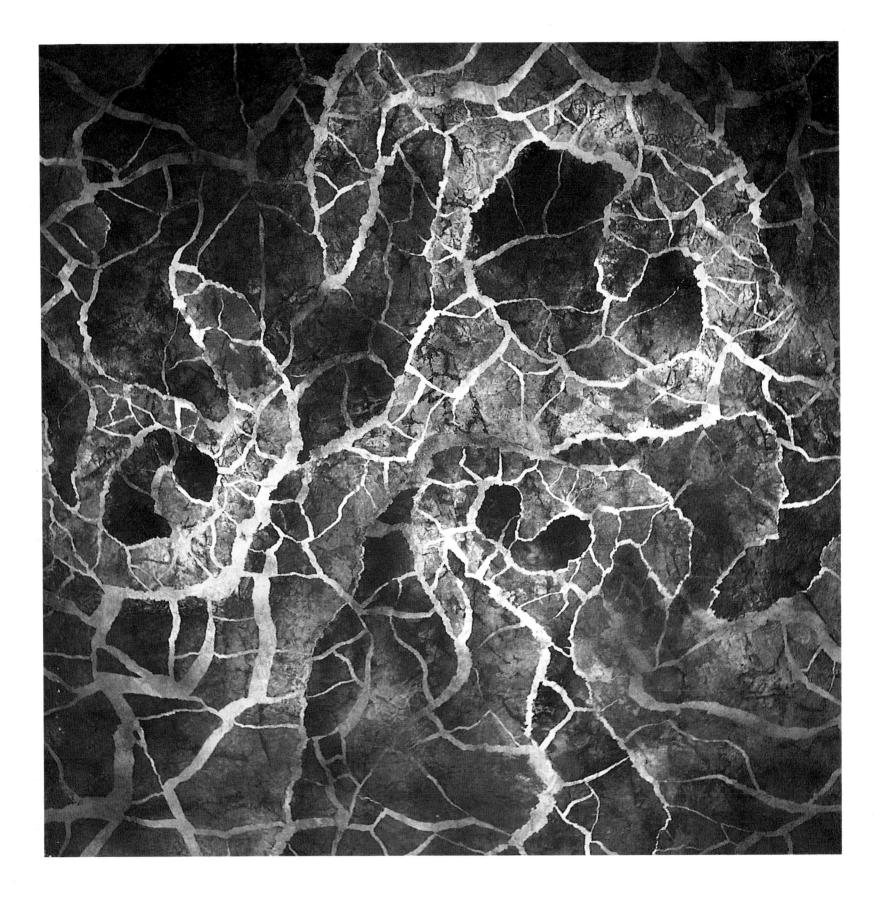

JOAN LEBOLD COHEN

THE NEW CHINESE PAINTING
1949-1986

HARRY N. ABRAMS, INC.
PUBLISHERS, NEW YORK

Project Director: Margaret L. Kaplan
Editor: Teresa Egan
Designer: Judith Michael

FRONT COVER: Chen Jialing. *Pink Lotus* (detail). 1980.
Ink and color on paper. Private collection. Photo by Otto Nelson
BACK COVER: Chen Yifei, assisted by Han Xin.
Looking at History from My Space. 1979. Oil on canvas

LIBRARY OF CONGRESS CATALOGING-IN-PUBLICATION DATA

Cohen, Joan Lebold.
The new Chinese painting, 1949–1986.

Bibliography: p. 159
Includes index.
1. Painting, Chinese—20th century. 2. Art, Chinese—
20th century. 3. Socialist realism in art—China.
I. Title.
ND1045.C63 1987 709′.51 86-22298
ISBN 0-8109-1372-0
ISBN 0-8109-2355-6 (pbk.)

Published in 1987 by Harry N. Abrams, Incorporated, New York
All rights reserved. No part of the contents of this book may be
reproduced without the written permission of the publisher

TIMES MIRROR BOOKS

Printed and bound in Japan

CONTENTS

PROLOGUE

After the death of Mao Zedong in 1976, China embarked on a new course. The winds of change affected all aspects of Chinese life, including art. Thus contemporary Chinese painting is viewed here from a post-Mao perspective. To explain the genesis of this book, a brief note about the time and place seems appropriate.

It was not until my fourth trip to China, seven years after my first visit, that my repeated requests to meet teachers of Chinese art history, visit art schools, and talk to artists were granted. This was in February, 1979, immediately after Deng Xiaoping's visit to the United States. During an extraordinary three-month period there was an outpouring of admiration by the Chinese for America, as if lost lovers had been reunited. I was aware that, at last, my opportunity to learn about contemporary Chinese art was at hand! The official slogan of that time—revived from the 1956–57 era—was "Let a hundred flowers bloom," which meant that once again the Chinese were urged to speak their minds on all subjects. It was the freest atmosphere ever enjoyed in the People's Republic of China since its founding in 1949. All over China citizens were putting up wall posters denouncing officials, airing grievances, and asserting rights.

I came to China with my husband, who is also a teacher in the field of Chinese studies. We were both on leave from our academic posts. During previous trips, beginning in 1972, the year of the first Nixon visit, our hosts had told me that art schools were closed and that the artists were in the countryside. The Great Proletarian Cultural Revolution, which began in 1966, was still in progress, and it would end only with the death of Mao.

This time it was different. I requested interviews with specialists in all aspects of contemporary Chinese art and art education, and I offered in exchange to talk about American art and art education. The authorities at Beijing's Central Academy of Fine Arts welcomed an exchange of ideas, and during our first hour of conversation I realized they were just as interested in finding out about America as I was in learning about China. They invited me to give three lectures, using slides to introduce American art. I gave two of the lectures in March, during the high tide of intellectual excitement. About three hundred people attended the first lecture, although it had not been publicized outside the academy. Apparently the word had spread by the time of the second lecture, which dealt with American art since the Armory show of 1913. Many people were turned away, but four hundred and fifty were crammed into the hall, and

the atmosphere was electric as they saw slides of Jackson Pollock, Willem de Kooning, and others. The extraordinary interest wasn't difficult to understand: I was told that these were the academy's first lectures on American art in thirty years.

A lively discussion with wide-ranging questions followed the first two talks: What role does the United States government play in art? Who is the best artist in America? Do American artists really starve? Which is the best art school? What is its philosophy? Curriculum? And so on.

I returned to China in April, 1979, to give the third lecture, as promised. By this time, however, the party line on intellectual freedom and the treatment of Americans had shifted. Discussions of previously forbidden topics could continue, but they were subject to important limitations, and the reception of Americans took place in an officially courteous, but distant and suspicious, environment.

This time I was shown into a classroom that accommodated forty people instead of four hundred. At the end of the slide presentation, which featured contemporary American painters, my host thanked me and said that it was interesting to hear how a foreigner explained her own culture's art, but the Chinese authorities had their own views on American art. He went on to say that, although I had said I would welcome questions, he was sure I was too tired to answer any. There were no questions and no discussion period. And so my lessons in art and politics began.

We lived in China for two and a half years, until mid-1981, and during that time I saw every art exhibition that I possibly could, visited many art schools and associations, gave lectures on American art, and talked to hundreds of artists all over China in as many cities as I could visit. Meanwhile, I wrote about Chinese art for foreign magazines and newspapers, and some of these articles were translated and published widely by the party's little-known but impressive internal-publications system, thereby adding to the dialogue. I was also able to collect the basic materials for this book, which I supplemented later during semiannual visits and through continuing contacts with many of the Chinese artists who have recently gone abroad to study.

The interviews in China were often difficult to arrange because of the bureaucratic morass of officialdom. Artists, art, and those with foreign connections had been key targets during the Cultural Revolution, so I was extremely concerned about causing problems for the artists to whom I spoke, and I tried to make my presence as inconspicuous as possible. Thus I often had to photograph under unfavorable conditions, and because of limited access, I was unable to have works rephotographed by a specialist with large-format equipment. Nor was I able to get the same amount of information about everyone. This fact, plus the narrative rather than encylopedic nature of the book, accounts for the variations in the artists' entries, which cannot always reflect the significance of their work. The artists are listed according to seniority.

This book could never have been written without the help of many people. It

was the desire of my husband, Jerome Alan Cohen, to live in China that gave me the opportunity. His expert, enthusiastic, and unflagging support has been vital throughout. Moreover, my colleagues at the School of the Museum of Fine Arts in Boston have been understanding, patient, and flexible. From the earliest stages through to the end, Maria B. Fang, the first American art student at the Beijing Central Academy of Fine Arts, has been my friend, introducer, translator, researcher, and fount of information. During my Beijing years Jane Debevoise, Judy Andrews, Lawrence Wu, Tang Muli, Wu Jieqin, and Chen Dexi all acted as guides, mentors, and interpreters at every level. Many people helped me with interpretation, including James Feinerman, Timothy Gelatt, David Finkelstein, Timothy Cheek, Catherine Maudsley, Tom Canellakas, Lynn King, Dora Chen, Peter Wang, and others to whom I owe thanks as well as sincere apologies for leaving them unlisted. My frequent companions at exhibitions, Elsie Shallon and Hiro Oka, were stalwart "other opinions" on whom I relied.

I wish to thank my many gracious Chinese hosts, especially our long-term host, the People's Government of Beijing Municipality, and the hundreds of artists and officials who were kind enough to talk to me. Without them this book would not have been possible.

Upon leaving China, I continued my contacts with a number of Chinese artists in China and in the West, which has allowed me to carry on the dialogue and remain in the network. Warm thanks to Han Xin, Sun Jinbo, Yuan Yunpu, Yuan Yunsheng, and Yan Yanping; and special thanks to Zhang Hongtu and Chen Dexi for that opportunity and for their kindness in reading and commenting on my manuscript. In addition, I wish to express my enormous appreciation to James Cahill, Jerome Alan Cohen, Dorinda Elliott, Wilma C. Fairbank, Howard Gardner, Merle Goldman, Mayching Kao, and Philip Kuhn for their thoughtful and stimulating comments on the manuscript, to Piriya Krairiksh and Hans Penth for information about Thai mythology and script, and to Alun Griffiths for botanical guidance. It is with pleasure I thank Sir Denys Roberts for his magnanimous gift of a quiet spot in which I could write this book. And thanks to my children, who have lived through it all, especially Ethan, whose pep talks spurred me on.

I appreciate the people and institutions that have provided photographic materials: British American Tobacco Company, Hong Kong; Chris Chen, Los Angeles; Chen Danqing, New York; Christie's, Hong Kong; Hong Kong Museum of Art; Li Miao, Beijing; Liu Tianwei, Boston; K. S. Lo, Hong Kong; Low Chuck-tiew, Hong Kong; Shen Yantai, Beijing; Sotheby's, New York and Hong Kong; Wang Datong, Chongqing; Wang Huaiqing, Beijing; Peter Wang, New York; Zeng Shanqing, Beijing; and Zhou Sicong, Beijing.

And finally, gratitude to editors Margaret Kaplan and Teresa Egan, and designer Judith Michael, for all their help.

Hong Kong
July, 1986

INTRODUCTION

C hinese art in the post-Mao period is at a crossroad. The developing work reflects the major changes taking place in China today. In current styles, fragments of the past mix with visions of the future. The Chinese artist of today is inspired by the dream of a modern state, rich enough to provide the good life for all, but the debate on how to achieve that goal is perpetually changing. Shifting government policies are mirrored in the changing art styles. Because of their enduring tradition, Chinese feel that their art must bear the particular mark of their culture, so the Chinese artist strives to create a national style that reflects the new, powerful China, a style that succeeds at home as well as internationally.

The art of new China, particularly the work of the years 1979–86, is the subject of this book. A group of artists, representative of the three generations working in China during those years, has been selected from different parts of the country. The accounts of the artists are not meant to be encyclopedic, but rather to show how each personal artistic expression casts light on the whole landscape.

Chinese artists painted throughout the turmoil and cataclysmic changes of the twentieth century. During the Republican period (1912–49) there was intense confrontation between Chinese tradition and foreign ideas. This confrontation has continued since 1949, when the Communists took power.

To understand the artists' perspective today it is important to look first at the major trends that were current in twentieth-century art and culture before the death of Mao Zedong in 1976.

Background to the Twentieth Century

At the beginning of the twentieth century, Chinese artists were carrying on a tradition of more than a thousand years of ink painting, on silk and paper, that depicted mountains in mist, birds and flowers, beauties and scholars. The tradition of painting on walls goes back even farther, to the first millennium B.C. By the late eighteenth century A.D., this pictorial tradition, the mainstream of Chinese painting, had become mere elaboration upon elaboration. By then, most Chinese painting was devoid of originality and vitality, mirroring the rigidity of the Chinese dynastic institution. The writings of Confucian scholar-painter Dong Qichang (1555–1636) were the paramount influence on artists for several hundred years. He set artistic ideals that were hundreds of years old into a specific formula that focused on maintaining the values and images of the past.

1. Lin Fengmian. *Autumn Landscape.* c. 1978. Ink and color on paper. Signature and seal. Collection K.S. Lo, Hong Kong

The intensely brilliant hues of autumn are painted in a style that has coloristic and emotional affinities with Post-Impressionism, yet the composition is comfortably familiar within the context of traditional Chinese painting. By drawing inspiration from the international styles, Lin Fengmian gave the old formulas new life. Although he had been a leader to many Chinese artists for more than fifty years, during periods of high political tension in the People's Republic he was criticized so severely for harboring foreign, bourgeois influences that he left China in 1977.

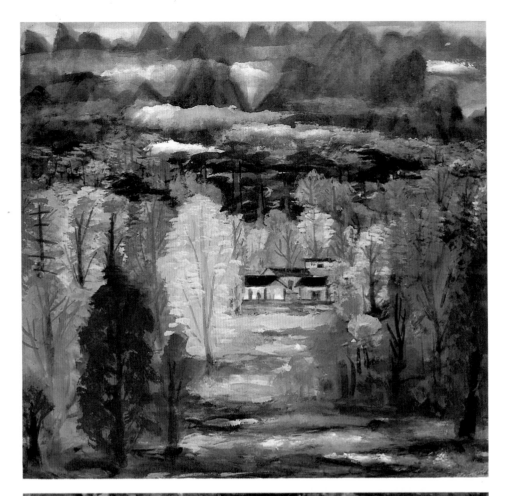

2. Zhu Qizhan. *Mountain Village.* N.d. Oil on canvas

Zhu Qizhan (b. 1892, Taicang district, Jiangsu Province) was trained as an oil painter, and he admired the Post-Impressionist works of Van Gogh and Cézanne. But like many of his generation, he may have turned to ink painting—for which he is most famous—because he felt isolated from international currents, or because he couldn't withstand xenophobic pressures. Ink painting is rooted in the Chinese literati tradition and continues to have great cultural appeal for many of the old guard of elite leaders.

The ideal artist was a scholar, poet, calligrapher, and painter—an amateur who was to emulate his master's work and who began by copying old Chinese paintings. Not until he was fifty or more was it considered possible for him to create his own style.

The most interesting artistic masters of the seventeenth through the nineteenth centuries were exceptions to the mainstream because their expression was so intensely personal. Nevertheless, although they were eccentrics whose work did not conform to the academic style, they stayed within the conventions of traditional Chinese painting.

Artists did not take seriously the trickle of foreign art that penetrated China, the Central Kingdom—a literal translation of what the Chinese call their country. As Central Kingdom implies, the Chinese were culture-bound in a system that could not conceive of cultural competition or alternatives.

During the nineteenth century, China was repeatedly defeated by states that had acquired modern technology. Britain inflicted the first of the series, the Opium War of 1839–42. Thereafter, although the Qing dynasty defeated the rebellious Taipings in the long civil war that ended in 1864, the Qing lived under the ominous shadow of Western troops. France defeated China in Vietnam in the 1880s; Japan defeated China in 1895. The final blow came in 1900 when the foreign treaty powers defeated the imperial troops in the Boxer Rebellion.

The Chinese establishment was slow to realize the need for reform and even slower to begin to modernize. It was China's ignominious defeat by "little" Japan in 1895 that illuminated the imperative nature of educational reform: To cope with foreign powers the Chinese simply had to acquire foreign knowledge. In principle, China and Japan had both embarked on a course of modernization in the 1860s. But in contrast to the Chinese, the Japanese achieved remarkable results. While reassuring their rulers that the traditional Chinese way was best, Chinese officialdom had repeatedly suffocated reform under a conservative mantle.

As Michael Sullivan explains in his pioneering book, *Chinese Art in the Twentieth Century*, by the time scholar-official Kang Youwei introduced the 1898 reforms, the teaching techniques of Western art were part of the package. Those reforms lasted only one hundred days, but in 1902 they were again adopted by the imperial government, which had finally determined to modernize. Western skills that were associated with science or technology—drafting, mapmaking, and illustrating—became part of the educational plan within the modern school curriculum. The first arts-and-crafts department was established in 1906 at the Nanjing Normal High School, and a test of artistic achievement was included in the new official examinations.

Japan, which had opened its doors to Western currents during the reign of the Meiji emperor (1867–1912), became a model. Chinese had begun to study in Japan after 1896, and their number there had swollen to fifty thousand by the 1920s. The Japanese also came to China, and along with their techniques for modernization, they brought Western art with them. Originally, Japanese art

3. *The revered eighty-nine-year-old master Zhu Qizhan poses thoughtfully next to a traditional bamboo composition. He painted it on the occasion of moving to his new house, which is surrounded by a bamboo grove. 1981.*

4. *Shanghai master Tang Yun (b. 1905, Hangzhou), who specializes in bird and flower painting, signs his work. He will also stamp it with at least one of his seals. His studio, like that of the traditional literati artists in old China, is full of paintings, calligraphy, and antiquities, and it is always crowded with admirers hoping that the master will give them paintings. Chinese in the People's Republic rarely buy paintings. They receive them as gifts in an elaborate exchange system that helps to smooth the path in making various arrangements. If an outsider wants to buy a painting, he can usually purchase it through the artist's work unit; in Tang Yun's case, this would be the Shanghai Painting Academy. 1980.*

teachers came to China to teach new methods of "scientific" drawing and perspective. Eventually, these Japanese were replaced by their own students and Chinese who had returned from Japan and Europe. And so it happened that even before the artistic elite was really aware of it, even before the collapse of the Qing dynasty in the revolution of 1911, the study of Western art had become part of the new educational scheme to modernize China.

The Twentieth Century

In the early years of the Republic of China, Shanghai became the center for foreign ideas. As Mayching Kao states in her unpublished 1972 thesis, *China's Response to the West in Art: 1898–1937*, some artists of that time felt that traditional Chinese art was bankrupt; they argued that borrowed and adapted aspects of Western art would revitalize the lifeless Chinese formulas and produce a new kind of Chinese art. And so in Shanghai several young artists started schools that taught Western painting techniques, including oil painting, although the teachers themselves had very limited training. These schools were independent of the newly formed state schools, which also included the study of Western art in the curriculum. Liu Haisu was one of the pioneers. He was only sixteen years old in 1912 when he founded the Shanghai Fine Art Institute, which became one of the most important art schools of the Republican era.

The new methods of Western art education introduced drawing with pencils and charcoal, painting in oil on canvas, and using watercolor and gouache on nonabsorbent paper instead of ink and color washes on absorbent paper or silk. Other innovations included drawing from life (using draped and nude models) and from plaster casts and painting from arranged still lifes and landscapes. The use of nude models was considered scandalous, and progressive art educators such as Liu Haisu and Lin Fengmian were subjected to extreme hostility for introducing nude models into the Chinese art curriculum. This reached a climax in 1927 when a warlord who was incensed by what he deemed to be an affront to public morality attacked Liu Haisu for such a practice—and for exhibiting paintings of nudes. He threatened to close down the school, but as good fortune would have it, the army of Chiang Kai-shek's Northern Expedition arrived to impose Nationalist party control, and the disapproving warlord was deposed.

May Fourth and the New Art Movement

After World War I, the Chinese were humiliated at the Paris peace talks when Shandong Province, which had been under German control, was not returned to China by the victorious Allies as promised but was made a Japanese concession. In China, this sparked the angry student riots that began on May 4, 1919, and led to what became known as the May Fourth movement. This movement had been inspired by anti-imperialist (antiforeign) feelings, but it brought about a

deeper commitment to societal reform and from it came the call for a new culture. John K. Fairbank and Edwin O. Reischauer, in *China: Tradition and Transformation*, tell us that the movement challenged all of Chinese culture, including its keystone, the Confucian code of behavior. The old code demanded the total obedience of subject to ruler, son to father, and wife to husband. In the wake of this challenge to the past, foreign ideas met a receptivity unknown in China for the previous twelve hundred years. Teachers such as John Dewey and Bertrand Russell personally introduced their own ideas as well as those of other thinkers—from Aristotle to Rousseau to Marx. There was an enormous interest in the Russian Revolution. Western books and periodicals poured into China, and Japanese influence waned as Europe became the focal point for the young intellectuals who explored all trends, including Bohemianism and avant-garde art. By 1920 a few Chinese artists had returned from their studies in Europe. They sought to revitalize Eastern art by applying to it some elements of Western art.

The new art movement was led by different apostles in different cities. In Nanjing, Xu Beihong (1895–1953) promoted realism based on French academic style. In Hangzhou, Lin Fengmian (b. 1900, Meixian, Guangdong Province) championed self-expression by sinicizing Post-Impressionist art techniques. Both Xu Beihong and Lin Fengmian had spent years in Europe mastering Western styles. In Shanghai and Beijing other progressive painters explored many alternatives. In 1929 the Ministry of Education sponsored the First National Art Exhibition in Shanghai, which included contemporary traditional and Western painting as well as sculpture, photographs, architectural design, and embroidery. Some of the most respected Japanese oil painters were also included.

The results of the First National Art Exhibition and the new art movement were disappointing. It was clear that the great synthesis of East and West had not yet occurred; much of the work looked like mindless borrowing and imitation. To the hard-line Communists in Shanghai at that time the new art seemed unrelated to life and the crises of the times. They labeled artists who practiced "art for art's sake" as imperialists and argued that artists should be responsive to the masses of China—to social and political problems.

Lu Xun, a leading writer of the 1920s and 1930s, used his art, in the form of ironic short stories, to awaken the Chinese social conscience through vivid depictions of suffering and oppression. Lu Xun advocated using not only stories but also newspaper cartoons and wood-block prints—a traditional folk-art medium—as cheap and effective ways to carry the message of change. Committed to changing the old society, Lu played a major role in supporting Communist artists. He argued, in line with the Communists, that images should be realistic so that everyone could understand them. He found the distortions of modern art repugnant and irrelevant to the mission of Chinese art. He was inspired by Lenin, who had clearly stated that art and literature should serve the revolutionary cause, and Lu Xun has become the patron saint of Chinese

Communist arts, even though he was not a member of the Chinese Communist party and his short stories did not follow the Socialist Realist model.

The genuine differences between the Nationalist party (KMT) and the Communist party over how to modernize and govern China resulted in an intermittent but devastating twenty-two-year civil war, which continued even while both parties were fighting the Japanese during World War II. One aspect of the domestic political struggle was a clash of views concerning what the new Chinese art should be. The anguish of disagreement was matched by the degree of commitment shown by the proponents of international styles such as Academic Realism, Modernism, and Socialist Realism and by those who advocated traditional Chinese art. Many artists tried variations and combinations of several styles.

Influences on Chinese Painting During the Second Quarter of the Twentieth Century: Archaeology, Wartime Travel, and Dunhuang

Three profoundly important experiences affected the consciousness of all Chinese artists at this time, according to Mayching Kao. The first was the development of archaeology. In the 1920s the Nationalist government conducted the first modern scientific archaeological dig in China, and spectacular bronzes were found in the excavations at Anyang, the ancient Shang capital in modern Henan Province, which had flourished in the second millennium B.C. The tombs contained many items of bronze, jade, and other key archaeological materials, which provided a host of details about ancient China. After years of soul-searching but inconclusive debates among intellectuals about the longevity of Chinese civilization, here at last was scientific proof of China's antiquity. Moreover, modern artists were moved by the beauty and high technological level of these ancestral creations of so many years ago.

The second eye-opening experience was wartime travel. Both the civil war and the war against Japan forced millions of East Coast people to move into China's interior. Those who followed the Nationalist government to the wartime capital, Chongqing, on the Yangzi River in Sichuan Province, traveled to the Southwest. The Beijing and Hangzhou academic artists resettled together in the hot, wet capital-in-exile. Earlier, the Communists had made their remarkable Long March—over six thousand miles to evade the Nationalist forces—which ended in the caves of Yan'an in Shaanxi Province in 1935. The Communists' base was in the austere dry plains and rocky mountains of the Northwest. The Chinese call the northern soil, windblown from the eroded plain, "red dust." Only the folk art of house decorations—cheerful paper cutouts pasted on the paper windows and bright New Year's pictures on the doors—relieves the monotone of the Shaanxi countryside. That imagery would be an important ideological factor in the new Chinese art of the Communist regime.

The third major experience affecting China's artists came from the Chinese rediscovery and popularization of the Buddhist cave paintings at Dunhuang in

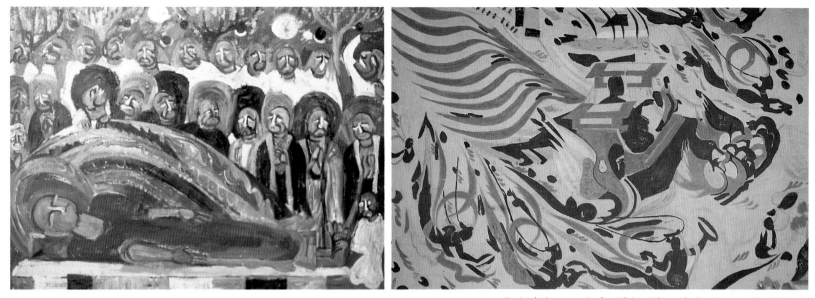

Gansu Province. Dunhuang had been an important oasis in the Gobi Desert along the great Silk Road from the West, which linked China to India and Persia as well as to the civilizations of the Mediterranean, but it had been long abandoned and forgotten in the desert sands. Caravan traffic had ceased at some time in the fourteenth century, but from the fourth until the thirteenth century, travelers desiring some insurance in this life or the next had richly patronized the Buddhist community at Dunhuang. Caves were carved out of the hillside by the pious and decorated from floor to ceiling with sculptures and paintings. The paintings were both narrative and decorative, depicting the heavenly host and sphere, stories of the Buddha, and the dark demons of the underworld. In 1942 Zhang Daqian, a painter in the traditional style, led a small group from Chongqing to copy sections of the fabulous cave paintings. Western explorers had also made records, through drawings and photographs. Zhang Daqian exhibited, both in China and abroad, the copies he had made during two and a half extremely difficult years. The response was enthusiastic.

The Dunhuang copies provided new sources as an alternative to traditional ink painting. To Chinese artists, the Dunhuang caves offered examples of mural technique, narrative and decorative composition, and a wide variety of styles, ranging from the work of the Six Dynasties period in the fourth century A.D. to that of the thirteenth-century Yuan dynasty. During the earliest period of Buddhism in China, from the fourth to the eighth century, the Chinese called Buddhism a foreign religion and its Indian imagery met with resistance. But at Dunhuang, the original Indian styles became sinicized. The PRC (People's Republic of China) artists of today have no apparent interest in the foreign roots of the paintings. They are considered authentic Chinese creations because they legitimize a tradition in Chinese painting that is entirely different from the dominant one of ink painting with pale washes, featuring birds, flowers, and mountain mists.

5. Artist's copy. *Indra Flying Through the Heavens.* N.d. From a Dunhuang cave painting, Tang dynasty. Ink and color on paper. Xinjiang Museum

Indra, the god who drives the sun through the sky, rides through the heavens in a sumptuous chariot drawn by birds and surrounded by flying Apsarases. The intense coloring, elongation of figures, linear design effects, and dynamic narrative style have inspired many contemporary artists.

LEFT:
6. Zhang Jianjun. Copy of *Buddha's Parinirvana.* 1980. From Dunhuang Cave No. 428, Northern Zhou dynasty. Ink and color on paper

This faithful copy of the Buddha's cessation of existence—hence the end of suffering—shows the reclining Buddha attended by his grieving followers. Sometime during the fourteen hundred years since the original was painted, the color of the pigments changed, and the top layer of paint, which outlined the faces, was damaged. The prevailing underpainting has a bold and emphatic Expressionistic look.

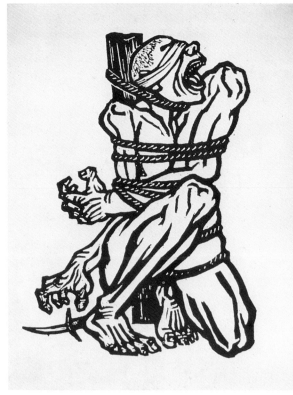

7. Li Hua. *Roar China*. 1935. Wood-block print

Chinese Communist art was born to propagandize the revolution by revealing the suffering of the masses. This print by Li Hua (b. 1907, Guangzhou, Guangdong Province) is an outstanding example from the earliest Chinese Communist period. China is personified as a blindfolded, shackled slave, having only an anguished roar to express his pain.

The Origins of Chinese Communist Art

Chinese Communist art began with the wood-block print movement advocated by Lu Xun in the 1920s and 1930s. Groups of wood-block propagandists and cartoonists, working in the urban revolutionary centers of Shanghai, Guangzhou, and Wuhan, dodged Nationalist government censors. Some of them went on the Long March; others joined the Communists after their base at Yan'an had been established. In 1938 the Lu Xun Academy of Fine Arts was founded there, so named to commemorate the Communists' cultural hero, who had died in 1936. In Yan'an teachers and students spent much of their time as soldiers. Artwork consisted primarily of propaganda-style wood-block prints and cartoons with social and political messages. Some artists painted stage settings for the troupes who performed propaganda plays in peasant villages. The plays, like their visual backgrounds, featured militant themes of imperialist aggression and the oppression of the masses. All were designed to raise the political consciousness of the peasants and spread the word about the Communist revolutionary cause.

The Soviet Union was the dominant influence in the Chinese Communist movement, and that influence affected all art. The Soviet Union packaged and exported Communist revolutionary models. Here, after all, was the shining example of a feudal society being transformed by the magical Marxist formula.

In 1942 Mao Zedong's "Talks at the Yan'an Forum on Arts and Literature" laid down a theoretical framework for Chinese Communist art. Although "Talks" has remained an official document, interpretations of that part of the text pertaining to art styles and subjects have shifted with the political tides. In the Yan'an "Talks" Mao stated that "there is no art for art's sake, no art that stands above classes, or art that is detached from or independent of politics." Class orientation is the central theme of this discourse. Mao argued that art must not only be for the masses but also must come from their experiences. Elitists, such as the bourgeoisie or intellectuals, he said, are incapable of writing or creating art for the masses until they have lived and worked with the people and undergone a class change. Mao spoke vividly of his own class change:

I began life as a student and at school acquired the ways of a student; I then used to feel it undignified to do even a little manual labor, such as carrying my own luggage in the presence of my fellow students, who were incapable of carrying anything, either on their shoulders or in their hands. At that time I felt that intellectuals were the only clean people in the world, while in comparison workers and peasants were dirty. I did not mind wearing the clothes of other intellectuals, believing them to be clean, but I would not put on clothes belonging to a worker or peasant, believing them dirty. But after I became a revolutionary and lived with workers and peasants and with soldiers of the revolutionary army, I gradually came to know them well, and they gradually came to know me well too. It was then, and only then, that I fundamentally changed the bourgeois and petty-bourgeois feelings implanted in me in the bourgeois schools. I came to feel that compared with the workers and peasants the unremoulded intellectuals were not clean and that, in the last analysis, the workers and peasants were the cleanest people and even though their

hands were soiled and their feet smeared with cow-dung, they were really cleaner than the bourgeois and petty-bourgeois intellectuals. This is what I meant by a change in feelings, a change from one class to another. If our writers and artists who come from the intelligentsia want their works to be well received by the masses, they must change and remould their thinking and their feelings.

Revolutionary art and literature, Mao said, must reflect the lives of the people serving the revolution. Mao also laid down a general guideline for acceptable art: "[We] criticize and repudiate all works of literature and art expressing views in opposition to the nation, to science, to the masses and to the Communist party." Mao called for a unity of politics and art, of form and content.

The conditions in Yan'an made it difficult to do work that went beyond the propaganda goals of poster and cartoon art. Being an artist came second; being a soldier was first. Many of the Yan'an artists were cartoonists with political backgrounds. They lacked previous fine-arts training and had no skill in either Chinese or Western art, and in Yan'an they lived in isolation, away from the mainstream of both. They were limited to materials that they could manufacture. Moreover, on class grounds, they rejected traditional Chinese painting as "feudal" and Western art as "bourgeois."

Local peasant art captured the interest of the Communist artists. However, they wondered how these colorful and fanciful paper cutouts and auspicious New Year's pictures could be harnessed to convey a revolutionary message.

Art in People's China, 1949–1966

By the time the People's Republic was established in 1949, the Chinese Communist victors and their artists were already adept in the propaganda skills learned in Yan'an and the base areas. Of all those forms, perhaps the most enduring was the comic-book style, illustrated serial story. It became the standard propaganda vehicle—an art for the masses. And, of course, Yan'an folk arts—paper cutouts, New Year's pictures, embroidery, and toys—were included in the plans for future Chinese art.

Some leading artists who had stayed in China after 1949 to continue their work—such as Xu Beihong—championed the idea that both oil and traditional painting could be practiced compatibly, side by side. These artists, all of whom had fine-arts training, were skilled in the international styles of the West and, in particular, the French nineteenth-century academic style. In addition, important influences came from the recent archaeological revelations, from viewing the landscapes of China's interior, and from the Buddhist mural paintings at Dunhuang. The big question was: What place would be accorded to traditional Chinese painting? It had been pronounced feudal and elitist, but it was also intricately interwoven in Chinese culture. Meanwhile, the international Communist form from Moscow—Socialist Realist oil painting, which had been introduced in the 1930s—blanketed China in the 1950s.

During the years 1949–59, the Chinese invited Soviet experts in all fields to

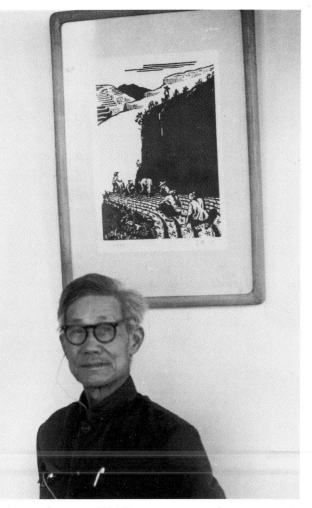

8. *Seventy-four-year-old Li Hua, a veteran woodcut artist, stands beside a print of his* Farming on a Mountain Terrace. *It hangs in the reception room of Beijing's Central Academy of Fine Arts, where he is a professor. After the Communist triumph in 1949, the woodcut artists turned to themes of hard work, progress, and prosperity, which lack the dramatic tension of the earlier work. 1981.*

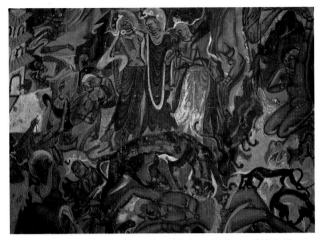

9. Sun Jingbo. Copy of *Jataka of Prince Sudana*. 1979. From Dunhuang Cave No. 254, Northern Wei dynasty

This is a story of the Buddha in a former life. While on a hunting trip with his brothers, Prince Sudana sees a starving tiger about to devour her new cubs. The prince sacrifices himself to save the mother and the cubs. The composition is arranged in a continuous narrative style, beginning in the center: Sudana and his brothers see the tiger. Far right: Disrobed, Sudana kneels and then dives off the cliff. Right center: The tiger and her cubs eat the prince. Left: The brothers recover the bones and enshrine them in a pagoda. This particularly well-integrated, simultaneous narrative composition has profoundly affected many muralists in China today.

10. Artist's copy. *Flying Apsarases*. c. 1978. From Dunhuang Cave No. 419, Sui dynasty

Demigoddesses called Apsarases float in the firmament with scarves billowing from their gracefully elongated torsos in softly rhythmic patterns. Apsarases have been universally admired in China and abroad, and they have become the symbol of the Dunhuang cave paintings.

teach them how to modernize. And China sent many students, including artists, to the Soviet Union. The ideal subjects of Soviet Socialist Realist art were larger-than-lifesize heroes engaged in dramatic revolutionary activities and strong, pink-cheeked heroines who were building the socialist motherland. This Western academic style had evolved from Grand Manner painting; the rules had been memorialized by Sir Joshua Reynolds, the president of London's Royal Academy, in his *Discourses on Art*. Written at the end of the eighteenth century, the *Discourses* prescribed that morality, lofty ideas, and great deeds must be portrayed in order to produce the sublime in art.

The basis of the Grand Manner style was facilely brushed oil painting. Drawing on Renaissance conventions, with man as the central focus, the artist created illusions of deep-space perspective and figures modeled in light and shade. Artists studied the human figure carefully, so that their heroic visions would be anatomically credible when rendered in a chiaroscuro technique; similarly, they made careful observations of the landscape to provide a believable setting. But the artists presented a highly idealized version of "objective truth." For example, Grand Manner heroes were generally draped in appropriately romantic and ennobling robes. Figures were chosen from history and the Bible—appropriate sources for sublime subjects.

Socialist Realism absorbed virtually all the Grand Manner characteristics of style and notions of lofty content. Only the class focus and the costumes were changed. The new subjects were class struggle; Communist revolutionary battles; heroic feats of peasants, workers, and soldiers; and political leaders and their meetings with the masses. Labor heroes replaced muses; Neoclassical drapery was dropped for proletarian garb that was made to look as stylish and swashbuckling as possible. Pale-faced lords and lithe maidens were transformed into stocky, healthy workers with bright pink cheeks.

The basic Soviet Socialist Realist style had also evolved from a Russian version of the nineteenth-century academic painting that was popular in Paris salons. The technique was developed by Chestakov, teacher of the Russians Repin and Serov. It involved six steps: outline, shadows, chiaroscuro, detail, color, and, finally, recalling the first impression. The softly muddied landscapes of Courbet, Millet, and Corot were emulated by the Russians, and, after the Russian Revolution, the romantically silhouetted reaper with scythe was gradually replaced by a smiling young woman and her tractor.

By 1949, when all mainland Chinese fell under the spell of the Soviet model, the Russian ideologists had denounced Impressionism and the subsequent "isms" of modern art as bourgeois and decadent. After all, the Impressionists had been Bohemians, so, therefore, their painting could not be suitable. The Chinese adopted the line.

It is noteworthy that Chinese revolutionary art had little in common with the original Russian revolutionary art—the work of such avant-garde artists as Kandinsky, Tatlin, Malevich, and El Lissitzky. By 1949, those authentic revolutionaries had been silenced for more than two decades and there was no

trace of their work in the revised party line. Stalin had not trusted the avant-garde artists and had dispensed with them, and the Chinese followed suit.

In the Chinese Communist party's propaganda department, which has an interlocking directorate with the government's Ministry of Culture, style and policy issues were debated in order to draw up a correct line for art. As each new line on art developed, became fixed, and then shifted again, the party's explanation of events obscured the stance that had been taken before. A previous party line would be wiped into oblivion.

The establishment in 1950 of Beijing's Central Academy of Fine Arts by the Ministry of Culture demonstrates the continuing changes. The Central Academy inherited the faculty and buildings of the Beiping Art College. Reorganization proceeded immediately. The former program was shortened to train popular-art workers in only three years, and the departments of traditional Chinese painting and Western painting were merged. This initial experiment was followed by frequent changes over the next thirty-five years, but the model of a four-year European academy was generally followed.

The first provost of the Central Academy of Fine Arts, Xu Beihong, and his disciple Wu Zuoren, the first registrar, would lead the new school in a struggle to follow the Yan'an goals: developing popular art for the masses and, at the same time, embracing Soviet ways. Both had taught and administered at the Beiping Art College, and both had studied in France and Belgium for at least a decade. They were masters of academic oil painting. Indeed, Xu Beihong, accomplished in both Western and Chinese styles, was one of the most influential artists in China during the years after his return from Europe in 1927. Xu Beihong believed that the only major difference between Western and Chinese painting was the medium. Convinced that he knew the proper ways to paint and to teach, he insisted that an equal understanding of both styles and mediums was essential to the creation of a new style.

Xu Beihong, like many who had worked for the Nationalists, chose to stay in China with the Communists. Although he was at first honored with a position of leadership, he was later subjected to devastating "struggle sessions," criticism, and reeducation through labor in the countryside—the program most artists and intellectuals had to endure to remold their thinking in accordance with the party line. Some suggest that the incapacitating stroke Xu Beihong suffered in 1951—which led to his premature death in 1953—was a result of his "reeducation."

Although economic conditions were generally better for Chinese artists after 1949, artistic freedom was severely curtailed. Since artists were considered to be an elite group regardless of class background, they were objects of suspicion.

During the first six years of the People's Republic, the fate of traditional Chinese art was in serious question. Under Soviet guidance, Communist theorists viewed traditional painting as elite—a vestige of feudal China. It was labeled "art for art's sake," which meant it was inconsistent with the role defined for art: to serve the revolution. However, a total denial of traditional painting

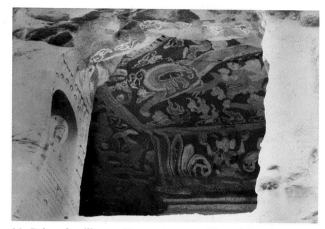

11. Painted ceiling at Yungang caves, Shanxi Province. Northern Wei dynasty. Fresco

The painted ceiling of this cave simulates the heavens, in which an animated peach-and-white dragon undulates through azure clouds. A multiheaded esoteric deity adorns the uppermost wall area, next to the ceiling. The forms and colors of the dragon, clouds, and deity all appear in Zhang Ding's airport mural, Nezha Defeats the Dragon King (plates 22 and 23).

12. Painted and carved niche with Buddha at Yungang Cave No. 12, Shanxi Province. Northern Wei dynasty

Sitting in a niche defined by stone-carved columns and a tied-back curtain, the Buddha reassures his followers with his right hand. His luminous emanations appear as waves. A predominantly blue halo with a white outline surrounds his head and a white mandorla with blue centers encompasses his body. Tiny attendant figures are woven into the mandorla ground, and two larger attendants stand on either side of the throne. Apsarases fly in small compartments above the niche, and the decorative borders at the top suggest a canopy.

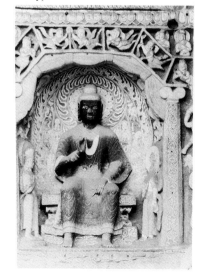

13. Fu Baoshi. *Boatman Beneath Willows.* N.d. Ink and color on paper. Signed Baoshi xie [painted by Baoshi]; one seal of the artist: Fu Baoshi. Formerly collection Dr. Ip Yee, Hong Kong

Stretching the limits of traditional Chinese painting, Fu Baoshi invented new ink-texture strokes, used here to suggest the flickering leaves of the down-swept willows, which evoke a romantic vision. The personal mood is new to Chinese painting and the decorative quality was inspired by some Japanese art of the twentieth century. The small scale of the boatman in relation to the vastness of nature is a continuation of traditional conventions.

was unthinkable, and a compromise was reached whereby figure paintings of the masses would be construed as revolutionary and landscape paintings would be considered patriotic. But bird and flower painting was labeled "feudal." Li Kuchan (1898–1983) was one of many artists who suffered from the compromise. He had been a professor of bird and flower painting at the Central Academy of Fine Arts. After the pronouncement in the early 1950s, he was demoted to gatekeeper. Some months later, a visiting American wanted to see how traditional Chinese painting was done. He was not interested in the Soviet-style oil painting he had been shown. According to Li Kuchan, he was the only person present at the Central Academy who was able to demonstrate the technique of traditional painting. After that, his title was reinstated, but the appropriate salary was not.

All this had a special poignance because Qi Baishi (1863–1957), also a bird and flower painter and Li Kuchan's teacher, was being lavishly honored by the Communist regime. Qi Baishi had an international reputation. Less visible artists, such as Li Kuchan, were being crippled by the new line, which determined correct and incorrect painting.

Li Kuchan's history suggests the continuing importance of nationalism and the tenacity of Chinese tradition, which, at least temporarily, overcame Marxist prescriptions. Indeed, in 1956 and 1957, academies of traditional painting were founded in many cities in China. They were founded during that period called "Let a hundred flowers bloom," when the party encouraged intellectuals to voice their ideas and criticisms concerning China, including the state of art.

When party officials, stung by the scope and depth of the response, clamped down in June, 1957, they initiated the first major "antirightist" campaign. The party leadership charged that many critics, now labeled class enemies, were subverting China's progressive course. Many intellectuals, including a large number of artists, were branded "rightists," ostensibly because they supported the wrong line. In fact, this was a highly sophisticated political power play designed to move opposing forces out of the establishment.

In a long series of struggle sessions that took place within every work unit and institution, groups of people accused the alleged rightists of all kinds of reactionary and even counterrevolutionary thoughts. Day after day, the accused were called on to confess errors, both orally and in writing. Sometimes they were beaten or tortured. They were always isolated, humiliated, and made to feel worthless, even immoral, in the light of the noble revolutionary cause.

Family members were also drawn into the attacks. The party pressured spouses to divorce the accused. Sometimes wives and husbands chose to do so to save themselves and their children from extreme stigma and other consequences. Upward mobility was cut off—specifically, job, party, and educational opportunities. And even if their rightist labels had been removed in the early 1960s, these people were still considered to be rightists and so were targets again during the Great Proletarian Cultural Revolution, which began in 1966. It was only after 1978, more than twenty years later, that many of these so-

called rightists were fully rehabilitated and had their jobs and status restored.

Least lucky in the antirightist campaign and the Cultural Revolution were those convicted of crimes and sent off to serve long sentences in public-security labor-reform camps in remote areas. Some did not survive the harsh conditions. Others, although not condemned as criminals, were also sent to the countryside for long-range reeducation. Some were sent to prison camps, where they too engaged in physical labor, confessed their deviations, and studied to correct their thinking. Some "rightists" remained in remote areas for twenty years or more. This campaign was supposed to spur artists and other intellectuals to shed bourgeois influences.

In the final years of the 1950s, with the deterioration of the Sino-Soviet relationship and the departure of Soviet experts, the status of traditional Chinese painting rose abruptly. The popularity of Socialist Realism declined as nationalistic sentiment ran high. In the early 1960s the credibility of Chinese intellectuals was restored. At last, talented artists, such as the Nanjing landscape painter Fu Baoshi (1904–1965), were given the recognition they deserved. Similarly, the achievements of Pan Tianshou (1886–1971) in Hangzhou and Guan Shanyue (b. 1912) in Guangzhou were acknowledged.

The Cultural Revolution

This heyday of traditional painting ended abruptly in 1966 with the outbreak of the Great Proletarian Cultural Revolution. Although most of the worst excesses of the Cultural Revolution had ended by 1969, the policies and the political climate they engendered spanned a decade. During that period, Jiang Qing, the wife of Chairman Mao Zedong, led a massive campaign to destroy all existing Chinese culture. She and other "radicals" claimed that all Chinese art created between 1949 and 1966, even though done under Communist rule, was bourgeois and reactionary—and therefore counterrevolutionary. She sought literally to exterminate almost all existing art forms except Socialist Realism and make new, pure creations that were "truly" revolutionary. This vision was deceptively simple. In the process, the great majority of the artistic establishment—policymakers as well as artists—were criticized, humiliated, and virtually imprisoned at their work units from 1966 until 1969. They were locked in rooms called cowsheds. Because intellectuals were classified as being from the "stinking ninth category," they were treated like cattle. Many people were beaten or tortured, and some were denied crucial medical care. Some committed suicide.

Subsequently, most of the victims were sent to the countryside for several years of labor and thought reform. All artistic creation, except for propaganda work, virtually ceased between 1966 and 1972. Even after the artists were allowed to return from the countryside, their work had to express high political consciousness in the form of patriotic, political subject matter. Professional artists had to form into creative groups and paint collectively—to submerge their

14. *Guan Shanyue's large screen with red plum blossoms in ink and color on paper was inspired by a poem of Chairman Mao's, and it decorates the Beijing Hotel Café. The composition was reproduced and hung in public buildings, airports, and hotels all over China to symbolize the Hundred Flowers period of 1978–80. It became the officially approved image of the national campaign. Its reproduction was also a continuation of the Chinese tradition of copying paintings. 1980.*

15. *This is one of two large screens that were painted in ink on paper by the Chinese-French artist Zhao Wuji for the lounge of the Fragrant Hills Hotel, Beijing. The hotel was designed by the Chinese-American architect I.M. Pei in 1981. The painter and the architect, both unusually gifted, have distinguished international reputations, yet when they returned to the motherland to contribute their considerable talents, many Chinese could only point out shortcomings. However, when hotel officials wanted to remove Zhao Wuji's screens because they were abstract, a group of Beijing artists petitioned to keep them. They have been kept, but their grandeur is trivialized by the presence of loudly colored, mass-market commercial paintings of indifferent quality. 1983.*

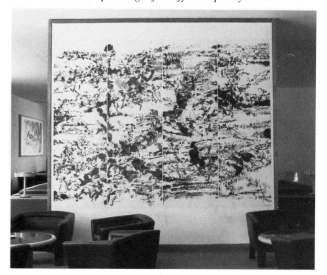

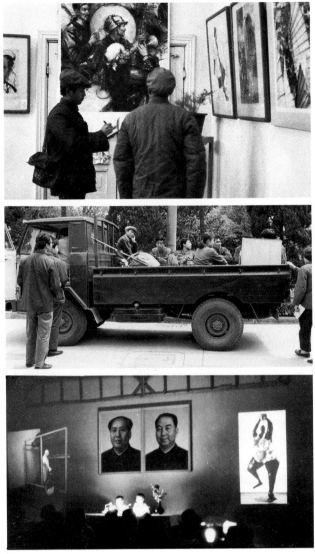

TOP TO BOTTOM:

16. *Artists view and sketch in the Central Academy of Fine Arts Gallery. The painting of the soldier in the background is by Shi Guoliang (b. 1955, Beijing) and is done in the Socialist Realist style taught in all Chinese art schools. 1980.*

17. *Art students at the Shanghai Drama Academy pile into a truck to go on a field trip. Sketching from nature—mountain, river, farm, and factory—is essential training in realism in Chinese art education. 1980.*

18. *During an illustrated lecture by the author, who was introducing twentieth-century Western art at the Guangzhou Academy of Fine Arts, slides are projected on either side of permanently fixed portraits of Chairmen Mao and Hua. The realism of George Segal's* Garage Mechanic *was no surprise to the audience, but the humor and whimsy of Niki de Saint-Phalle's* Black Venus *brought down the house. 1980.*

individuality. Only amateur artists were given credit for their work, which is how some aspiring young artists who could not go to art school during the Cultural Revolution—such as Tang Muli (p. 100) and Chen Danqing (p. 103)—became famous. Socialist Realist oil painting best expressed the ideals of the Cultural Revolution, and once again it became the favored official style. Peasant painting was also promoted and exported by the revolutionary leaders.

In 1974 another wave of terror swept the artistic community when the works of some artists were impounded and exhibited as "Black Paintings." The radical leaders felt that these artists had not changed their counterrevolutionary course and had persisted in using bourgeois styles and subjects. These artists were labeled "Black Painters." Special exhibitions, held in the official art galleries of major cities, for Chinese only, displayed Black Paintings as negative examples. The label "counterrevolutionary elements" was written out and displayed next to the paintings. "The artist has used too much black ink and therefore the painting is counterrevolutionary" sounds like a line from *Alice in Wonderland* to us. But what may appear to be nonsense resulted in suffering, degradation, and humiliation for the artists. For example, Huang Yongyu, one of China's internationally admired artists, was accused of making fun of the regime in his animal cartoons and poems. He was forced from his home to live in a leaking hovel without any amenities, and then was hounded by inquisitors for a year.

After Mao Zedong died in September, 1976, Huang Yongyu was given a major commission to design a tapestry backdrop for the white marble sculpture of Mao in the first hall of the mausoleum. He received the commission on merit and, no doubt, to reassure him that the art establishment intended to repay him in prestige and honor for his extreme suffering during the period of the "Gang of Four" (as Jiang Qing and three high-ranking associates came to be known).

Virtually every artist was severely criticized or otherwise affected by the Cultural Revolution. Mao had always distrusted artists as much as intellectuals, professionals, landlords, and the bourgeoisie because they were an elite class. Since Mao believed that China would achieve communism only when the masses were in charge, he periodically attacked the elite, first during the campaigns of the 1940s, and after Liberation in 1949, in a series of campaigns culminating in the antirightist attack of 1957. But those who were punished or dismissed from their jobs then were only a small proportion of that unfortunate elite class. The scale changed dramatically during the Cultural Revolution, when the entire elite was subjected to a massive attack.

Lenin pronounced art to be a cog in the wheel of the revolution; in China the party controls art by being both patron and educator. The artistic power structure functions through the propaganda department of the party, which instructs the Ministry of Culture. The Ministry of Culture administers art education, art associations, museums and galleries, and related art units. Provincial municipal and county governments and all their institutions are also guided by the national policy set by the Ministry of Culture. In the overall scheme, the ministry decides who will work as an artist, how the artist will be

educated, what subjects and styles the artist will employ, who will be exhibited, and what will be published. The right of the artist to pick his style and subject matter varies according to the political tensions of the period. In periods of relaxation, such as the Hundred Flowers periods, 1956–57, 1978–80, and 1985–86, experimentation was encouraged. Yet, even then there were limits—and during the Socialist Morality campaign in 1981 and the Anti–Spiritual Pollution Campaign of 1983–84, artists were criticized for their deviations.

The Artist in the Post-Mao Era

To safeguard against possible future disasters such as the Cultural Revolution, the Fourth Congress of Artists and Writers met in November, 1979, and issued a statement that constituted a compromise between party control and artistic freedom. "The Chinese National Artists Association will legally defend the artist's right to individual expression . . . as long as the artist does not subvert the goals of the Communist party."

Some art is still found to be "unacceptable" and it is criticized in many ways. Work is called "formalist," which translates as "decadent art," if the subject is not recognizable. In the relaxed political climate of the post-Mao era, unacceptable work is not readily exhibited or published, but the artists are free to work privately.

The generation of professional artists who have been educated in art schools since 1949 is coming increasingly into the limelight. The lucky ones are those who, from a vast pool of applicants, successfully competed for the scarce spots in the schools run by national, provincial, or municipal cultural bureaus. The graduates, like all Chinese, are given assigned jobs. Some of them are employed by research units that give them time and space to paint; others teach or do artwork for factories or companies.

As of 1984 artists were paid the same salaries as most teachers. They start at about forty-five yuan a month—which in the 1984 period was worth about twenty dollars—and can earn as much as three hundred yuan, but the average salary is seventy yuan. Their monthly housing costs range from three to five yuan; their health care, roughly two yuan; and education fees average two yuan per child. The best-known artists can sell their work through painting shops or through their own units, and they keep a certain percentage of the sale price (it varies from thirty to seventy percent). Paintings are priced by size and the seniority and importance of the artist, in most cases without reference to the market. Another source of income for artists is from publication of their work, and they always hope for honoraria for creating decor for hotels, airports, or other public buildings. While on the job, they are usually given room and board, with privileged use of a car and access to the theater and other entertainment. But an important perquisite for artists is an annual month-long paid trip to go somewhere and just paint. Most Chinese have no chance to travel, and this part of the artists' jobs takes them to the most remote, exotic parts of China.

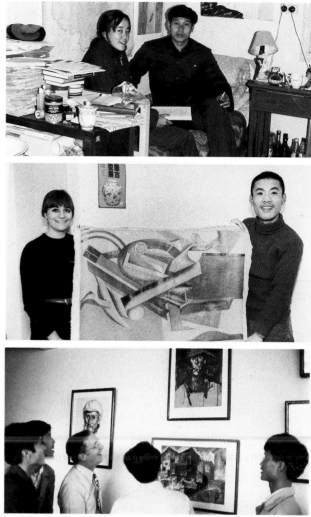

TOP TO BOTTOM:

19. *Two graduate students at the Central Academy of Fine Arts sit in a typical dormitory room. Maria B. Fang, an American artist of Chinese descent, was the first American to study at the Central Academy of Fine Arts after the Cultural Revolution. A student of traditional Chinese painting, she discusses art history with classmate Lawrence Wu, who studies that subject. 1979.*

20. *Zhang Ga (right), a student at the high school affiliated with the Central Academy of Fine Arts, experimented with abstract compositions outside of school. He shows his work to Canadian graduate student Catherine Maudsley. Interested in international intellectual trends, in words as well as images, Zhang Ga translated essays by Kandinsky and Duchamp, read Marcuse, Kant, and Marx, and then went on to explore religious ideas, which ultimately led to his arrest. 1982.*

21. *In 1980, after American Consul General Richard Williams opened the United States Consulate in Guangzhou, he invited art students to exhibit their work in the new offices. This was a significant step toward cultural exchange. Post-Impressionism was the prevailing style. 1981.*

NEW WAVES: THE POST-MAO PERIOD

With the death of Chairman Mao and the arrest of the Gang of Four in the autumn of 1976, a new era began with the promise of new directions for art.

In a massive shift away from radical revolutionary policies, the new leadership set out to reshuffle political and economic priorities. Economic development and increased production replaced class struggle as the top concerns. The Four Modernizations introduced by Premier Hua Guofeng in 1978 meant new directions at home and more open attitudes toward the outside world. After ten years of virtual isolation, China turned outward again, seeking foreign capital and technology in her quest to modernize.

In a more relaxed environment, the art world, which had been isolated and splintered during the Cultural Revolution, began to stir. By 1978 the old slogan from 1956–57, "Let a hundred flowers bloom," had been revived. The post-Mao leadership rehabilitated the vast majority of the artists and intellectuals who had been accused of class crimes and revisionism. These people, who had been humiliated and often physically abused, returned to their former jobs, homes, and whatever possessions could be located. By late 1978 the new authority, under the leadership of Deng Xiaoping, sought to reassure them that things were really different now, that aberrations such as the Cultural Revolution would never happen again.

As China opened its doors to foreign ideas, people, and products, artists suddenly had access to a range of foreign books and magazines—as well as to scholars, especially from the United States. In late 1978 and early 1979, for the first time, the party tolerated Chinese artistic expression in modern styles, beginning with Impressionism and all the other "isms." The government planned cultural exchanges that included exhibitions of foreign art and programs for artists from the West and Japan to study and teach in China and for Chinese artists to study abroad.

For a few months the new Hundred Flowers period bloomed in a surprisingly free way. Spoken and written criticism of the bureaucracy was allowed. Organized religion reemerged. Peasants were permitted to sell some produce in free markets. Even disco dancing was tolerated. The climate was truly conducive to experimentation, especially for young people who had not lived through the repression that followed the 1956–57 Hundred Flowers period. Many older

artists remained skeptical of Deng Xiaoping's relaxation, but the post-Mao policymakers reassured them that the government would not repeat the errors of the past.

Moreover, in 1979 the government redefined the line "Art must serve politics," saying that it had not served the "politics of the masses," but merely a few politicians, "a handful of careerists and conspirators." In other words, the Gang of Four, who were being blamed for the Cultural Revolution.

For almost a year, Chinese were allowed to express their anger at the injustices of the Cultural Revolution. Many people wrote bitter indictments on large posters, which they placed on what became known as "Democracy Wall" in central Beijing and on other walls all over China. Young artists from remote parts of China came to Beijing to hang their paintings on Democracy Wall. They exhibited work done in such previously taboo styles as Impressionism, Post-Impressionism, and Abstract Expressionism. Young people published independent magazines, thus spearheading a democracy movement. China saw a freedom it had not known since 1949.

The period of relaxation was short-lived and gradually came to an end. In November, 1979, the government began to require permits for putting up large Chinese-character posters, and some of the free-speech leaders were arrested that year. The crackdowns on art lagged somewhat; they were not really enforced until April, 1981. But from then on, the line tightened. The party rejected almost all art that was not recognizably realistic, and nudes could not be shown. Narrative art was strongly favored. Works that stretched the limits were still occasionally exhibited, and some articles questioning the tighter policies were published. However, most artists retreated to their homes to continue to experiment in private. But in 1985 a notable liberalization occurred, which has continued through 1986. It is complementary to the "economic responsibility system" (first initiated on a small scale in 1980), whereby individuals and units have been given greater freedom from government control.

Wall Painting

Wall painting appeared as a significant art movement with an important future in 1979, in conjunction with the new Beijing International Airport mural project. The time, which coincided with the thirtieth anniversary of the People's Republic, was one of great hope, and wall painting seemed to be a promising new form of modern Chinese art expression. The opportunity for artists to create works for large spaces led to the possibility of being liberated from the conventional formulas. The artists could work beyond the confines of a stretched canvas or the edges of a paper scroll. A mural carries none of the enormous burden of traditional ink painting, which restricts the artist to old formulas, nor does it carry the onus of oil painting on canvas, commonly referred to as "Western art." Moreover, murals could be accepted as legitimately Chinese, because they had been done in China for millennia.

In ancient times, the Chinese had decorated their palaces and tombs with murals that portrayed life at court and in the countryside, as well as scenes of cosmic fantasy. However, contemporary artists have been particularly inspired by the bold narrative schemes, brilliantly decorative styles, and rich colors of the art in the Buddhist cave temples at Dunhuang and other oasis cities along the Silk Road, as well as by the art in structures such as the Yongle Gong, a Yuan dynasty palace in southern Shanxi Province. When Buddhist art arrived in China, the Indian style had already been intermingled with Central Asian characteristics. Ultimately, it underwent a sinicizing process. Another Chinese source that wall painters draw on is Ming dynasty (1368–1644) decorative bird and flower painting, done in bright, opaque colors. This Chinese decorative style was admired by the Japanese and the Persians, who adapted aspects of it in their own creations of that period.

Wall painting also has authentic Marxist roots, deriving from the Mexican Communist muralists of the early twentieth century such as Diego Rivera, David Alfaro Siqueiros, and José Clemente Orozco, who painted the story of the oppressed Mexican peasants and their struggle for revolution in a Socialist Realist style. The Mexicans received international recognition for their socially conscious, powerfully expressive works.

During the 1940s, the Chinese government, after hundreds of years of neglect, took an active interest in the archaeological exploration and preservation of Dunhuang. At the end of the nineteenth century, Western explorers rediscovered the Silk Road, which skirted the great Takla Makan Desert. For the next fifty years, these foreign adventurers attempted to piece together, from the remains of once-flourishing Buddhist communities, the lost histories of the oasis cities. At the same time, they collected archaeological treasures from these sites and took them home to their respective countries, including England, India, France, Germany, Russia, Japan, and the United States.

Persuaded by the ink painter Zhang Daqian's enthusiasm, the Nationalists formed the Dunhuang Research Institute in 1943. Several artists, including oil painter Dong Xiwen, joined Zhang Daqian in an ambitious project to copy the murals. Zhang's copies were not literal. He used what he thought had been the original colors. This experience in using rich, opaque colors and gold profoundly affected Zhang Daqian's future work, which also inspired the new generation of Chinese artists to look for fresh sources in Chinese tradition and engendered a new Chinese art based on the murals' style and technique.

But during the early years of the People's Republic, wall painting was still only an idea for the future. Russian-influenced Socialist Realist canvases were officially patronized in the 1950s and during the decade of the Cultural Revolution. Traditional Chinese painting was favored in the years 1960–66, but wall painting was never really given a chance until 1979.

In 1973 murals were planned for the new wing of the Beijing Hotel, but while work was in process, paintings were seized by one of Jiang Qing's henchmen,

who exhibited them as Black Paintings and denounced them as decadent and counterrevolutionary. Later, a single mosaic mural depicting the landscape of Guilin was made for the new restaurant, but it has aesthetic shortcomings because it was conceived as a painting; the medium is particularly unsuited to illusionistic perspective. Moreover, it has technical problems because the tiles are too large to be truly evocative in such realistic work.

The time for wall painting finally arrived when the new Beijing airport was nearly complete. Unlike all other Chinese airports extant in 1979, this one would have no paintings or sculptures of Chairman Mao or other political figures, no quotations from the poems and slogans of Mao, not even a workers' solidarity picture or a peoples-of-the-world friendship picture. Instead of commissioning propaganda paintings, the leadership asked Zhang Ding, head of the Beijing Central Academy of Arts and Crafts, to select artists to create murals.

The introduction of a new kind of painting into public places meant the omission of the kind of art previously created for those spaces: specifically, Socialist Realist political canvases or enlargements of traditional landscape or flower works in ink. Thus, according to one artist who heard the remark, the old powers within the art establishment were angry and jealous of the wall painters: The famous poet Ai Qing bluntly stated that wall painting was a threat to the old "art circles." The embattled muralists had to form their own organization, which was answerable directly to the Ministry of Culture and not to the Chinese National Artists Association, which was dominated by the old guard.

In China muralists face the same problems that any other Chinese artist does in creating for public spaces. Both the commissioning party and art officials exercise supervisory control over subject matter and style. Sketches and work in progress are both reviewed, and suggestions for changes are made. Perhaps the review-revision-approval process seems more intense for the wall painter, because the presumption of permanence is stronger. Officially, commissions come through art units. However, political and personal contacts seem to be more important.

Payment for murals has been a particular source of tension because artists expect to be paid but few commissioning units want to comply. All professional artists who are asked to do murals receive a salary from their own employment units. The commissioning ministry or group provides the artist with bed, board, and transport while the work is in progress and considers those perquisites, plus the psychic income from being selected, to be enough. Since Chinese avoid direct confrontation whenever possible, the matter of payment is rarely negotiated in advance. After the fact, the artist is often bitter and without recourse. After not receiving even a token sum, the Beijing airport artists complained to top government ministers, who then ordered the Chinese aviation authorities to pay them. It was an unpleasant squabble that illustrates differing interests in the system. The government says that those with high political consciousness should serve without question, but artists want tangible recognition of their efforts and recompense for their product.

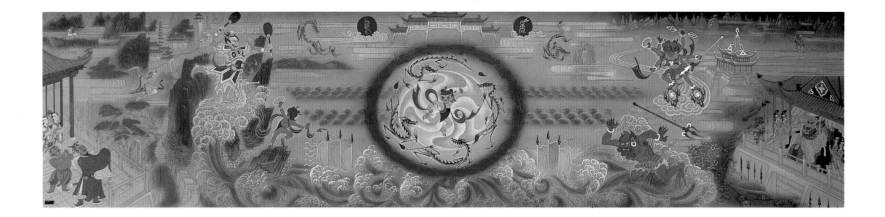

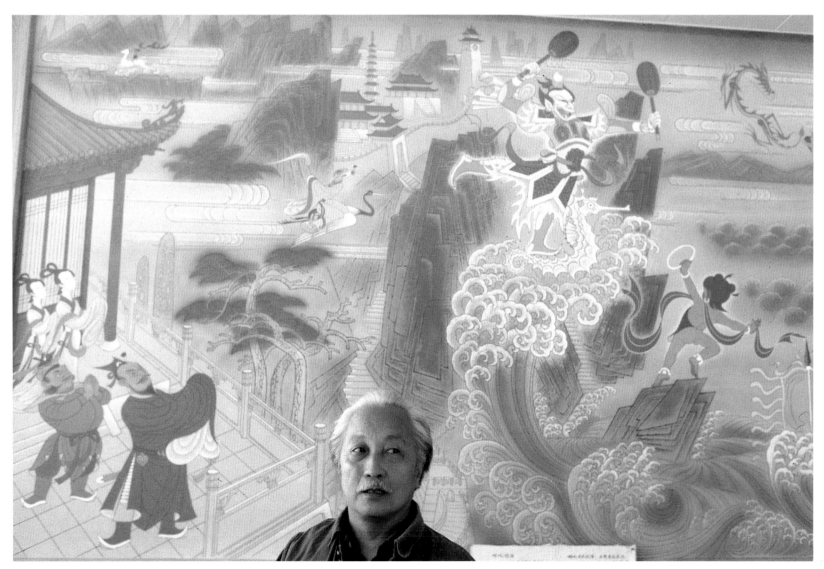

Another problematic situation for all Chinese is access to the murals in hotels for foreign guests—even for the artists who painted them. Unless they have specific business there, Chinese are excluded from these hotels "for the peace and convenience of foreigners," say the authorities. Many Chinese are furious over such exclusionist policies, which smack of the special privileges foreigners enjoyed during what the Chinese call the semicolonial period of the pre-1949 past and which were supposed to have been done away with in new China!

Some of the artists who participated in the Beijing airport project are discussed in this section. From this diverse group, a new style of wall painting is emerging.

ZHANG DING *(b. 1917, Fangshen Village, Heishan Prefecture, Liaoning Province)*
The airport mural commission went to Zhang Ding, an excellent artist with impeccable revolutionary credentials. This short, handsome, energetic man is now in his late sixties. He has lived through all the stages of the Communist revolution and is an archetypal leader in Communist art.

Born in the northeastern province of Liaoning, he came to Beijing to study art at the age of thirteen. He carried with him some silver coins that his father had tied around his waist. When these coins were taken from him by his traveling companion, the young Zhang had to beg for bed and board. However, the enterprising young man soon entered the Beiping Art College, and he had his first exhibition in 1932 at the age of fifteen. The famous bird and flower painter Qi Baishi, who was then almost seventy, admired his work.

In the years after the Japanese occupation of Manchuria in 1931, the ominous specter of a Japanese invasion of the rest of the country was pervasive. Zhang Ding joined with other young Chinese in the Federation of Artists to make anti-Japanese cartoons as well as large paintings that were inspired by the work of the Mexican muralists. He did not know that the federation was a Communist-front organization until, at age sixteen, he was arrested and sent to the Suzhou Reformatory by the Nationalists. It was there that he learned about communism and became a believer.

After his release in the mid-1930s, he went to Shanghai, where he discovered that his cartoons had been published and he had become famous. In the Shanghai and Nanjing press, he joined other political cartoonists, such as Ye Qianyu, to attack the Japanese occupation and other miseries of Chinese life. In the course of his work, he met Chen Buwen, a woman who was a newspaper correspondent. He fell in love and married her. Together, they decided to go to Yan'an to join the Communists. There, beginning in 1938, he taught at the Lu Xun Academy of Fine Arts and devoted most of his spare time to cartoons, propaganda paintings, and New Year's paintings. But his course was not a smooth one. When he exhibited, some of his work was called "formalist"—a potent rejection by the Communists. The leaders called Zhang Ding's paintings "too decorative," and they objected to his elongated figures.

OPPOSITE, ABOVE:
22. Zhang Ding. Detail of *Nezha Defeats the Dragon King*. 1979. Fresco on clay and straw. Beijing International Airport

In the center of the mural, Nezha, the mythical boy-hero, surrounded by a flaming mandorla and four small dragons, holds high his golden ring-weapon while he dances on waves of rainbow-like emanations. Simultaneous narration goes on from the left. The divine boy challenges the son of the tyrant Dragon King while Nezha's father prays for a heavenly resolution. Nezha kills the dragon's son and flies away. To retaliate, the furious Dragon King, Lord of the Waters, floods the earth with the endless expanse of water seen in the central part of the mural. Part of the story is not shown in the painting, but it is well known to Chinese viewers: When the boy realizes the terrible destruction he has wrought—as a consequence of the flood—he takes his own life in anguished humiliation. On the right side, Nezha is shown reborn with the many heads and arms of an esoteric Buddhist deity, holding an arsenal of ultimate weapons. Below, on the extreme right, the defeated Dragon King sits feebly, having conceded to defeat and the relinquishing of the power to flood.

OPPOSITE, BELOW:
23. Zhang Ding. Detail (with the artist) of *Nezha Defeats the Dragon King*. 1979. Fresco on clay and straw. Beijing International Airport

Nezha's father, a robed Confucian gentleman, and servants and ladies raise their hands, beseeching Nezha to stop his battle. Nimble Nezha dances on the top of a rock challenging the wave-clawed dragon, who has a seahorse head and is ridden by the thunder god, waving his clappers. Nezha's mentor, a pink-robed immortal, flies in on a crane to help. The landscape is punctuated with dramatic rock outcroppings like those of Guilin in Guangxi Province.

In 1940 Zhang joined Zhou Enlai in Chongqing to do anti-Japanese cultural work as part of the then-prevailing Communist-Nationalist United Front. However, when the United Front dissolved in 1941, Zhang and the poet Ai Qing disguised themselves as Nationalist officers so they could pass through Nationalist lines and return to Communist headquarters in Yan'an. In 1942 Zhang Ding participated in the historic Yan'an Forum on Arts and Literature. On that occasion Mao Zedong pronounced that Chinese literature and art must be subordinate to politics.

In the rectification campaign against those who had deviated from the Mao line, Zhang and his wife were mistakenly accused of being Nationalist agents because they had lived in Nanjing, which had been the Nationalist capital before the wartime move to Chongqing. His house was searched, his property confiscated, and he was arrested. When some Soviet and American journalists visited Yan'an, Zhang and others from Shanghai or Nanjing who had been arrested were released. The only explanation given for their arrest was "misunderstanding." Nevertheless, after the Japanese surrender in 1945, Zhang Ding and his family traveled by foot, with the two Zhang children in baskets suspended from either side of a mule, to the Northeast to fight the Nationalists in the continuing civil war.

When the People's Republic was founded in 1949, Zhang Ding was called to Beijing to assist with plans for the development of the arts. At the Central Academy of Fine Arts he served first as chairman of the department of applied art and, later, of the department of Chinese painting. There was a continuing debate about the correct line for Chinese art, and during the 1956–57 Hundred Flowers period, he argued for the precedence of traditional Chinese painting over Soviet-style Socialist Realism. He articulated the position of Chinese intellectuals who opposed slavish borrowing from the Soviets. In 1957, party policymakers adopted his view. Another old comrade-in-arms of Mao's, Jiang Feng, who had been a wood-block artist at the Lu Xun Academy of Fine Arts in Yan'an, was the president of the Central Academy. He maintained that Soviet-style painting was the most appropriate revolutionary form. When the anti-rightist campaign was launched in June, 1957, officials used it for personal as well as ideological purposes. Zhou Yang, the Minister of Culture, denounced Jiang Feng as a rightist, and Jiang was purged. He stood before large crowds of people and was "struggled against." He was then sent to the countryside for reeducation through physical labor. For the next few years Zhang Ding's view prevailed because of the break with the Soviet Union and the increase in nationalism. And in 1957 Zhang was made vice-president of the Central Academy of Arts and Crafts. Later, however, he too would suffer these same humiliations—and much worse—during the Cultural Revolution.

During the 1950s and 1960s, Zhang Ding frequently went to Russia and Europe to design installations for Chinese exhibitions. He met Picasso in France, and they exchanged sketches. His Picasso sketch, along with all his paintings, books, and other possessions, disappeared when Red Guards vandalized his

house during the Cultural Revolution. During the most radical phase of the Cultural Revolution, the years 1966–69, waves of revolutionary fervor and violence swept virtually all officials, intellectuals, and artists out of office and into arenas of denunciation. In theory, in order to restore a truly revolutionary spirit to China, the Red Guards were to remove the cadres from office when it was assumed they had grown corrupt and fat. Because of his lofty position Zhang Ding was particularly vulnerable. Among the "crimes" he was accused of were surviving in prison at age sixteen and creating "formalist art." His son, Zhang Langlang, wrote in an unpublished manuscript, *The Story of My Father and Myself*, that

with paint on his face, a dunce cap and paper clothes, he was dragged through the streets to be criticized at struggle meetings. He was compelled to kneel on a high bench, and, even after falling off several times, he was forced to climb on it again. Later, I was also pushed to the platform to receive struggle. Our house was searched time and again. Hundreds of father's paintings were completely destroyed. . . . Father was later banished to a cowshed and forced to wear a black sign around his neck, clean latrines, and weed the garden. He had to perform a laborer's tasks in a sewage and heating system.

Zhang Ding was subjected to continuing punishment, which included being sent to a May 7 Cadre School—reeducation through a combination of physical labor and ideological training that, in his case, lasted for two years. The cruelest torture of all, perhaps, came in 1968 when his son Langlang was arrested as a spy and counterrevolutionary. Langlang spent almost six years in detention awaiting execution and then, when his sentence was commuted, another four years in prison. Zhang Langlang had studied French in high school and had made friends with several French students in Beijing. He writes, "My crime was my casual conversation with my friends and political jokes that I made, such as 'The victory of the Cultural Revolution had to be subject to one condition, namely, Chairman Mao divorcing Jiang Qing.' This was twisted into 'supplying information to French spies' and 'viciously attacking leaders of the central government.' " Also, he was accused of the "intent to rebel against his country" because he wanted to go abroad to study. In late 1977 Langlang was released after almost ten years in prison.

Zhang Ding returned from the May 7 Cadre School in April, 1978, and was appointed president of the Central Academy of Arts and Crafts. Soon after, he was given the commission to create works for the new airport and to supervise the work of other artists. For the project, he did a narrative painting in a cartoon-like style, *Nezha Defeats the Dragon King* (plates 22 and 23), about a mythical boy-hero. It is a Chinese version of the flood story. Different parts of the story are portrayed in different parts of the painting.

The style seems to have a strong affinity to Disney animation, but many details, such as sea, clouds, waves, auras, and fire orbs, are drawn directly from Buddhist wall paintings, and the deep, opaque coloring is adapted from the ancient murals. Another similarity to Buddhist wall painting can be seen in the

simultaneous narrative composition, where the figures reappear in various scenes throughout the story. Zhang Ding used the old fresco technique in which water paints made with vegetable and mineral pigments are applied to a dry, smooth, clay-and-straw ground.

Zhang Ding has used ancient art resources to enrich his cartooning skills, and he has made a prizewinning animated film, using wall painting as a basis. Before he was rehabilitated, he kept his cartooning talents sharp by attacking the Gang of Four. After he was readmitted to the Communist party in 1978, he had more to say about the Gang of Four, who for ten years had called him a

24. Zhu Danian. Detail of *Forest Song*. 1979. *Jingdezhen* ceramic tile with enamel overglaze. Beijing International Airport

The compositional style has a kind of decorative realism that at its best includes brilliant design passages, such as the waterfall descending into the river. Forest Song *is a huge composition, 20 meters long and 3.4 meters high, showing life by the Lancang River (known as the Mekong in neighboring Laos) in Xishuangbanna. It is made of thousands of rectangular tiles that were fired from three to six times in the famous old imperial kiln at Jingdezhen.*

25. Zhu Danian. *Coconut Grove*. 1978. Ink on paper

Zhu spent months sketching the flora, fauna, and tribal people of the remote Xishuangbanna jungle, near the Burmese border. His appreciation of these nobly articulated coconut trees is apparent in this brilliant study. The patterns of the giant trees are so impressive that the Dai dancers and their drums seem strictly incidental.

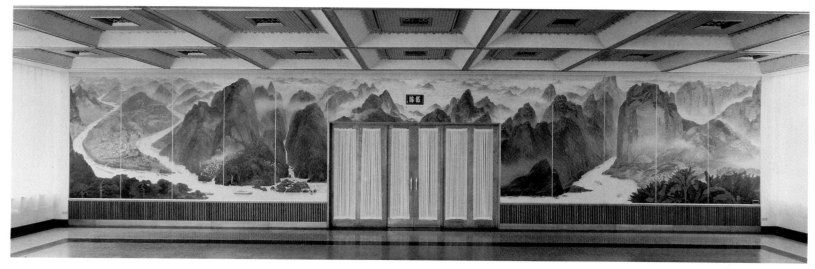

counterrevolutionary. He made vitriolic cartoons attacking Jiang Qing, including one showing her dressed as the wolf in "Little Red Ridinghood."

Since 1980 Zhang Ding has devoted most of his artistic energies to his first love, traditional Chinese painting, and he has had exhibitions in Hong Kong and Japan. He has the traditional Chinese gentleman's distaste for commerce and is very proud that he has never had to sell his paintings.

ZHU DANIAN *(b. 1915, Hangzhou, Zhejiang Province)*
Zhu Danian was one of the senior artists in the airport mural project. In *Forest Song* (plate 24), one of his contributions to the project, he shows the flora and fauna found along the river in Xishuangbanna, the lush border region of Yunnan Province in the southwestern corner of China, next to Burma. His specialty is the art of clay, and so he made his mural of ceramic tiles. Zhu said, "I want to use clay, a material with such a long and important history in China; but now with our modern living conditions there is no place for decorative bowls or vases." (Most Chinese today live in extremely cramped quarters.)

Young Zhu Danian attended both high school and college at the Hangzhou Academy of Fine Arts (the predecessor of the Zhejiang Academy of Fine Arts). He then spent the years 1933–37 studying art and the technology of ceramics at the Imperial College in Tokyo, where his eyes were opened to Japanese achievements. He has absorbed those influences and adapted them to a Chinese context.

After Liberation, Zhu worked for the Ministry of Light Industry, where in 1951 he created, for the Beijing Hotel, an appealing blue-and-white chinaware pattern, adapted from a Ming dynasty design. In 1956 he became the first chairman of the department of ceramics in the Central Academy of Arts and Crafts. However, this honor was short-lived. In 1957 he was accused of being a rightist, part of the so-called Jiang Feng clique. The importance of this political event cannot be underestimated, yet he did not have to go for labor reeducation

26 and 27. Yuan Yunfu. Full view and detail of *The Rivers and Mountains of Sichuan*. 1979. Acrylic on panels. Beijing International Airport

This vast mural depicts China's noble mountains interfaced with mists and the life-giving rivers that cascade and flow into the Yangzi, which the Chinese call the "Long River." Although artist Yuan includes boats on the river and the city of Chongqing nestled in the mountains, he observes the canons of traditional painting: The man-made creations are dwarfed by the natural phenomena.

in the countryside; he had to give up the chairmanship of the department, but he was allowed to keep his teaching job. During the Cultural Revolution, of course, he had to spend three years laboring in the countryside and studying Marxist-Leninist-Maoist classics with his colleagues from the academy.

Zhu Danian designed a second mural for a small lounge in the airport, *White Flower Tree*, executed in oils by Chen Kaiming. In 1981 he did another ceramic mural, *Bamboo Plum and Pine*, for the new Yanjing Hotel in Beijing.

Zhu is aided in his search for appropriate twentieth-century uses of fired clay by the fact that a ceramic mural has a great advantage over conventionally painted surfaces. In the polluted, dusty atmosphere of Beijing, ceramics fare far better than frescoes or works on canvas or paper.

YUAN YUNFU *(b. 1932, Nantong, Jiangsu Province)*

In the wall-painting movement, Yuan Yunfu is one of the most successful leaders of his generation. He is also an accomplished painter in oil, gouache, and ink. His artistic gifts and his easy smile, genial personality, and good sense have proved to be a winning combination. He executed three large mural commissions between 1979 and 1981 and has frequently exhibited and published his work in China and, in 1981, in the United States. Working in close association with Zhang Ding, president of the Central Academy of Arts and Crafts and the leader of the wall-painting movement, Yuan Yunfu has shared the vicissitudes of the wall painters as head of the academy's department of decorative arts, which includes mural painting.

Yuan Yunfu began to study painting at the Hangzhou Academy of Fine Arts in 1949. He explored Western shading, perspective, and color, as well as Chinese brushwork, seeking to combine them in a new way to develop his own style. He had grown up with traditional Chinese paintings in his home in the Yangzi River town of Nantong in Jiangsu Province. Although the family of eight children had very limited means, Yuan's father, a middle-school teacher, had a keen interest in painting and had formed a small collection. In addition, New Year's pictures, family funeral paintings, and the guidance of an older cousin—a student of the distinguished painter Xu Beihong—all contributed to the artistic vision of the youngster who annually won the town's children's painting contests. Yuan claims that his success fired a competitive spark in his younger brother Yuan Yunsheng, who then took up painting.

After graduation from the Hangzhou Academy of Fine Arts, Yuan joined a Beijing publishing house as art editor until 1956, when he joined the faculty of the Beijing Central Academy of Arts and Crafts. He married his classmate Qian Yuehua, a book designer, and they have two sons, Yuan Zuo and Yuan Jia, both artists.

During the Cultural Revolution, Yuan Yunfu was sent, with his school, to the countryside for labor and reeducation. By 1972, his third year in the countryside, political tensions had become so relaxed that when Yuan and his colleague Wu Guanzhong went off on their daily task of collecting dung, they

managed to include paintbrushes in the bottoms of their buckets. Their artist friends teased them as the Dung Bucket School of Painting.

Upon their return to Beijing in 1973, both Yuan and Wu Guanzhong were asked to participate in the decoration of the new wing of the Beijing Hotel. They, along with Zhu Danian and Huang Yongyu, went to the Yangzi River for some months to make sketches. However, while they were traveling in remote areas, in Beijing the political attacks on artists were resumed, which culminated in the Black Paintings exhibitions. On September 26, 1979, in his dedication at the opening of the Beijing airport, the architect Wu Liangyung, who had collaborated with Yuan Yunfu and Wu Guanzhong, noted: "The Gang of Four murdered it [the Beijing Hotel mural project] when it was still in the cradle."

Within six years of the Beijing Hotel fiasco, Yuan Yunfu, a child of the Yangzi, was able to create murals inspired by the river on whose banks he had spent his childhood. He completed *The Rivers and Mountains of Sichuan* (plates 26 and 27) at the airport in 1979, and in 1981 he created *Ten Thousand Li of the Yangzi River* for the Jianguo Hotel. This huge mural depicts the full length of the river, from source to mouth. In it, Yuan included some of the imagery of the airport mural, but the two versions are quite different in scale and effect. The airport mural is completely accessible and all-encompassing; it covers the end wall of the large restaurant almost from floor to ceiling. The Jianguo mural has been installed inaccessibly high—above and in back of the main desk in the lobby. In both murals the images are cinematically sequential rather than panoramic. In *Ten Thousand Li* the Yangzi River is revealed as in a gradually unfolding scroll, descending from the mountains through dramatic gorges to the alluvial plain, past great cities and blossoming countryside, into the Yellow Sea. Both murals are painted with acrylics. The artist has harmoniously combined Western-style, deep-space perspective with traditional Chinese-style multiple perspective points. There is a remarkable freshness about the paintings, the result of combining aspects of Western-style landscapes and direct observation. No doubt, Yuan's new look at old sources, such as the "blue-green" landscape style of the sixth-century Dunhuang Buddhist paintings, contributed.

In 1980 Yuan Yunfu painted a mural called *Light of Wisdom* for the Yanjing Hotel in Beijing. In the August, 1981, issue of *Chinese Literature*, Yuan wrote: "I want to stimulate our sense of national pride in our cultural heritage and revive old tradition." In his Yanjing mural there are more than twenty individual scenes that refer to art objects—from Neolithic painted pottery to Qing dynasty decorative painting—produced during the five millennia of Chinese history. During the Cultural Revolution, many of these relics of Chinese history were denounced, defaced, or destroyed by revolutionary committees, or they were confiscated and sold off. Although the mural suffers from a lack of overall unity in its composition, it is a decorative encyclopedia of Chinese artistic achievement. Painted in muted acrylic colors, the subjects are accented with relief outlines of gold leaf. Several scenes are especially successful, such as the one of soldiers from the warring states, the bronze designs from the fifth century B.C., the

28. Yuan Yunfu. *Street Scene in Hubei Village.* 1972. Gouache on paper

When Yuan was sent to the countryside during the Cultural Revolution to live with the peasants and undergo political reeducation, he painted this village street. Its distinctive charm is marked by wall posters that punctuate the monotonous village grays and beiges with shades of pink and purple.

29. Yuan Yunfu. *Flags.* 1980. Oil on canvas. Shown in the Oil Painting Research Association Exhibition, National Art Gallery, Beijing, 1980

This painting can be viewed as a nonobjective color study, which would mean that Yuan had ventured over the edge of the party line. However, it can also be seen simply as rows of flags. This festive composition was reproduced in tapestry form and then in ceramic tile for the entrance hall of the Central Academy of Arts and Crafts.

Buddhas of the fourth to fifth century A.D. Yungang caves, the Yuan dynasty (1279–1368) birds and flowers, and the Ming dynasty (1368–1644) brocade patterns. In 1984 Yuan completed another vast historical mural for a Beijing subway station. Done in ceramic tile, it depicted Chinese science of the past and present, with visions of the future.

Yuan Yunfu has traveled to many places in China to paint scenes of industry, villages (plate 28), the seashore, forests, and flowers. He uses a variety of mediums, including gouache, with great skill.

Yuan is a leading member of the Oil Painting Research Association, and he showed *Flags* (plate 29) in their 1980 National Art Gallery exhibition.

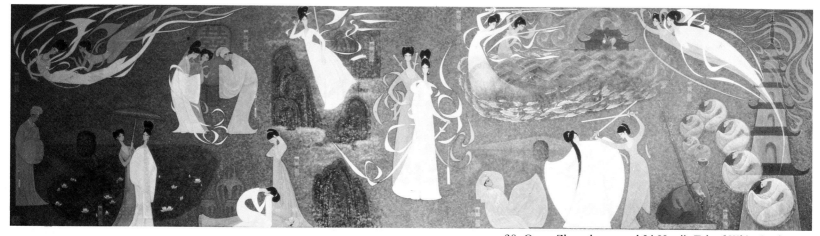

30. Quan Zhenghuan and Li Huaji. *Tale of White Snake*. 1979. Oil on canvas. Beijing International Airport

The narrative mural portrays scenes from a folktale about a snake spirit who takes the form of a beautiful woman. She falls in love with a man, and they marry and have a child. However, when a Buddhist priest discovers her secret, he reveals the truth to her husband. The priest tries to separate the couple, and a tragic battle follows.

31. *Quan Zhenghuan and Li Huaji with three studies for* Tale of White Snake. *The scenes float on the surface of the canvas in a style inspired by the murals at Dunhuang. The artists adapted not only the whole narrative concept of multiple scenes but also a mountain landscape and the elongated female beauties, flying with their scarves like the Apsarases. The dreamlike look of a Russian fairy-tale illustration, often seen in Soviet books in China, is another stylistic influence.*

QUAN ZHENGHUAN *(b. 1932, Beijing)* LI HUAJI *(b. 1931, Beijing)*
Wife and husband artists Quan Zhenghuan and Li Huaji are frequent collaborators. Both attended the Central Academy of Fine Arts, and since his graduation in 1959, Li Huaji has remained there as a teacher of oil painting.

In the late 1940s and early 1950s, Li Huaji was with the People's Liberation Army in southern and western China. Quan Zhenghuan graduated in 1953 and stayed on as a graduate student and teacher until 1956, when she joined the faculty of the Central Academy of Arts and Crafts. They are both members of the Oil Painting Research Association, a group composed of thirty-six outstanding oil painters, ranging in age from the thirties to the sixties.

The painting couple collaborated on the airport mural *Tale of White Snake* (plates 30 and 31), a commission of Quan Zhenghuan's.

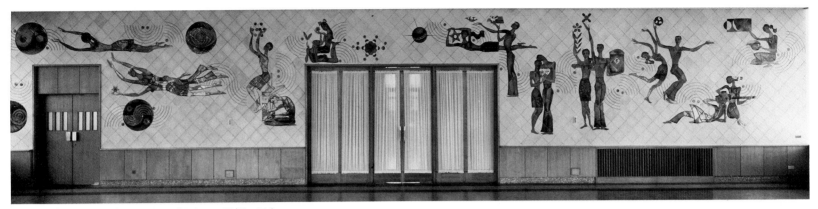

32. Xiao Huixiang. *The Spring of Science.* 1979. *Cizhou*-ware ceramic tile. Beijing International Airport

This composition celebrates the renaissance of the muses of art and science. On the right side of the mural, the muses of painting, music, poetry, dance, athletics, and agriculture appear as lithe, appealing maidens and youths practicing their respective arts. On the left side, chemistry and physics are portrayed as youths juggling atoms and playing tape machines. Graceful figures float in space as man further explores the universe, which is symbolized in circular, abstract forms. The symbols are adapted from traditional Chinese yin-yang designs such as a circle bisected by a wavy line. Each half contains nucleus-like dots.

XIAO HUIXIANG *(b. 1933, Changsha, Hunan Province)*

Xiao Huixiang, one of the two women who participated in the airport project, designed *The Spring of Science* (plate 32). It was executed as a relief in *Cizhouyao* ceramic tiles. Xiao's idea was to show the grand unification of the muses of science and the arts engaging in discovery during China's current modernization period. The muses represent the hope for cultural florescence and the promise of scientific benefits.

When Xiao Huixiang studied wood-block printing at the Central Academy of Fine Arts, she became very interested in the stamped tiles that were made in the Han dynasty. She says that those ancient stamped figures were her inspiration. Thus, she adapts from the old as well as from the twentieth-century Futuristic look that was so popular in the 1930s. Her mural plan, like all the others, had to be approved by three groups: the Ministry of Culture, the Airport Authority, and the Central Academy of Arts and Crafts. There was much criticism of the muses' figures because "they appear nude through transparent clothing." However, Xiao persisted, and the mural won approval when it was completed. Its composition, color, and material are especially well suited to its architectural setting, and it is one of the most successful of all the murals.

Xiao Huixiang says she has chosen not to marry because the demands of husband, in-laws, children, and housekeeping would keep her from her art. In 1957 during the antirightist campaign, she defended a male friend who had been accused of being a rightist. To support an individual accused of revisionism was tantamount to being a rightist oneself. During the divisive struggle period of 1959, she was dispatched to the art academy at Taiyuan in Shanxi Province. There, she was the "new teacher" in a remote place where people were particularly suspicious of strangers. She was soon subjected to criticism and was sent for reeducation to the countryside, where she had to cut grass to feed the donkeys at a time when, because of the near-famine conditions of 1959–60, it was hard to find enough food for herself. When she became ill in 1961, she managed to arrange a transfer to Hunan Teachers College in Changsha, her birthplace. This temporary improvement was short-lived. During the "Criticism of Confucius" campaign of 1973–74, which coincided with the Black Paintings exhibitions in major Chinese cities, Xiao Huixiang was called "bourgeois" and

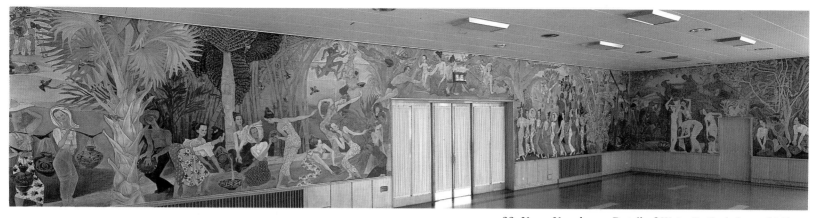

"revisionist" and her work was denounced as formalist. In 1979, after the post-Mao liberalization, she was rehabilitated and was happy to be transferred to the Central Academy of Arts and Crafts, where her teaching schedule allows her some time to paint.

YUAN YUNSHENG *(b. 1937, Nantong, Jiangsu Province)*
"If you eat cat meat, it doesn't mean you'll turn into a cat," says China's most controversial artist, Yuan Yunsheng. He refers to the implied risk in adapting elements of traditional Chinese art and Western art in his paintings. He exhorts his students to "be yourself as an artist, don't be afraid of being eaten up." In the context of Chinese art, "let the past serve the present" has been the approach—except during the Cultural Revolution. However, where the artist must serve the masses, follow the party line, and still try to be himself, observing this dictum can cause problems. Being oneself could result in the kind of individualism that is not possible within the framework of Communist ideology.

After sixteen years of exile in the Northeast, Yuan Yunsheng returned to Beijing in 1979 to participate in the airport mural project. His *Water Festival, Song of Life* (plates 33, 35, and 36) depicts the annual April festival of China's Dai people, a Thai minority group living in the southwestern part of the country. In addition to dragon boats, tropical plants, flowers, and birds, about a hundred figures in different poses and costumes—including two nude women—appeared in the mural.

The original composition, which has a bold narrative scheme, full of action, was on two walls of one of the airport restaurants. With consummate skill, the artist designed the mural to flow over doorways and around a wall clock.

Water Festival, along with the other airport murals, was proudly featured in many Chinese publications from October, 1979, until 1980, when, suddenly, *Water Festival* was no longer mentioned. The painting of nudes, critics sniped, is not a part of the Chinese tradition, and therefore the mural was unsuitable for the nation's most prestigious reception point for foreigners. Some claimed the subject matter wasn't really Chinese because it depicted a national minority, one that resembles the people of Southeast Asia more than it does the dominant Han

33. Yuan Yunsheng. Detail of *Water Festival, Song of Life.* 1979. Acrylic on canvas in plaster. Beijing International Airport

The Dai people celebrate by splashing water at each other, bathing, and dancing. The festival commemorates the death of a legendary tyrant and the cleansing and purification of the Dai people after his destruction. The story was an appropriate political metaphor at that period, when the party line was denouncing the oppression and excesses of the Cultural Revolution. The artist has absorbed aspects of the Mexican muralists' Socialist Realist style, such as Diego Rivera's noble and expressive peasants. The work also shows the influence of the ancient Dunhuang artists, who gracefully elongated the Apsarases and created compositions of simultaneous narration. However, the overwhelming brilliance of the compositional scheme—building action along a diagonal axis that crests over the doorway and is repeated in a large arc that unifies the dancers on the right—demonstrates Yuan's genius in integrating action and narration on a monumental scale.

34. *Three artists who worked on the airport murals: from the left, Xiao Huixiang and the brothers Yuan Yunfu and Yuan Yunsheng. They pose with art historian Lawrence Wu (right) in front of Yuan Yunsheng's* Water Festival, Song of Life. *1979.*

Chinese. But, of course, it had long been a party policy to feature national minorities in the arts. Some critics, ignorant of their Chinese heritage, carped that wall painting isn't a Chinese medium. *Water Festival* was also condemned as "ideologically impure" because of the elongation of its human figures, which was called "distortion." That many great painters, such as Botticelli and El Greco, enhanced the beauty of their figures through elongation didn't impress the orthodox party-liners. Nor did the fact that Socialist Realism also "distorts" figures have any effect.

At first, China's highest leaders seemed ready to tolerate *Water Festival*, but later, even they became embroiled in the controversy. According to a newspaper account, when Deng Xiaoping and Li Xiannian, who was then also a vice-premier, saw the nudes, Deng remarked, "Is that what they [the critics] are afraid others will see?" After a group of party policymakers had intensified the attack, the then Party Chairman and Premier, Hua Guofeng himself, was asked to pass judgment on the suitability of the painting. His response was that "the Dai people themselves must decide."

In December, 1979, a delegation of Dai people living in Beijing was summoned to view the painting. They confirmed that they did indeed bathe nude. Reportedly, most thought the painting was good and considered it an honor for the Dai to be the subject of an airport painting. Only minor objections were raised, and they concerned errors in costume details. They pointed out, for example, that men wore their best clothes, not shorts, to the festival.

By March, 1980, the situation had changed. Reports claimed that officials from Yunnan Province, the home of the Dai, had written to the central authorities and complained that the honor of the Dai people had been besmirched by *Water Festival*. The long-necked beauties were said to be ugly as well as distorted. Further, the officials were reported to have said, they had been embarrassed not only by the nudes but also by a scene in which two boys are chasing a girl. They asked: "Why shouldn't Han Chinese be shown doing that?" In April, 1980, in consideration of these protests, the central authorities had curtains hung over the section depicting the nudes. But depending on the political tides, the curtains were alternately opened and closed for the next eleven months. During that period, crowds of Chinese and foreigners enthusiastically viewed the notorious painting by simply parting the veil, if necessary. However, in March, 1981, as part of the Socialist Morality campaign, the offending section of the painting was walled over. The official party line claimed that the nudes were covered up in response to the objections of the Dai people.

Yuan Yunsheng, the creator of *Water Festival, Song of Life*, had been called a rightist in 1957. In 1960 he was sent to a labor camp for two years to reform his "counterrevolutionary ideas." Although the rightist label was removed in 1961, and he was allowed to finish art school in Beijing, after his graduation in 1963, instead of getting a good job at an art school, an art association, or a government ministry, he was sent to Changchun, Jilin Province (formerly Manchuria), in the

35. Yuan Yunsheng. Detail of *Water Festival, Song of Life* (right section, now walled over). 1979. Acrylic on canvas in plaster. Beijing International Airport

Within the vast narrative mural, many figures are bathing and throwing water—the ritual activity. Two nudes are part of a group of four bathers, and they are shown rinsing off, as they do in real life. The bathers are composed in a rectangular group with an ovoid center, which fits into the overall compositional arcs that advance and unify the richly inhabited creation.

36. Yuan Yunsheng. Detail of *Water Festival, Song of Life*. 1979. Acrylic on canvas in plaster. Beijing International Airport

The section of the mural with the nudes was walled over in March, 1981, as shown here.

Northeast to "correct" paintings in a workers' cultural palace—a blue-collar social club. This turned out to be a sixteen-year artistic exile in a place referred to by urbane Chinese as a "city of silent culture." Labor camp and artistic exile were only two of the many hardships Yuan Yunsheng endured. Intolerably long family separations, overcrowded living conditions when the family was finally reunited, and not enough money to live decently were also his lot. Only in 1980 was he able to take a teaching job at the Central Academy of Fine Arts.

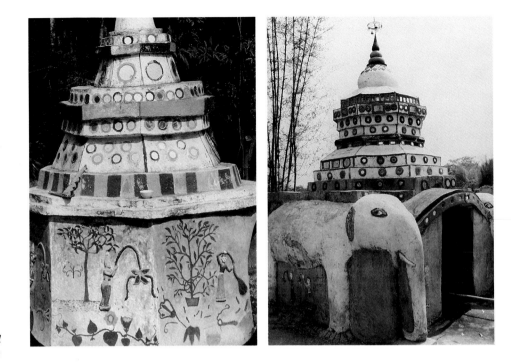

RIGHT:

37. Detail of male and female reliefs. Geometric, floral, and mirror designs on a pagoda set over a well. 1981. Mirrors and color on concrete and plaster. Xishuangbanna, Yunnan Province

The Dai people of China have retained their customs and religion. A Buddhist pagoda enshrines a well, signaling its sacred nature. The naive painting on the pagoda is the sort that contemporary artists seek out as a fresh resource for a new Chinese art. The male figure standing near a tree and holding a trident with a flower-wand suggests fertility, but he is also like a godling who floats about in a Buddhist heaven. The female figure is Mother Earth and is shown slightly elongated, wearing a tight shirt and sarong, conforming to local custom. Fulfilling her role as the source, she wrings water out of her hair. She looks much like the bathers in Water Festival.

FAR RIGHT:

38. Elephant and polygonal and rounded designs on a pagoda set over a well. 1981. Mirrors and color on concrete and plaster. Xishuangbanna, Yunnan Province

This is one of a number of fanciful pagodas, all having individual forms, that serve as sacred enclosures for water. The inlaid mirrors are highly decorative, shining like jewels, especially when they reflect the sun. Moreover, they are thought to frighten evil spirits.

Born in 1937 in Nantong, a small city near Suzhou on the Yangzi River in Jiangsu Province, Yuan Yunsheng left home in 1955 to study at Beijing's highly regarded Central Academy of Fine Arts. Although his father had not encouraged his sixth child to be an artist, Yunsheng insisted on following the same path as his older brother, Yuan Yunfu. By the second year, however, he had become disenchanted with the restrictions of academic painting and Socialist Realism. He wanted to explore forbidden Post-Impressionist styles, especially that of Van Gógh. He also rebelled against being taught only one system of drawing at the Central Academy. Volumes and planes created with chiaroscuro were emphasized, so the Soviet teacher did not approve of Yuan's consuming interest in line. Individualism was not encouraged; the students were all expected to paint in the same style.

During the 1956–57 Hundred Flowers movement, when people were encouraged to speak out and criticize the establishment, Yuan was known to have criticized Stalin and the oppressive aspects of Soviet art in informal conversations with fellow students. In June, 1957, when the antirightist campaign was launched and all criticism was cut off, many of those who had spoken out—even if only among "friends"—were attacked. Yuan was "capped" as a rightist because he didn't listen to the criticism, confess his errors, or stop "distorting" (elongating) figures. Fortunately, the labor camp to which he was sent for two years, along with other "rightists" from the Central Academy of Fine Arts, was outside Beijing. A few less fortunate colleagues were sent to prisons in the Northeast, near the Siberian border, or to the deserts of the Northwest, for more than six years.

After his release from labor camp in 1962, Yuan was able to return to school,

and there he painted a huge graduation picture of peasants celebrating the New Year. He meant it to be a "beacon of hope" in those very bleak years. However, the painting was attacked as reactionary because the figures were elongated, and since that violated the canons of Socialist Realism, some said Yuan should not be graduated. His critics called Yuan's peasants ugly because they were "distorted" (the same criticism that was to be leveled against *Water Festival* sixteen years later). Thus, he was sent into his long artistic exile in the Northeast, from 1963 until 1979.

When the officially disapproved graduation painting was subsequently used as a table-tennis backstop, an outraged friend removed it from the academy for safekeeping. However, there was an uproar about the theft, and the friend's mother discovered that her son had stolen the painting for Yuan. She urged her son to confess. Because he did so, the friend was not punished. Today, he wryly comments that his confession was called "a victory for the thought of Mao Zedong." This occurred on the eve of the Cultural Revolution, when so many objects of culture were confiscated and destroyed, as was Yuan's painting.

Yuan recognizes that the new direction of art in this century is toward the expression of individual feelings. In an interview in 1980 he said, "Each artist wants to use his own language to express his own feelings. The true people's art is to be able to express what is in your heart." He sees that traditionalism can be a trap, and he admonishes: "Do not rely on traditionalism or let it confine you. Turn to tradition if you need it, as a natural source, but use it to express individualism."

Yuan, like so many Chinese artists, has been inspired by Chinese Buddhist wall painting, especially the narrative painting style of Dunhuang. To him it has none of the illusionistic limitations of academic Western painting. He especially admires the graceful elongation and linear flow of the figures of the Northern Wei period (386–534). Line is Yuan's principal vehicle, and he uses a variety of brush styles, from one that is precisely linear to an expressionistic, broadly stroked and splashed one. According to his mood, he uses his brush brilliantly and powerfully—or with tenderness. Between 1977 and 1982, Yuan used these two rather distinct styles, the linear and the expressionistic, simultaneously. His styles began to fuse after his 1982 visit to the United States, where he viewed original Western art for the first time and received encouragement from Abstract Expressionist Willem de Kooning and other leading artists. Although Yuan retains some figuration in his work, he shows a strong affinity for Abstract Expressionism. His stay in America proved to be enormously productive, and it allowed him to break through to a deeper level of artistic maturity.

Yuan Yunsheng's elongated women are particularly alluring. Always in action, they are amply built, expressing the essence of femaleness with full breasts, small waists, and broad hips. Sometimes he paints them within a romantic idyll, but they also appear in bleak scenes of torture and death. His men, horses, and bulls are often shown in combat or struggling and in anguish. These representations strongly suggest the allegory of man's quest to free his spirit.

OPPOSITE, BELOW:
39. Interior of elephant pagoda. 1981. Mirrors and color on concrete and plaster. Xishuangbanna, Yunnan Province

The chamber over the well contains a bamboo-handled dipper and a large mirror. Villagers use the mirror as a communal convenience as well as a talisman to scare off evil spirits. When they see their own reflection, they retreat. Below the mirror is a double image of Mother Earth wringing out her hair, the sacred source of water. The inscription beside the mirror is written in a northern Tham Sip Song Pan Na variant of Thai script and says that the pagoda was built in 1981. The well itself is old.

40. Yuan Yunsheng. *Self-Portrait*. 1980. Oil on board. Exhibited in *Painting the Chinese Dream*, Smith College Museum of Art, Boston City Hall Gallery, The Brooklyn Museum, 1982–83

In this tense, Expressionistic composition, Yuan crowds the edges with his abruptly foreshortened body. The face is a good likeness of the artist, yet his brown-toned skin evokes the coloring of Gauguin. His Post-Impressionist palette and technique create a singular psychological statement about how enclosed he feels.

41. Yuan Yunsheng. *Black Figure*. 1981. Ink on paper.
Exhibited in *Painting the Chinese Dream*, Smith College
Museum of Art, Boston City Hall Gallery, The Brooklyn
Museum, 1982–83

*This kneeling, chained figure is both symbolic and literal, showing
the humiliation that Chinese artists, intellectuals, and officials have
suffered, especially during the Cultural Revolution. Being forced
to assume such a position for hours on end, in front of hostile
crowds struggling against them, was a devastating experience for
China's elite. In a black-ink composition, the artist powerfully
expresses the bitterness of enslavement.*

42. Yuan Yunsheng. *Bull*. 1981. Ink on paper

*Yuan frequently uses bulls as a subject. He explains that he grew up
with water buffalo and always liked them. Moreover, according to
the Chinese zodiac, he was born in the year of the cow. His bulls
remind us of Picasso's, but they also recall Northern Wei flying
demons.*

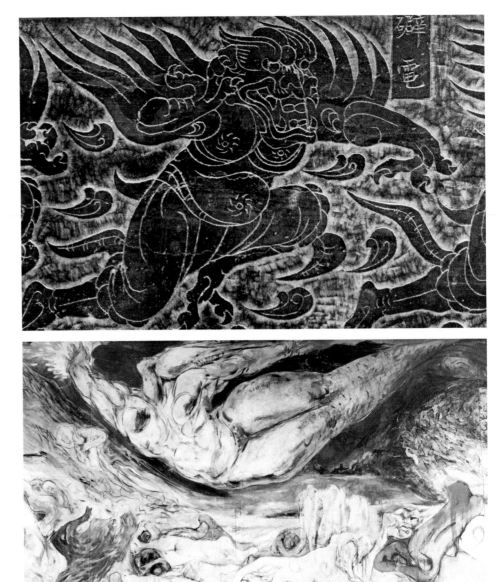

Although Yuan Yunsheng competed for several mural commissions after the
airport controversy, he received only one, for a new hotel. However, when the
commissioning authorities saw the subject matter of *Spring Festival along the
Suzhou Canals*, which was already painted on a vast canvas, they did not approve
it, and the commission was canceled.

Since 1979 Yuan has exhibited his work in China a number of times. He has
been artist-in-residence at the University of Northern Iowa, Tufts University,
Smith College, the Five Colleges in the Connecticut Valley, Harvard University,
and Radcliffe College. In 1983 he created for the Tufts University Library a
huge mural based on the Chinese flood and creation stories, *Two Ancient Tales:
Red + Blue + Yellow = White?* (plate 44). In 1984 Yuan began work on a mural
for Currier House, Radcliffe College.

LIU BINGJIANG *(b. 1937, Beijing)* ZHOU LIN *(b. 1941, Tianjin)*

In 1980 a husband-and-wife artist team, Liu Bingjiang and Zhou Lin, was selected by the Chinese National Artists Association to do a vast mural (five meters by seventeen meters) for the east-wing restaurant of the Beijing Hotel. Both artists had spent long periods living in remote parts of China among the various national minorities, whom they depicted in a mural called *Creativity Reaping Happiness* (plates 49 and 50). It is the apotheosis of representative ethnic groups from all over China, joining together to celebrate the human and agricultural cycle.

Liu Bingjiang studied oil painting from 1957 until 1961 with the distinguished teacher Dong Xiwen at the Central Academy of Fine Arts. Liu was there during the antirightist campaign of 1957, when any oil painter with an interest in Western painting styles—other than party-approved Socialist Realism—had political problems.

In 1964, in anticipation of the impending Cultural Revolution, Liu Bingjiang, along with his students from the Central Institute of Nationalities, was sent to Sichuan Province to do propaganda work and teach the peasants how to criticize officials and conduct struggle sessions. But he fell in love with the painter Zhou Lin, one of his students, and married her. This violated the academic behavior code, which forbade teachers to have romantic relationships with students. They were disciplined. Zhou Lin was sent to a town in Yunnan Province, near the Burmese border, for a term of eight years, and their child was sent to Beijing to be cared for by Liu's mother. Zhou Lin had no one else to turn to.

It was during these difficult years that both artists saw the varied landscapes and peoples of China. In 1973 Liu Bingjiang was allowed to return to Beijing to care for his aged parents. He was able to see Huang Yongyu during that artist's darkest hours, when most of his friends had forsaken him. Now, both Zhou Lin and Liu Bingjiang still look to Huang Yongyu for inspiration.

Liu Bingjiang was a founding member of an important private group, the Oil Painting Research Association (discussed in "Groups," pp. 53–59), and he

OPPOSITE, ABOVE RIGHT:
43. Lightning demon. Detail from epitaph tablet of Lady Yuan. Northern Wei dynasty. Carved limestone. Museum of Fine Arts, Boston

The tablet is inscribed: "To avoid lightning." Yuan Yunsheng has studied sculpture from this period intensely and he admires it enormously, especially the linear freedom and rhythm of the relief carving. His bulls gain energy from the inspiration of the demon.

OPPOSITE, BELOW RIGHT:
44. Yuan Yunsheng. Detail of *Two Ancient Chinese Tales: Red + Blue + Yellow = White?* 1983. Acrylic on canvas. Wessell Library, Tufts University, Medford, Massachusetts

In the central section of this vast mural, Nu Wa, the only female among the immortals, repairs the hole in the sky with her right hand. The disaster that brought on the great flood was caused by the demon Gong Gong, who had smashed the mountain that holds up the sky. Nu Wa's fish-tailed, buoyant form has the power of Michelangelo's Adam and the large hips of a Lachaise nude, symbolizing the fecund role she plays as creator. Below, a demon-like figure approaches the field of corpses—flood victims waiting for Nu Wa to renew life. On the right, not shown here, is a renaissance of humanity and a utopia where man and beast are truly civilized, living in joyous harmony.

FAR LEFT:
45. Liu Bingjiang. *Uighur Lady.* 1981. Felt pen on ceramic plate

Liu Bingjiang paints in several styles simultaneously, as demonstrated by the stiff official style used in the mural (plates 47, 49, and 50) and the intense Expressionistic style used here. He employs both color and form to make a touching and brilliant statement. Playfully analyzing the Uighur lady's face in a Cubist manner, he is quite at home in Modernist vocabulary.

LEFT:
46. *Hani (Aini) woman wearing tribal headdress. Xishuangbanna, Yunnan Province.* Mural artists Liu Bingjiang and Zhou Lin, like many Chinese artists, have journeyed to China's most remote regions to paint the minority people and their costumes. No tribal headdress could be richer than the one in this photograph. It is covered with colored yarns, beads, silver buttons, and coins (including two minted for French Indochina in 1909 and 1911). 1983.

45

47. Liu Bingjiang and Zhou Lin. Detail of *Creativity Reaping Happiness*. 1980–82. Acrylic on canvas in plaster. Beijing Hotel

For two years, both artists devoted themselves to the planning and painting of this mural. One year was spent at the drawing board and one to sketch on the design and paint it. This is the final stage, with Liu painting from a scaffold and Zhou from the floor.

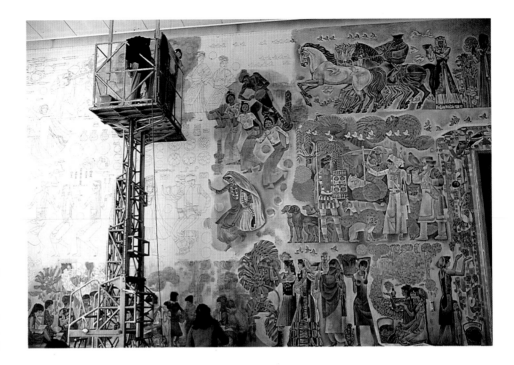

48. Liu Bingjiang. *Nude*. 1979. Oil on canvas. Shown in the Oil Painting Research Association Exhibition, Beihai Park, Beijing, 1979

Liu painted an exotically voluptuous bronze beauty whose jeweled neck, ears, and wrists glow against a patterned screen. These features and her kneeling position, which is not within the academic painting repertoire, suggest that the artist was probably inspired by a calendar from South Asia. The fact that this painting, so reminiscent of a calendar pinup, was exhibited without criticism during October, 1979—when the initial volleys were being fired at Yuan Yunsheng's nudes—proves the complexity of art and politics. It suggests that criticism of nudes may not have been the issue, but rather a personal or factional attack involving power politics.

exhibited in all three of its exhibitions. In the second exhibition, held in Beihai Park in October, 1979, Liu and some of his colleagues showed paintings of nudes (plate 48) for the first time since the founding of the People's Republic. At the same time, the nudes of the airport murals were also unveiled.

Liu Bingjiang and Zhou Lin worked on the Beijing Hotel mural for two years, from 1980 until 1982. The colors used in the mural harmonize with the architectural details of the restaurant. One major compositional area is filled with national minority figures dancing; and in another area, there is a grand arbor, heavy with grapes and filled with songbirds. Despite its lack of an integrating compositional force, the work succeeds as wall decoration.

The original sketches for the mural included a nude figure, but as the mural progressed, officials persuaded the artists to exclude it. The elongated figures are similar to those in Yuan Yunsheng's *Water Festival*, but Liu and Zhou were not criticized on that point. Perhaps elongation was more acceptable in 1982 than it was in 1979—or perhaps Yuan was a more controversial political target than the husband-and-wife team.

Zhou Lin, who is also an art teacher at the Central Institute of Nationalities, has recently turned to oils after many years of working in Chinese colors and ink. Both her works and those of her husband have been frequently exhibited and published in China. In 1986 Liu went to Paris to study.

LOU JIABEN *(b. 1941, Shanghai)*
Lou Jiaben attended the high school affiliated with the Central Academy of Fine Arts and then the Central Academy itself. He graduated in 1965. Twelve years later he returned as a graduate student after taking the first competitive

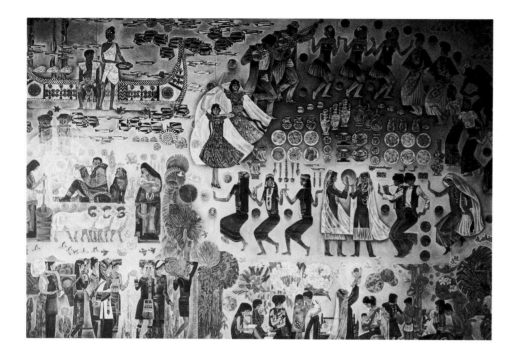

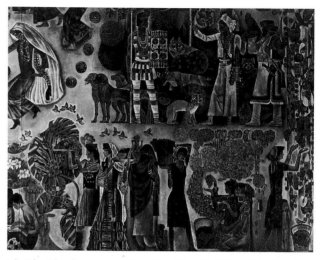

49. Liu Bingjiang and Zhou Lin. Detail of *Creativity Reaping Happiness*. 1980–82. Acrylic on canvas in plaster. Beijing Hotel

The principal focus of this vast mural is a great circular dance performed by various Chinese ethnic groups, which symbolizes their fruitful harvest and national harmony. Around the circle people hunt, gather, plant, harvest, herd, fish, and admire babies.

50. Liu Bingjiang and Zhou Lin. Detail of *Creativity Reaping Happiness*. 1980–82. Acrylic on canvas in plaster. Beijing Hotel

The artists created a handsome convocation of colorfully costumed minority people painted in encyclopedic detail. They depicted appropriate flora, fauna, and clothing for all the groups. The figures themselves are somewhat stiffly elongated, and their faces are idealized into youthful masks.

51. *Zhou Lin works on a small-scale sketch of* Creativity Reaping Happiness, *the mural she and her husband, Liu Bingjiang, created for the Beijing Hotel. In the early planning stage, they made paper cutouts of the figures.*

entrance examinations to be given after the Cultural Revolution. After completing his studies in 1980, Lou was asked to stay on as a teacher in the wall-painting department.

Source of Chinese Spirit (plate 52) is a large five-panel piece that presents the story of the creation of the world in a series of dramatic scenes. Not illustrated is the right-hand panel, in which the hoary, bearded Kuafu drinks up the river, trying to slake his unquenchable thirst—an allegory of man's quest for enlightenment.

Lou Jiaben's large-scale composition is a dynamic narrative, rich in colors and gold. The figures and the setting are closely interrelated, and the action within the composition flows with ease from one epic event to another. Lou has studied the cave paintings at Dunhuang, and he has drawn some imagery and inspiration from them. He also draws on the heroic figures of Michelangelo and the Romantic, poetic ones of William Blake. Pre-Raphaelite painting was absorbed into the Soviet academic style, and it has been an important source for many Chinese artists. Lou has been inspired by its warm coloring as well as by its sweet atmosphere of noble optimism; his work also has the kind of pictorial authenticity that is associated with fairy-tale illustration.

KONG BOJI *(b. 1932, Shanghai)*

Kong Boji is a well-known artist in Shanghai. Intense in his search for a new synthesis, he says that he seeks "to combine ancient tradition with contemporary feeling." Kong values honesty and expression of feeling in creation, and he has been open-minded and experimental in his work.

In 1979 and again in 1983 Kong went to Northwest China to see the Buddhist

52. Lou Jiaben. Detail of *Source of Chinese Spirit*. 1980. Ink and color on paper. Shown in the Graduation Exhibition, Central Academy of Fine Arts Gallery, Beijing, 1980

From the left, Lou Jiaben shows the first Chinese ancestor, Pan Gu, a muscular, Atlas-like giant who shaped the earth. His hair is the stars; his muscles become mountains; his blood, the rivers; one eye the sun, the other the moon. In the middle panel, mythical hero Yi shoots nine out of ten suns from the sky with his bow and arrows. In the third panel, Nu Wa, the beauteous immortal, is flying in the heavens, mending the sky.

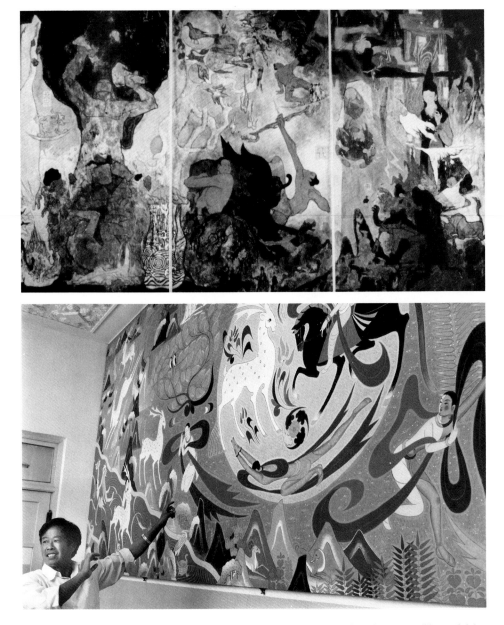

53. Li Zhenpu. *Jataka of the Nine Colored Deer*. 1982. Acrylic on canvas. Bank of China, Dunhuang, Gansu Province

The Dunhuang artist Li Zhenpu (b. 1940, Guoyang, Anhui Province) explains the Jataka tale about the former life of the Buddha, and his painting follows, somewhat literally, the idea and form of the Northern Wei mural in Cave No. 257 at Dunhuang. After graduation from the mural department at Beijing's Central Academy of Arts and Crafts, Li was assigned to work at Dunhuang as a resident artist to study and copy the Buddhist cave paintings. In 1984 he completed a group of murals for a new Dunhuang hotel, in which he adapted the ancient forms more freely.

54. *Kong Boji with his wife and daughters in their apartment in Shanghai. 1981.*

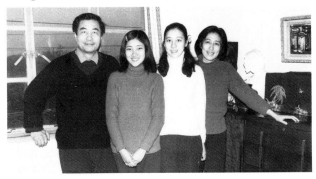

cave paintings at Dunhuang and at the Yongle Palace. What he saw affected his work profoundly. He copied the paintings, then later, he remembered the Buddhas (plates 55 and 57), Bodhisattvas (plate 56), beauties, and demons, and they were an inspiration to him. Using oil stick and ink on paper, Kong paints large heads in a personally expressive style that borrows from Chinese sources and also from Post-Impressionism. His work has a numinous, dreamlike quality as well as an authentic emotional tone.

The only formal art training Kong has ever received came from a high-school commercial-art course. In 1960, after doing product-design work in a factory, he had an opportunity to join the art faculty of the Shanghai Drama Academy, where he concentrated on drawing and painting. Charcoal was his favored

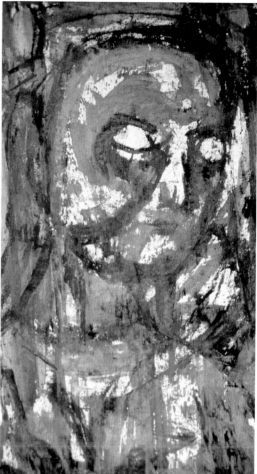

medium in the 1960s, but eventually he felt it was too limited; he needed color to depict the whole world. In 1969 he turned to oil stick as a medium.

During the violent phase of the Cultural Revolution (1966–69) Kong, criticized and humiliated along with the other leaders of the Drama Academy, was sent to the countryside for a year of reeducation and physical labor. He recently said, "I never gave up painting under any condition, even during the most difficult periods. I would hide in a mosquito net so that I could continue painting in the countryside. I felt the urgency of time and have had no vacation for eleven years, working in the hottest and coldest days." In 1982 Kong became art editor in the research department of the Drama Academy, where he had been an admired and revered teacher of painting. His encouragement of young artists extends far beyond the Drama Academy. Because the Shanghai Art College was moved away in 1965, for the next eighteen years the only college-level art instruction available was given at the Drama Academy and the Teachers College. Many young artists in Shanghai have come to Kong for individual guidance.

Although he is a member of the conservative Shanghai Artists Association, Kong Boji is different from other artists in that elite circle. The official party line says that artists are encouraged to seek new styles, but in fact, tradition is cherished more than innovation. Thus, Kong's conservative critics attempt to denigrate him by calling his work "not real painting." Kong had exhibitions in Fujian Province and Wuhan in 1980 and in Shanghai in 1981. In 1982 and 1983 his work was shown in many major cities of Japan, including Tokyo, Osaka, Fukuoka, and Nagoya, where it is particularly admired for its Buddhist content. However, in China, in the early 1980s, Kong was controversial—too foreign-influenced, too different. Some teachers at the Wuhan Art College forbade their students to visit his officially sponsored show.

Kong Boji advises his children: "Paint with your life, don't just paint with your brush."

55–57. Kong Boji. *Buddhas*, 1979 and 1980, ABOVE AND FAR LEFT, and *Two Bodhisattvas*, ABOVE CENTER, 1981. Ink and oil stick on paper.

The Buddhas in the Dunhuang caves provided Kong with the imagery for a series of paintings. In plate 55, painted in 1979, a Buddha's face emerges through an ink-streaked veil. Perhaps the image suggests the sands that have been advancing over the caves, or is it the expression of man's suffering, exemplified in Western art by the crucified Christ? Some colors in the Dunhuang murals have disappeared, revealing the original underpainting (see plate 6). Kong's Buddha of 1980 has an emotional, Expressionistic look, with symbolic colors and heavy black outlines. He frequently uses bits of transparent ink and color as a partial veil through which his subject is seen. The shadowy figures seem to emerge as in a dream. The compassionate Bodhisattvas who aid all beings to attain enlightenment have extraordinary beauty and repose in this spiritual composition.

GROUPS

The emergence of private artistic groups has been one of the most important occurrences of the post-Mao era. In the late 1970s all over China, artists spontaneously organized themselves according to their own, rather than the party's, artistic principles; they shared the desire to exhibit, to exchange ideas, and to offer mutual support.

Almost all the artistic groups included here held at least one exhibition during the year 1979–80. Undoubtedly there were other groups and exhibitions that were unknown to the artists who were interviewed because of narrowly regional perspectives and the lack of communication and mobility in China. By 1981 new rules made it much more difficult, and in some cases, impossible, for privately formed groups to exhibit as a unit.

The formation of private groups is significant because artists, for the first time since 1949, were able to organize outside of the government-controlled art associations and other official art organizations. This was possible in that period because Deng Xiaoping needed the intellectuals' support against both the left and the conservatives in order to secure his own position. Artists began to define aesthetic concerns in their own terms rather than the party's. Conservatives stayed within the party line as they understood it; others pressed the limits well beyond what would later be acceptable. During the 1978–80 Hundred Flowers period, when artists were exhorted to experiment, it was hard to know exactly where the line was. Moreover, private groups were an artistic analogue to the new "economic responsibility system" that encouraged private initiative.

In the autumn of 1979, the leaders of the Chinese Federation of Literary and Art Circles, who set artistic policies, called for liberalized thinking. They noted that China's "objective reality" had been totally limited by Russian and Eastern Bloc socialism. The party line on art, which had been based almost exclusively on Soviet Socialist Realism, French academic painting, and post–Song dynasty brush painting, must be opened to other possibilities. Members of the federation called on the Chinese to free themselves from that model. Capitalist societies had not declined as predicted; indeed, they had prospered, and China had to face this reality. The leaders urged artists to stop their factional infighting—some artists had attacked others over the years, particularly during the Cultural Revolution—and unite on the issue of modernization. Artistic standards must be raised, the leaders said, and officials (politicians) should not interfere. Thus

began a period of high hopes in which artists would experiment and look for fresh inspiration from national and international resources. The private artistic groups were a natural outgrowth of the artists' desire to exhibit and to exchange ideas with congenial spirits in a nonpolitical environment.

April Society

A group of young Beijing photographers was among the first to organize and exhibit. The members were mostly amateurs, some of whom had begun taking pictures at the Tiananmen incident of 1976, on April 5, the day on which the Chinese traditionally memorialize their dead. On that day, crowds came to Tiananmen Square to lay wreaths on the Monument to the Martyrs in honor of Zhou Enlai, who had died in January. The authorities had the wreaths removed, and it was reported that they had done so under pressure from Jiang Qing and the Gang of Four, who were trying to discredit Zhou Enlai. A bloody melee ensued.

The young photographers, who called themselves the April Society after the Tiananmen incident, held three exhibitions in 1979 and 1980. As many as 160 photographers contributed to a single show, and the first exhibition toured to at least five cities.

The April Society photographers work in styles ranging from direct, unvarnished photojournalism to artistic and experimental modes that have special significance in the Chinese context. The most influential and rewarded photographers in the PRC have been those who photographed the leadership. Of course, the leaders want to be shown in the best possible way and have cultivated the photographers to assure such results. In China, photography for exhibition and publication had existed exclusively as a propaganda tool. The ideal photograph, according to Socialist Realist principles, is posed to convey the most romantic and glamorous views of the motherland: social, economic, and political triumphs; the strength, courage, and resourcefulness of the people; and the wisdom of their leaders. Moreover, since film and processing facilities are scarce and expensive, the posed shot makes economic sense. Thus, a setup shot not only allows for heroic postures but also conserves film. In the West, where spontaneity plays a larger role and where time is more expensive than film, there is less tolerance for the posed cliché. Art policymakers, who since 1949 have assigned a propaganda role to photography, have consistently endorsed it as a craft rather than as a form with artistic and experimental potential.

The April Society wanted to—and did—allow as many new photographers as possible to exhibit. Experimentation was encouraged. Consequently, there was unevenness in the work, which ranged from rudimentary to excellent. The strength of the exhibitions was in their freshness and exploratory nature.

WANG ZHIPING *(b. 1944, Lingqing City, Shandong Province)*
Wang Zhiping, who works for the Agricultural Publishing House, is a major

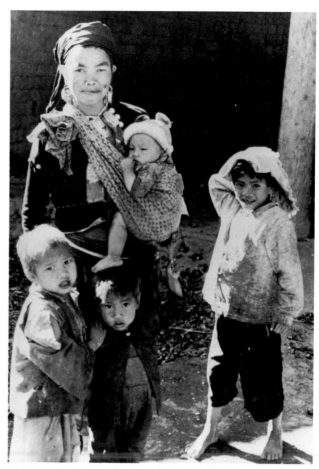

58. Wang Zhiping. *Mountain Tribe Family.* 1981. Black-and-white photograph. Shown in the April Society Exhibition at the National Art Gallery, Beijing, 1981

The minority people of China have become an officially recommended subject for artists and photographers. Yet such a refreshingly frank view of this backwoods family would never be included in a Chinese Photographers Association exhibition because the subjects are not Ivory Snow clean. Indeed, they are poorly clad and unshod. Such frank photojournalistic statements do not represent the propaganda ideal that the party promotes.

59. *Wang Shu and Geng Ying painting at a meeting of the Green Grass Studio in Geng Ying's apartment in Beijing. Both artists create figures, but in different styles. At the left, Wang Shu inscribes a work he has just completed. It is a rapidly brushed ink painting done in the Impressionistic style called* xieyi. *Geng Ying (right) paints in the meticulous style called* gongbi. *Her small, precise strokes are building a composition of many colors—a lengthy process. 1979.*

figure in the April Society and a first-class photojournalist. His job has taken him to remote parts of China, where he has photographed the people and the landscape with sensitivity (plate 58). His commitment to record life-as-it-is may not seem unusual to a Westerner, but his photos of rural families—which show the poverty and squalor of their lives—contrast sharply with China's propaganda photos of smiling, singing, harvesting, dancing peasants. To show life as it is, rather than as the party sees it, is a courageous act.

In the summer of 1981, Wang was invited informally to exhibit his photos at the French Cultural Center. After the exhibition had been open for some days, the Chinese authorities closed it, with the explanation that it had not been organized through proper channels. This was one of many signals that Chinese officials sent in mid-1981 to herald a tougher policy toward foreigners and art, whose fates were often intertwined. Chinese had to break off relationships with foreigners, and unorthodox exhibitions were not allowed.

Green Grass Studio

The Green Grass Studio was a five-person painting club in Beijing and was among the earliest of the post-Mao groups. Organized in the beginning of 1978, it consisted of two female and three male painters, including the eighty-year-old teacher, Wang Zhongnian. Each member specialized in some aspect of traditional Chinese painting. The group assembled on a weekly or biweekly basis and painted together, exchanging views freely. One imagines such gatherings as being something like the old-style meetings of the literati. In a congenial setting, the artists pursued their shared interest in expanding and perfecting techniques.

Bird and flower painter Yan Jiabao was trained at several universities, as well as by her father. She has exhibited for more than thirty years. Guo Zengyu, who works at the Beijing Palace Museum, paints flowers and landscapes. At his job he copies ancient Chinese paintings from the Song and Yuan dynasties for exhibition and sale.

Geng Ying specializes in painting ancient beauties in a dainty style called *gongbi*, which is characterized by precisely outlined images (plate 59). Her heavenly beauties were very successful in a 1981 New York show. Daughter of former Defense Minister Geng Biao, Geng Ying is part of the renewed elite of high cadres and their children—former targets of the Cultural Revolution radicals. The Geng family all suffered greatly. Geng Ying was held prisoner for some months in the countryside, where Red Guards subjected her to their version of Chinese water torture. They kept her immersed in a well for most of every day for some two months, until she was rescued by a rival group. After the Cultural Revolution, she became a doctor of traditional Chinese medicine and was attached to a unit of traditional painters, which gives her time to paint.

Wang Shu specializes in figure painting. He studied with his father, Wang Zhongnian, the studio's teacher. Wang Zhongnian was an established artist when he realized, early in the Cultural Revolution, that he and his family would face

hard times, so they moved back to his native village. The youngest son eked out a living for the family as a construction worker, breaking rock for roads. Wang Shu, who was ill and unable to work during that period, now has a job as the artist for a song-and-dance troupe.

Oil Painting Research Association

In March, 1979, a group of thirty-six important oil painters formed the Oil Painting Research Association (OPRA). Their inspiration was an exhibition called the New Spring Art Exhibit, shown at Zhongshan Park, adjacent to the Beijing Palace Museum. The introduction to the show was written by Jiang Feng, the newly rehabilitated head of the Chinese National Artists Association and president of the Central Academy of Fine Arts. Apparently, twenty years of exile had not quenched his optimism. In his introduction, he enthusiastically encouraged creativity, free choice of subjects, the formation of private groups, and the sale of paintings. Artists whose confidence had been shattered during the Cultural Revolution were encouraged by such a statement of artistic freedom by a high official. OPRA's stated goals were to improve the level of oil painting and provide opportunities to exhibit and exchange ideas. In October, 1979, a second exhibition—the first under the OPRA name—was installed in Beijing's centrally located Beihai Park. The show included work done in diverse painting styles, including Post-Impressionism, and many nudes—apparently the first shown publicly in the People's Republic. The show coincided with the unveiling of Yuan Yunsheng's airport nudes. Both Yuan Yunsheng and his brother Yuan Yunfu are members of OPRA, but they did not participate in the exhibition because of their obligations at the airport. Wu Guanzhong, Quan Zhenghuan, and Li Huaji, who were also involved in the airport project, did participate. The exhibition was the talk of Beijing. When it toured to Guangzhou, Wuhan, Changsha, Hefei, Hangzhou, and Shanghai, it was viewed appreciatively, especially by young people. OPRA members felt greatly encouraged. Some old-guard officials, however, expressed outrage. One even threatened to kill Jiang Feng, who did die—of natural causes—in 1982.

The exhibition stirred heated discussion of the two most sensitive issues: nudes and abstract art. According to Mao Zedong's Yan'an Forum rules, artists must paint for the masses. Exhibiting nudes had always been a problem in China, and in 1979 and 1980, some officials affirmed the traditional attitude: The masses would think "wrong" thoughts about nudes. Moreover, revolutionary as well as traditional values were puritanical. Abstract art, the officials also stated, would never be understood by the masses. Therefore, it could never be a part of Chinese art. However, in this liberal era the official line from Jiang Feng was, "You can paint whatever you like, but that does not mean we will support you." He was emphasizing the right to paint freely in private, but he was also warning artists that the public-exhibition policy would allow only officially approved works to be shown.

60. *Sichuan oil painter Xue Mingde (born c. 1955) shows his Post-Impressionist work to foreigners at the Beijing Hotel in February, 1979. During this period, called Beijing Spring, the masses were permitted to hang wall posters and distribute independent newspapers that expressed their anger over the injustices and excesses that had occurred during the Cultural Revolution. A number of artists came to the capital from remote areas to exhibit their paintings on Democracy Wall. However, Xue Mingde sold paintings to foreigners privately, which was not approved by the government. In 1981 he was arrested on undisclosed charges.*

61. Zhao Yixiong. *Awakening of Tarim.* 1979. Oil on canvas

This painting was rejected for the Oil Painting Research Association exhibition of 1979, and it was not exhibited in a one-man show in Beijing in 1984. Tarim symbolizes the beginnings of modernization on the edges of the great Takla Makan, China's most terrible desert. She awakens on a vibrant patchwork of Silk Road images: camels, mosques, oil derricks, Buddhist deities, oases, grapes, gourds, and pomegranates.

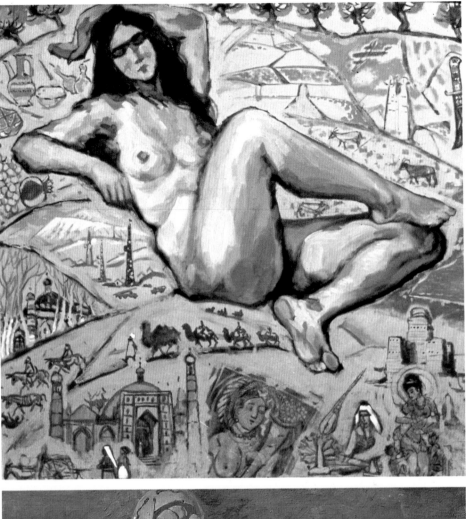

62. Zhao Yu. *Nude.* Oil on canvas. 1979. Shown in the Oil Painting Research Association Exhibition, Beihai Park, Beijing, 1979

This skillfully painted academic nude is a fine example of the artist's easy mastery of chiaroscuro figure painting in oil. It also shows his facility in handling the textures of skin, fabric, and ceramics.

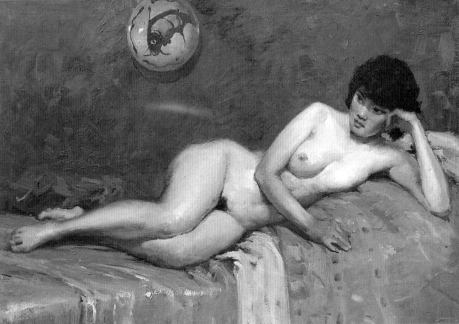

54

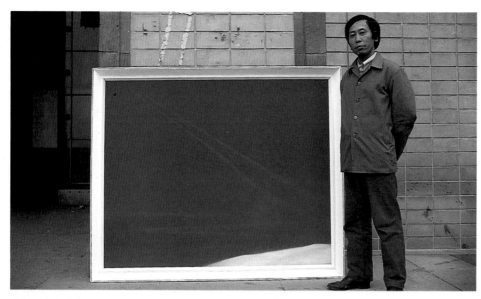

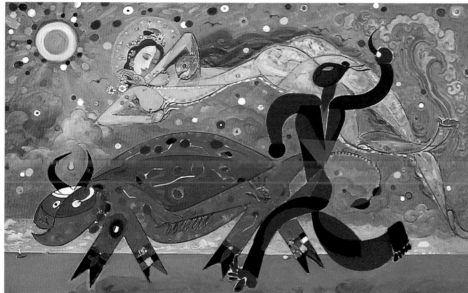

63. Zhao Yixiong. *Jeep in the Desert.* 1981. Oil on canvas

The theme of "Developing China," illustrated by this desert survey team, continues to be a stock subject in the post-Mao era, but the heroes of progress have been scaled down to lifesize. A realism based on observation is characteristic of the new generation of artists. Zhao shows old and new China—desert camels near today's Jeeps.

ABOVE LEFT:
64. Wang Leifu. *Sky Traces.* 1980. Oil on canvas. Shown in the Oil Painting Research Association Exhibition, National Art Gallery, Beijing, 1980

The artist (b. 1941) made a fine blue sky with jet-stream traces and a suggestion of the frozen northland—or is it the ocean? He has gone beyond the conventional panorama of stage-set views into a realm that reflects international trends in the West.

LEFT:
65. Ji Cheng. *Herd Boy and Weaving Maiden.* 1980. Oil on canvas. Shown in the Oil Painting Research Association Exhibition, National Art Gallery, Beijing, 1980

Ji Cheng (b. 1943) showed a fanciful version of an ancient Chinese legend. The primordial Chinese couple, the herd boy and the weaving maiden, meet once a year while crossing the bridge created by the Milky Way. The whimsical lovers, inspired by Miró and Picasso, were called derivative, despite their authentically joyous Chinese roles.

OPRA includes China's leading oil painters, mostly in their forties or fifties, many of whom attended the Central Academy of Fine Arts. OPRA's senior painter, Wu Guanzhong, and Yang Yanping are discussed in "Chinese Ink Painting" (pp. 122–23 and 128–30); the Yuan brothers and Liu Bingjiang, in "New Waves: The Post-Mao Period," (pp. 34–36 and 39–46); Zhang Hongnian, in "Chinese Art: Realism and Beyond," (p. 101). The youngest OPRA members are Feng Guodong and Zhong Ming, two of the three amateurs in the group. Both experiment in Expressionism and other international styles. They have never had formal art training because the Cultural Revolution began just as they finished high school.

The painting styles of the group members range from conservative-academic to Post-Impressionist, Expressionist, and Abstract Expressionist. That such

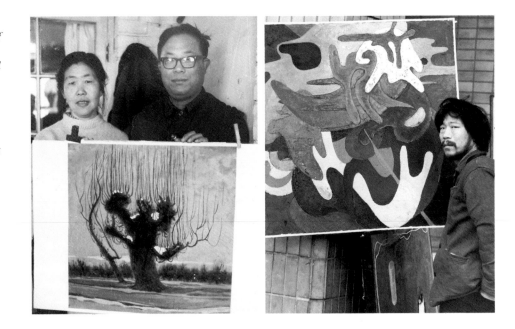

66. Zhao Yixiong and his artist wife, Geng Yukun, both members of the Beijing Painting Academy, pose by his painting Red Willow, *which portrays a desert bush in oil on paper. The bulbous form and profuse new growth make a striking image. 1981.*

FAR RIGHT:

67. Feng Guodong looks away uncertainly from his abstract composition Floating Circles, *shown in the 1980 OPRA exhibition. Because he used the vocabulary of the Surrealists, critics called his work "slavishly Western."*

previously taboo styles were allowed to be shown did not mean that officials had suddenly stopped distinguishing between "correct" and "incorrect" art. An interesting point can be made by comparing two of the nudes submitted to the second exhibition—one that was accepted and another that was rejected.

ZHAO YU (1926–1981)

The accepted nude was by Zhao Yu, the vice-president of the oil-painting department of the Central Academy of Fine Arts. He and other painters of his generation were much influenced by Xu Beihong and the French academic tradition. By influencing teachers in China, Zhao Yu carried on the academic principles of chiaroscuro modeling and handling paint with skill. His nude (plate 62) was a handsome, academic one, but the only clue to the artist's nationality is that the model looks Chinese. She is a curvaceous, but slightly uncomfortable-looking, beauty, posing on a bed against a wall hung with a Chinese fish plate of a traditional blue-and-white design.

ZHAO YIXIONG (b. 1934, Beijing)

The rejected nude was by Zhao Yixiong, who paints a Post-Impressionist world. In his *Awakening of Tarim* (plate 61), the dreamily Expressionist nude seems more in tune with Matisse than with David. As a painter for the Museum of Chinese History and the Revolution, Zhao Yixiong has spent much time in the western desert area of Xinjiang, sketching from life to produce authentic material.

Why was Zhao Yixiong's painting rejected when other nudes were shown? The OPRA group excluded it because of the green streak on the woman's buttocks—an Expressionist gesture that was apparently thought to be offensive.

Zhao Yixiong, however, did show a painting that depicted the Turkic minority people who have lived in Turkestan, near the Takla Makan, for two thousand

68. Feng Guodong. *Self-Portrait.* 1979. Oil on canvas. Shown in the Oil Painting Research Association Exhibition, Beihai Park, Beijing, 1979

This haunting self-portrait expresses the inner feelings and the surreal world of the artist. Such imagery was daring in China, where Freud and the concept of the unconscious are dismissed as bourgeois phenomena. Moreover, to express frankly such tortured feelings about one's job was yet another blow to officialdom.

69. Feng Guodong. *People at Ease.* 1980. Oil on canvas. Shown in the Oil Painting Research Association Exhibition, National Art Gallery, Beijing, 1980

That the artist, so committed to expressing a surreal world, should use the vision and vocabulary of Dali and other Surrealists offended the Chinese art community. The work was called imitative, yet Feng had never seen an original Surrealist painting—only reproductions.

years. Currently, that area of Turkestan includes both Chinese and Soviet territory. In a Chagall-like scene, the artist used authentic colors, costumes, and characters of the region. Zhao Yixiong's vision spans many aspects of realism.

70. Zhong Ming. *Jean-Paul Sartre.* 1980. Oil on canvas. Shown in the Oil Painting Research Association Exhibition, National Art Gallery, Beijing, 1980

In this brilliant exposition of Sartre's image and ideas, Zhong Ming shows the philosopher and his half-full glass (or is it half-empty?) within two intertwined, stringlike white lines that hover near the borders. The painting represents the personal isolation that exists in modern city life.

57

71. *Zhong Ming, an active member of OPRA and one of its several amateurs, poses emphatically next to one of his 1980 exhibition pieces. His stance suggests his combative attitude toward life and the system. He, like the actor pictured in* National Opera, *cuts through ignorance and bureaucracy to reveal the truth.*

72. Li Shuang. *Bicycle.* 1981. Fabric collage

The rider bounds over bumps on an undulating roadway made from blanket stripes.

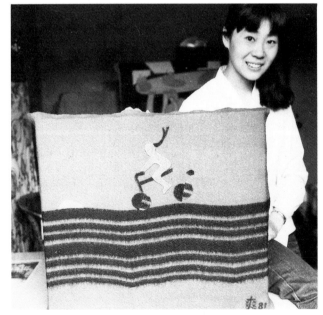

His joyous relationship to the landscape and to humanity is emotionally reflected in Expressionistic color reminiscent of the Fauves, who expressed their feelings by using brilliant colors that were unrelated to observed reality.

After graduation from the Central Academy of Fine Arts in 1964, Zhao did propaganda work with the peasants of the parched, desert-like rural districts outside Beijing. He has described this experience just as he paints—with the forthrightness of a realist. He remembers that he received only two cans of water a month to satisfy his liquid-intake needs.

FENG GUODONG *(b. 1948, Pan Ya County, Guangdong Province)*
Feng Guodong's Surrealistic *Self-Portrait* (plate 68) was the most adventurous work in the October, 1979, OPRA show. He painted a tortured, redheaded man—the traditional Asian image of a demon—among flying brooms. The artist's life story explains the symbolism. After high school, Feng was sent to work as a cleaner in a canvas factory. As of 1980, he had worked there for sixteen years. With this job, he had no time to paint; he wanted to transfer but was not permitted to do so, because in China, jobs are generally lifetime assignments. Unless one has good political connections, artfully used, it is almost impossible to change jobs.

The second OPRA exhibition was subdued compared with the third one, in November, 1980, where Feng Guodong's two pieces—especially *People at Ease* (plate 69), composed of a Surrealistic group of abstract figures—drew hostile reactions and were attacked as "derivative." The exhibit coincided with another attack against "bourgeois democratism" and other corrupting foreign influences. After two years of relaxation, the controls were tightened again. As a result, official art policies were changed, and by 1981 it became almost impossible for private groups to get exhibition space. Moreover, works had to be closely reviewed and approved before they could be shown.

ZHONG MING *(b. 1949, Beijing)*
Zhong Ming, then an editor at the People's Literary Publishing House in Beijing, showed a number of adventurous paintings in the third OPRA show. The most arresting was a large, earth-red canvas with a black-and-white photographic image of Jean-Paul Sartre (plate 70). It is a striking work that expresses Sartre's existential philosophy. "It is the isolation of the individual in a modern urban context," says the artist, who combined his two passionate interests in this painting—art and philosophy. Zhong Ming also showed other work in quite different styles, including a swiftly brushed, cartoon-like painting of a Beijing opera character, entitled *National Opera*, in which the artist playfully oozed the pigment. In *No Movement*, he used an unsized canvas as a background for the barely brushed suggestion of a tree, its leaves, and a moon.

Both Yuan brothers also exhibited works in the third OPRA show. One of Yuan Yunsheng's entries was *Self-Portrait* (plate 40), painted in a Post-

Impressionist mode. It is an artful likeness, but at the same time the artist looks like Gauguin. One of the paintings shown by Yuan Yunfu was *Flags* (plate 29), a festive, bird's-eye view, which is a visual pun on abstract painting. The fresh exuberance of the experimentation in this show is noteworthy, but the work of all thirty-six members is too numerous to mention individually.

OPRA had been officially registered as a group with the Chinese National Artists Association. During a brief political relaxation, OPRA had a fourth exhibition at the National Art Gallery in the summer of 1982. This came about because of good official connections and the high quality of the art. Hua Junwu (b. 1915, Wuxi, Jiangsu Province), the famous cartoonist and rehabilitated vice-director of the Chinese Federation of Literary and Art Circles and the Chinese National Artists Association, played guardian to the principles of socialist art and carefully excluded nudes and abstract works.

Star Star

No group demonstrated more daring or received more notoriety than the Star Stars, now functionally defunct. The members dramatically infused new blood into the enervated art scene. They demanded exhibition space and got it. They showed previously forbidden styles and pushed the limits of exhibitable subjects far beyond the former boundaries for political, erotic, and nonobjective art. In late September, 1979, twenty-nine amateurs in their twenties began the movement by setting up a sidewalk art show in front of Beijing's National Art Gallery. For three days they conducted a sit-in, demanding exhibition space. On October 1, 1979, the thirtieth anniversary of the People's Republic, the group marched in central Beijing with placards, again calling for space to exhibit. This was the same day that both the new airport and the second OPRA show opened. In mid-November, the Stars were finally given space in Beihai Park. This event, ironically, coincided with the closing down of Democracy Wall. Over a ten-day period, despite a publicity blackout—except for a single one-inch ad in the *People's Daily*—thirty-three thousand people came to see the previously taboo

73. *The author with some founding members of the Star Star group at an informal showing of their work in Huang Rui's room. 1980. From left: Ma Desheng, Yan Li, Li Shuang, Huang Rui, the author, Bo Yun, and Qu Leilei.*

74. Wang Keping. *Lin Biao.* 1979. Wood, metal, and plastic

Lin Biao, open-mouthed, calls out his support for Mao while holding The Little Red Book *in his left hand. However, he holds a knife in his right hand—to stab Mao in the back. The sculpture summarizes the official line on Lin Biao, once named Mao's successor, who then allegedly turned traitor and died mysteriously in 1971. Lin Biao was supposedly killed in a plane crash while escaping to the Soviet Union after an unsuccessful effort to assassinate Mao.*

75. *Wang Keping is seated in his Beijing apartment studio with his hand on* Reclining Figure. *He works principally in wood, and his sculpted forms suggest anthropomorphic and zoomorphic beings.* 1983.

76. Huang Rui. *Syncopated Rhythm.* 1982. Monotype on paper

In 1982 Huang Rui began experimenting with monotype printing, which gave him new freedom. The speed and economy of the medium allowed him to do his best work.

RIGHT:

77. Wang Keping. *Blind and Silent.* 1979. Wood. Shown in the Star Star Exhibition, Beihai Park, Beijing, 1979

Wang Keping's directness with wood is primal because he finds the image within the medium. The tension of the varied textures in the single wood block expresses the artist's feelings. The circle of the blind eye is repeated in the circular corked mouth.

FAR RIGHT:

78. Wang Keping. *Torso.* 1979. Wood. Shown in the Star Star Exhibition, Beihai Park, Beijing, 1979

In this lovingly fashioned piece, the wood grain ripples over the abdominal sections, and the knots on the breasts are Surrealistic. With an artistic transformation that appears magical, Wang Keping liberates the material to reveal the qualities that articulate his vision.

works. Sculptor Wang Keping was often the spokesman. He was one of the principal organizers, along with Ma Desheng (discussed in "Chinese Ink Painting," p. 139), oil painters Huang Rui and Qu Leilei, and the painter-writer Zhong Acheng.

WANG KEPING *(b. 1949, Beijing)*

Wang Keping, a self-taught sculptor, showed bitingly satirical works that poked fun at the Gang of Four and officials in general. He portrayed the number-one villain in *Jiang Qing Holding High the Banner of Mao*, a relief sculpture fashioned from a wooden gunstock. It parodies Jiang's superpatriotism, which was, in fact, a cover for her grab for power.

Blind and Silent (plate 77) has a face with one eye patched over and a cork in its mouth. "This is my image of myself and of all the Chinese people who have been oppressed," Wang Keping told *Los Angeles Times* reporter Linda Mathews. "See, one eye is shut so we can't see much of what's going on around us, and the mouth is corked, like a Thermos bottle, so we cannot speak. I've taken the cork out of my own mouth for a while at least, but eventually, of course, somebody may stuff it back in."

Wang Keping's sculpting is strong and direct and produces powerful and amusing political indictments as well as satisfying objects. His forms have a natural authenticity, as if they grew from within the wood. They also have an ambiguity that is teasingly erotic. Wang's adventurous spirit comes through in his art. In puritanical China, his interest in the nude leaves him as vulnerable to official wrath as do his political statements. In 1984 Wang Keping married a Frenchwoman and went to live in France.

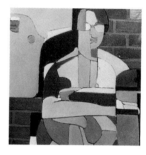

79. Huang Rui. *New Life in the Yuan Ming Yuan.* 1979. Oil on canvas. Shown in the Star Star Exhibition, Beihai Park, Beijing, 1979

In this movingly patriotic piece, the columns of the ruined Summer Palace come to life in a semiabstract, anthropomorphic embrace.

80. Huang Rui. *Self-Portrait.* 1980. Oil on canvas

One of the disadvantages of having no formal art education is the lack of opportunities to draw from a model. Huang Rui and his friends periodically pooled their resources to hire one. More often he painted himself, and here his image becomes a Cubist synthesis.

81. Mao Lizi. *Double Happiness.* 1981. Oil on canvas

To put a double-happiness character on the door of a newlywed's house is a typical Chinese way of expressing connubial good wishes. The ability of the artist to fool the viewer into believing that he pasted a red paper-cutout character onto a wooden door is quite remarkable. Mao Lizi is an outstanding artist of the New Realism in China.

HUANG RUI (b. 1952, Beijing)

One of the oil paintings that Huang Rui showed in the Star Stars' exhibition was *New Life in the Yuan Ming Yuan* (plate 79). The scene depicts the remains of the "Little Versailles" part of the Summer Palace, burned down in 1860 by a European retaliatory force during the Taiping Rebellion. This incident, remembered as the ultimate outrage performed by the hated foreign devils, continues to be a patriotic rallying point. The work addresses the renaissance of the Chinese spirit as it rises from the ashes of the Cultural Revolution. Huang Rui married a Japanese woman, and he went to live in Japan in 1984.

MAO LIZI (b. 1950, Xianyang, Shaanxi Province)

Mao Lizi is a talented and amusing *trompe-l'oeil* artist (plates 81, 82, and 83) whose work has been acknowledged by a prize in China's National Youth Art Exhibition of 1981 and by sales abroad.

Also shown in the Beihai Park show were Ma Desheng's thoughtful, angry woodcuts in black and white. Both Yan Li (b. 1954, Shanghai) and Li Shuang (b. 1957, Beijing) showed oil paintings of dreamlike, Surrealistic figures (plates 86 and 87), and Xiao Dayuan exhibited an abstraction painted in the spirit of Jackson Pollock's skeins.

In June, 1980, a prominent magazine, *China Reconstructs,* ran an illustrated piece on the first Star Star exhibition. Flushed with victory and the backing of art leader Jiang Feng, who encouraged the group movement, the Star Stars were able to get exhibition space in the National Art Gallery in August, 1980.

82. Mao Lizi. *Mooch*. 1980. Mixed mediums on board. Shown in the Star Star Exhibition, Beihai Park, Beijing, 1980

The artist created a Superreal piece of Beijing pavement, complete with cigarette butts, burned matches, and footprints. The painting was admired for its technique and its humor.

83. Mao Lizi. *String*. 1982. Oil on canvas

Like a magician who always fools the eye, Mao Lizi absolutely convinces the viewer that there is a string hanging in front of a blank canvas.

Evidently, before the exhibition was hung, Jiang Feng inspected the works and indicated that certain ones were inappropriate. However, the Star Stars did not accept his guidance and elected to exhibit everything. Jiang felt betrayed, and he withdrew his support from the group. But another key factor was, no doubt, that he felt under increasing pressure from both left and right, who clearly had to disapprove of the Star Stars because Deng Xiaoping was withdrawing his support from liberal intellectuals.

The Chinese airline's *In Flight* magazine of February, 1981, headlined the show as "An Exhibition Which Took Beijing by Storm" and reported that "the daily attendance reached nearly 10,000." However, after officials had previewed the exhibition, Wang Keping hurriedly installed a wooden head titled *Idol* (plate 84), which looked like both Buddha and Mao. This was at a moment when the Chinese government was conceding Mao's errors and when the Chinese talked privately about the Gang of Five, meaning the Gang of Four plus Mao. Yet to poke fun publicly at the "Great Helmsman" was too cheeky to be tolerated. Thus, praise of their great success was immediately followed by a flood of unremitting criticism. Articles in art magazines called their work "too derivative," "not skilled enough to be called art," and "incomprehensible to the masses." The Star Stars were called together to meet with art officials for criticism and self-criticism. According to various members, the group accepted the discipline and agreed to follow the party line. But official support was lost. The Chinese airline withdrew the February, 1981, issue of *In Flight*, which had praised the Star Stars. The group was refused another chance to exhibit. By 1982, one official noted, "They dropped out of sight." No longer having access to exhibition space, the Star Stars lost their group existence.

Several Star Star artists, including Li Shuang, had quit their jobs because they were able to support themselves by selling their work to foreigners in Beijing. Once the group had fallen from grace, these artists faced severe long-term recriminations: Once a Chinese quits a job, it's unlikely he or she will get another one. Since the state assigns jobs, it can retaliate by not assigning any job to a political nonconformist, especially when there is not enough work to go around.

In June, 1981, the attractive artist Li Shuang and the foremost Star Star patron, French diplomat Emmanuel Bellefroid, became engaged. She went to live with Bellefroid in the French Embassy compound. When the French diplomat was temporarily abroad, Chinese security police forced Li Shuang into a Jeep at the entrance to the French diplomatic compound and detained her. The French government registered strong protests: She was the fiancée of a diplomat and she was within the compound, supposedly out of bounds to the Chinese police. Although they did not specify the crime, Chinese authorities said she had broken the law. They sent her to the countryside for two years of reeducation through labor. After she served her term, she was allowed to emigrate to France to marry Bellefroid, who had had to leave China earlier. But he had been able to take many paintings with him.

The incident may be interpreted in various ways. Some say that Li Shuang's

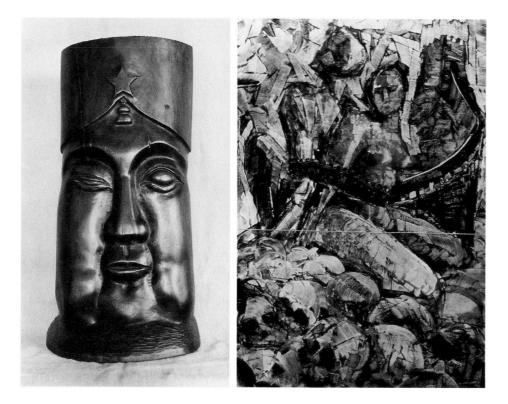

arrest was motivated by China's desire to expel Bellefroid because of his closeness to the young dissident writers in the Democracy Wall movement rather than by Li Shuang's Star Star activities or her social life. Others say it was unacceptable for an unmarried Chinese woman to live openly with a foreign male in puritan China. Such a situation infuriates the Chinese because It symbolizes past foreign exploitation and exacerbates the especially sensitive issue of foreign men associating with Chinese women.

Southern Fujian Art Group

Fujian Province is naturally separated from the rest of China by a ring of mountains on three sides and water on the fourth. The Fujian dialect symbolizes a long history of isolation because it is so different from all others. Yet the message of the new art policies reached this enclave with all possible speed. During November, 1979, in sleepy Quanzhou—called the pearl of the Orient by Marco Polo in the thirteenth century—a group of eleven male artists between the ages of eighteen and fifty-one formed a group. Invoking the guidance of the municipal cultural agencies, the artists called themselves the Southern Fujian Art Group. They published a manifesto stating their goals: to organize cultural activities, to do research, and to create art. They proposed to democratize and modernize art and at the same time to emphasize local characteristics in their work.

The group had its first exhibition in Xiamen (Amoy) in January, 1980. The

86. Yan Li and Li Shuang (right) in their studio. Both active members of the Star Star group, they quit their jobs so they could devote full time to painting. Their works hang on the wall. Yan Li's painting Runaway hangs in lower center; Dream Dancing is upper right. Li Shuang's small painting Gu Gong has red walls and hangs to the right of Yan Li's face. 1981.

87. Yan Li. *Song for a Laborer.* 1982–83. Oil on canvas

In this witty, dreamlike composition the artist expresses a view shared by many intellectuals who were sent to the countryside to do manual labor during the Cultural Revolution. Their labor was part of the campaign to raise their political consciousness. In a parody of the set political messages they constantly heard, the arm of the phonograph plays directly into the laborer's hat.

88. Chen Zhangpeng. *Ten Years of Education.* 1980. Oil on board

Chen's Expressionist work is an indictment of the ten wasted years of the Cultural Revolution. A powerfully brushed blue-black building is in flames against an angry sky. The foreground reflection suggests pools of blood.

artists showed a variety of styles: freely brushed traditional Chinese ink paintings as well as the international styles, including realism, Expressionism, and semiabstract oil paintings. They had seen such work published in books and journals.

CHEN ZHANGPENG *(b. 1941, The Philippines)*
Leader and spokesperson Chen Zhangpeng is one of the many Fujianese who have overseas ties. The Fujianese, more than any other Chinese group, have settled in a network of communities in Taiwan, the Philippines, Indonesia, and Singapore. These communities maintain close relations with the motherland, and in some cases, as in Chen's, members return to China to live and work. Chen has succeeded in expressing his views in several witty and forceful styles (plates 88 and 89).

LI MUER *(b. 1953, Quanzhou, Fujian Province)*
Although the prominent young painter says he is self-taught, he was exposed to art in a home where both father and grandfather were artists. However, he has not had a chance to acquire a formal art education, and his job as a factory worker does not offer ideal opportunities for artistic development.

Huang Huihui, the youngest artist in this remarkable group, is discussed in "Chinese Ink Painting" (p. 143).

Word of the Southern Fujian Art Group was transmitted beyond the province by a Shanghai artist who coincidentally happened to exhibit in Xiamen at the same time and in the same place. The artist from Shanghai was deeply impressed by the high quality and adventurous nature of the work, but no other artists, apart from those in Quanzhou, seemed to have heard of the group.

In general, artists of the eastern seaboard cities do enjoy a certain amount of intercommunication. The Fujian enclave is the exception. It is true that a group in Fujian's capital city of Fuzhou or one in the port city of Xiamen—which has frequent ferry service to Hong Kong—would have a better chance of being known than one in sleepy Quanzhou, whose harbor silted up about five hundred years ago and whose outstanding feature is a magnificent temple that dates back to the Tang dynasty (618–907).

The Shanghai Groups

Shanghai is China's most culturally sophisticated city. It is in the vanguard of commercial, industrial, and intellectual activities. Perhaps it is the fearsome memory of the pre-1949 foreign influences, art and Bohemianism, and that Shanghai was the center of the Cultural Revolution that makes its art leadership so conservative. In 1965, in accordance with the government's educational plan, the Shanghai Art College closed its doors. Thereafter, the best opportunity for an art education in the region was to be found at the Zhejiang Academy of Fine

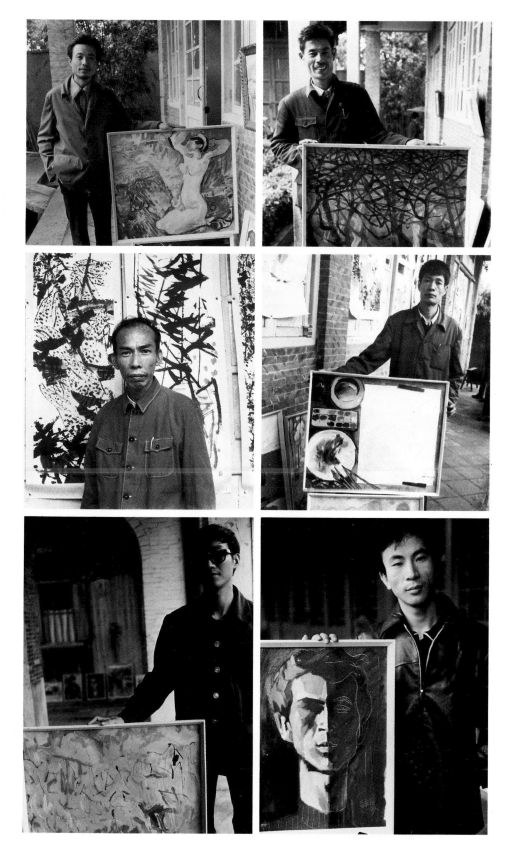

CLOCKWISE, FROM TOP LEFT:
89. Chen Zhangpeng. *Innocence.*
1980. Oil on board

Chen's sketchy study of a nude kneeling next to a tiger expresses the ancient Chinese idea that the untrammeled nature of the wild creature is innocent. Likewise, primitive people, uncorrupted by civilization, are innocent, a concept similar to Rousseau's romantic notion of the noble savage.

90. *Huang Qingqi shows several of his oil paintings of the forest and fields of his native Fujian Province. He stands in the courtyard of the Buddhist temple Kai Yuan Si, which dates back to the Tang dynasty. Today, parts of it are used as a meeting place for the Quanzhou Cultural Center. 1980.*

91. *Lin Jianpu (b. 1949, Quanzhou, Fujian Province) shows an oil painting on paperboard,* Blank Sheet, *at the Buddhist temple Kai Yuan Si. Lin was included in the Provincial and National Youth Art Exhibition of 1980–81.*

92. Peng Chuanfang. *Self-Portrait.* 1980. Oil on board

This haunting self-portrait speaks of the inner life that sparks the artist (b. 1955, Quanzhou, Fujian Province) and many kindred spirits in that outpost of culture. Peng is self-taught and holds a design job in a printing house.

93. Li Muer. *Sad Song of Autumn.* 1980. Oil on board

In a somewhat Abstract Expressionist outpouring, Li Muer created a vaguely recognizable field of grain swaying in a rhythmic mood. The blobs of yellow pigment evoke harvest colors. The artist draws on both traditional Chinese ink-stroking technique and Abstract Expressionist gestures.

94. Cai Zhanlong. *The Four Seasons.* 1980. Ink on paper

Cai (b. 1927, Quanzhou, Fujian Province) is the senior member of the Southern Fujian Art Group, and he paints traditional subjects with vigor.

95. Huang Qingqi. *Trees*. 1980. Oil on board

Huang Qingqi (1938–1982), from the Nanan District of Fujian Province, was a leading member of the Quanzhou Cultural Center. He was a traditional painter who took up oil painting late in his life. His brilliantly colored Trees shows interwoven branches brushed together in a lyric composition. He carried his fluent ink strokes over to his oil painting with splendid success.

96. Li Muer. *Unforgettable Village*. 1980. Oil on board

In the background Li Muer re-created the village where he spent anguished years during the Cultural Revolution. The intensely blowing fields in the foreground, painted with poignant colors and agitated strokes, express his troubled feelings about the place.

Arts in Hangzhou. In spite of the loss of the college and the relatively unliberated nature of the art officials, the Shanghai art scene still has vitality. Kong Boji, a member of the Shanghai Artists Association and an exception

among his conservative associates, exhibited with a pioneering group called The Twelve, which formed to exhibit in 1979, but broke up soon after. Kong Boji is discussed in "New Waves: The Post-Mao Period," (pp. 47–49).

Grass Grass

Two other artists from The Twelve became part of another group called Grass Grass. The name Grass Grass was chosen because it symbolizes "strength of life." Grass lives almost everywhere, in most seasons, and it gives hope. Originally there were twelve artists in Grass Grass, but one dropped out because he was afraid of being a member of an unsponsored, unofficial group. All were men between the ages of thirty and fifty, seven from Shanghai and four from Hangzhou. They modeled the ideals and structure of the group after those of the Oil Painting Research Association, artists who were congenial and shared similar ideas. They exhibited watercolors and traditional paintings at the Luwan District Cultural Palace in February, 1980. Before the show opened, a nude was withdrawn to avoid controversy. The exhibition was remarkably strong; it included both Cubist and Expressionist experimental works, based on styles the artists had seen in books. But most interesting were the works in which ancient Chinese practices and new watercolor techniques were combined. The exhibition, called *Painting for the '80s*, showed the germ of a new Chinese style.

Although the Grass Grass exhibition was received enthusiastically, and people in both Hangzhou and Fujian Province expressed interest in showing it, the head of the Luwan District Cultural Palace refused to take responsibility for such a controversial show, especially since it was privately organized—not officially sponsored through an artists' association. Since no official would accept responsibility, without further exhibition prospects, Grass Grass ceased to function as a group.

QIU DESHU *(b. 1948, Shanghai)*
Qiu Deshu, the organizer of Grass Grass, is an artist-worker at the Luwan District Cultural Palace. He may well be the outstanding painter and theoretician of his generation. More than any other artist in China today, Qiu Deshu experiments through his work, always searching for an exciting and surprising new application of both traditional and modern techniques. His creativity is explosive; he turns out an astonishing number of fresh works every season. In the group's exhibition, he showed a number of works in Chinese ink and color on paper that were Expressionistic and semiabstract. Six months after the show, he shifted even more toward integration of Western influences with ancient Chinese forms, a direction he has continued to explore in the ensuing years.

Qiu is an accomplished traditional calligrapher and seal carver. He draws ideas from Chinese philosophy as well as from Buddhist sources, just as he adapts ancient calligraphic and seal styles. Indeed, he has explored his rich national heritage, as the party line exhorts artists to do. But the fact that he

97. Guo Runlin. *Suzhou Reflections.* 1970. Ink and color on paper. Shown in the Grass Grass Exhibition, Luwan District Cultural Palace, Shanghai, 1980

This favorite subject of bridges and white houses with black tiled roofs reflected in a canal is shown here in soft, rich tones. Guo's vision is cast in broad and flat areas; he builds up the structure in the manner of Cézanne, yet he presses beyond into Cubism.

98. *Qiu Deshu poses with a sheet of freely brushed, archaic-style pictographic forms. This ancient script was scratched onto oracle bones four thousand years ago. Qiu has written the individual characters as if they were linked in the essay form that was developed two millennia later. 1980.*

reaches back to use forms from twenty-five hundred years ago—and more—apparently confuses officials who seem not to have much more than a thirty-five-year-old memory. Qiu's ideas on art and the universe are profound: He questions the limitations of illusionism and seeks a universal approach to solving the riddle of the nature of substance—its limitless and ever-changing quality.

Qiu admires Jackson Pollock, whose painting he saw for the first time when a Boston Museum of Fine Arts exhibition came to Shanghai in October, 1981. He says the great achievement of Pollock was that he had followed his own "dauntless spirit," which allowed the artist to "free himself from the mundane." But Qiu also admires the unfettered souls of the ancients, and he says that "they could more clearly create images of universal truth." According to Qiu, the ancients were not trammeled by the restrictions of society or by technical knowledge, nor were they enticed by fame and wealth. In *Natural Order, Series IV* (plate 100), Qiu uses his newly discovered "variegated ink-splashing technique," which, he says, "contains various images, satisfies visual experience, but, most importantly, epitomizes, refines, and shows the world in true naturalness." The artist says the symbolism of his series called Rifts is an interaction between elements in the real and surreal worlds. He goes on to say that the elements are not physical or chemical but philosophical. "These elements are just the naturalness I want to display. These rifts represent my own pain and suffering."

In his Structure of Painting and Calligraphy series of 1981–82, Qiu seeks to reunite characters and images. The images of the seals become an integral part of the composition. For *Natural Order, Series IV*, Qiu used natural, uncut stones as seals. After he stamped the paper, he tore it up and scattered the pieces on the painting.

Since 1980, Qiu has experimented repeatedly with ink, color, and paper, seeking a form for his ideas. He developed a pierced-paper method to liberate his brush lines and to reveal other levels of existence under the surface. Both the surface and the imagery recall the stone rubbings done in China for two millennia. In 1983, Qiu turned to his Rift series (plate 103), works that are usually created with torn paper, a process that integrates line and surface more completely. The compositions are in low relief, with layers of painted or printed torn paper, which produces a sophisticated new creation in these traditional materials.

Qiu Deshu, who finished high school on the eve of the Cultural Revolution, held a factory job from 1968 until 1977, when he was transferred to the Luwan District Cultural Palace as a working artist. Although he had no formal art education, he studied traditional painting with Chen Jialing, who joined the Grass Grass group and is discussed in "Chinese Ink Painting" (pp. 131–32). Because of his wildly innovative style, Qiu was singled out and ordered to stop painting during the 1983 Anti-Spiritual Pollution Campaign. Because his work was labeled bourgeois, his future is far from clear. Qiu Deshu's works have been exhibited and published in Shanghai, Hong Kong, and the United States. For

99. Qiu Deshu. *Nature of Substance* (one of a series). 1981. Ink on paper

Combining some calligraphic forms with cosmic ones, Qiu envisions a universe of continuous creation and expansion. Energy and atom-splitting are precisely described in Chan Buddhist symbols.

100. Qiu Deshu. *Natural Order, Series IV.* 1981. Collage; ink on paper. Exhibited in *Painting the Chinese Dream*, Smith College Museum of Art, Boston City Hall Gallery, The Brooklyn Museum, 1982–83

The artist has kept a ribbon of white that cascades across a cosmic sort of ink configuration. The ink spreads across the paper like tempestuous capillary action. The image recalls Chinese landscape paintings in which silver-white waterfalls thread among rock faces. At the top, seals made with uncut stones rhythmically punctuate the black band. After Qiu stamped the paper, he tore it apart and scattered the pieces on the band.

101. Qiu Deshu. *Heart Cracks.* 1984. Collage; ink and color on paper

Heart Cracks has a distinctly anatomical look, with red, blue, yellow, and white-gray lines that suggest veins and arteries. They crisscross and repeat again and again, as if a web were hanging in front of the chaos of substance. Backlighting reveals the color and compositional depth. Once again the heart cracks are torn and pasted—engineered with fine craftsmanship by this resourceful artist.

102. Qiu Deshu. *Cracks.* 1984. Collage; ink and color on paper

After the Rift series, Qiu moved on to a closely related group titled Cracks, in which he found new metaphysical space. The little black figures have been consolidated into a larger primal force, which has a strange resemblance to a tortoiseshell and a scapula bone, the kind used in ancient Chinese divining rites. These so-called oracle bones were touched with hot sticks by a shaman who read the crackles for answers sent by the Great Spirit Under Heaven. Qiu infuses purples into the black-and-blue relief of painted and torn papers.

103. Qiu Deshu. *River Rift #6.* 1983. Collage; ink and color on paper

Most of Qiu's compositions have at least one pair of eyes staring out of the dynamic interacting masses. This work, which strongly evokes water, river, and wave imagery, is intensely inhabited by shadowy black organic beings. The brushed figures float in water, defined by what appear to be white wave strokes. Although they look like strokes, they are in fact rifts. The artist tears the paper to create the gesture, which allows the white ground to be revealed.

the school year 1985–86, he was artist-in-residence at Tufts University, where he created a monumental mural called *Cracks*.

GUO RUNLIN *(b. 1940, Shanghai)*
Guo Runlin had been part of The Twelve before he joined Grass Grass. His watercolors are accomplished Post-Impressionistic creations with particularly Chinese subjects (plate 97).

Since 1960 Guo Runlin has worked as a designer in the Triumphant Song radio factory. Because Guo was an artist, he was attacked during the Cultural

Revolution and "criticized" seventeen times for his political "errors." Because they thought Guo was insufficiently apologetic and repentant, workers set fire to a suitcase containing his artwork. His paintings also were hung in a Black Paintings exhibition as an example of unacceptable art.

Shen She

In July, 1980, a group of more than twenty accomplished and mature artists from Kunming, in China's southwestern province of Yunnan, banded together to exhibit their experimental work. Their name came from the popular designation for the zodiac year: 1980 was the year of the Monkey, and *Shen She* means "Monkey Year Group." The group stated that its purposes were to give art a new beginning and to make art democratic. The show created a sensation.

Shen She artists have listed reasons why their work is so distinctive: They are in a remote area, isolated from both party scrutiny and modish Eastern trends; they live among twenty-six minority nationalities who provide colorful subject matter; their region is rich in rare and exotic jungle flora and fauna. Moreover, among them there is no single, towering artistic leader for everyone to copy.

Beijing officialdom took note of the Shen She exhibition and invited ten of the Yunnan artists to exhibit at the National Art Gallery in 1981. The full group was not invited, presumably because official exhibition policy toward privately formed groups had changed. Among the artists invited to show in Beijing, several are particularly notable.

LIU ZIMING *(b. 1927, Kunming, Yunnan Province)*
A leading member of Shen She, Liu Ziming has a mature oil-painting style that is very much her own. She has never allowed her loss of hearing, caused by an illness at age eleven, to inhibit her professional work.

Liu had rigorous academic training in oil painting at the Beiping Art College from 1946 until 1949 and at an art academy in France for the following seven years. Although she was very successful in France, she returned to her country and her fiancé, who had waited for her return. After experimenting with a Barbizon School style of painting and with Impressionism, she decided that Post-Impressionism was the style most suited to her in making her own statement. She especially admired Cézanne's sense of structure.

On her return to China, Liu Ziming joined the prestigious, nonteaching Beijing Painting Academy in the year it was founded, 1957, and in 1962 she was transferred to the Yunnan Artists Association in her hometown, Kunming. At last, she and her husband, who had had to remain in Kunming, could live together. She is unwilling to talk about it, but she went through especially hard times during the Cultural Revolution because she had lived abroad. In addition to being relegated to the so-called stinking ninth category because she was an artist and an intellectual, she was also called a spy because of her international background.

Nevertheless, Liu Ziming is a joyous, optimistic person who wears her burdens

lightly. She has gone beyond her original subject matter, flowers, to include landscapes and figures. Painting from life with the discipline of a committed artist, she simplifies the subject matter and creates her own classic compositions. She does not imitate Cézanne; yet one can see that she embraces his ideas about structure. Her colors are rich, opaque, earth tones, and the subjects are outlined in black in the manner of traditional Chinese ink painting. Liu Ziming's painting is strikingly successful and subtle in its blend of East and West (plates 104 and 105).

YAO ZHONGHUA *(b. 1939, Kunming, Yunnan Province)*

A cheerful, attractive member of the Yunnan Cultural Bureau, Yao Zhonghua has experimented widely and thought deeply about the problems of art. He, like Yuan Yunsheng, was a favorite student of Dong Xiwen at the Central Academy of Fine Arts at the end of the 1950s. Both students suffered later because they had been inspired by their teacher's vision.

In 1955, Yao Zhonghua was admitted to the highly competitive high school affiliated with the Central Academy and then went on to the academy itself in 1959. When he joined Dong Xiwen's studio, Yao Zhonghua was exposed to European art, Buddhist murals, and folk art—a change from the conventional art dogma. Dong Xiwen introduced these artistic modes at a time when it was only safe to study Socialist Realism; he encouraged individualism at a time when the party wanted everyone's work to look the same. Dong Xiwen's own position was reasonably secure because Chairman Mao loved one of his Socialist Realist paintings, *October First 1949 Festivities at Tiananmen,* which was in the Museum of Chinese History and the Revolution. But Dong's students had no such defense. Moreover, Yao was especially vulnerable because he had been a leader in forming a student organization.

Yao Zhonghua was criticized in 1963 for following the "Impressionist line," defined as bourgeois and decadent, and his subjects were denounced because they did not exemplify "the glorious struggle." One of his paintings, inspired by the style of Picasso's Rose Period, pictures the mythical hero Quafu, who, like Icarus, tried to fly to the sun but died of thirst. It was criticized both for its style and its content. One should not portray defeat, the officials said, because China always triumphs. Furthermore, they said, the painting was a statement against Mao's thought, since the sun is a metaphor for Mao. Yao's critics said his graduation painting, *Two Bulls Fighting,* referred to the savage backwardness of China—always fighting. Another painting, *Black Cat at Night,* they said, was too black and had a hidden meaning. Yao disclaims any hidden meanings. Looking back, Yao Zhonghua says with sadness that it was the works he liked most that were criticized. He had been young and hopeful, but then his world was crushed. After his criticism, he did not want to go on living. When he was sent to the countryside in 1964 to labor for a year, he went as a convalescent. After a year of digging and drawing water and learning to live like a peasant, Yao Zhonghua was assigned to work making film advertisements. Such a lowly job was a reflection of his political "problem."

104. Liu Ziming. *Market Day.* 1982. Oil on canvas

The artist conveys the idea of a busy, crowded market, yet she has carefully summarized, arranged, and eliminated. Organized around a strong, whitish diagonal ground, the market people, with a few exceptions, are gray-blue rectangular units. Conically shaped umbrellas and bamboo peasant hats syncopate the composition, which is varied in front with stacked dishes and green fruit. Although the crowd is animated, it is also impersonal. The composition has a distance and solidity that evokes a Neoclassicism similar to Morandi's.

105. Liu Ziming. *Three Pagodas of Dali.* 1982. Oil on canvas

These Buddhist pagodas, reliquary towers enshrining the remains of the Buddha or his symbols, are widely reproduced as a major Yunnan tourist site, yet, as late as 1983, foreign visitors were still excluded from Dali. The local hill-tribe people, members of Chinese minority groups, freely patronize religious establishments since they have been reopened in the post-Mao era. Liu sets the scene for us, carefully including several power lines, lest she be accused of being only interested in the old religious power!

106. Yao Zhonghua. *Untitled.* 1981. Oil on canvas

While attending a special course at Beijing's Central Academy of Fine Arts in 1981, Yao lived on the twelfth floor of the dormitory. That experience stimulated his sense of space. At one point, when he noticed that the splashed paint on the edges of his easel board had a spatial configuration related to his new feelings about space, he began to play with the idea of forming abstract shapes. He added a moon. But he says he would not exhibit this work because its abstract quality would incur official wrath.

107. Yao Zhonghua. *O Earth.* 1981. Oil on canvas. Shown in the Sixth Chinese National Exhibition, Shenyang, 1984; Beijing, 1985

In this vast Expressionistic work, Yao dramatically pours out his deep feelings about the land. Using symbolic, rich earth colors, he depicts an intense plowman and two powerfully brushed bulls. He draws on nineteenth-century academic painting as well as on the Mexican muralists, who provided inspiration as Communist artists.

108. Yao Zhonghua. *Woman.* 1982. Oil on canvas

This freely brushed, joyously voluptuous figure expresses the artist's gusto for life despite his many disappointments. Yao's wife is a beautiful dancer, and perhaps she was his inspiration.

During the Cultural Revolution, Yao's father—a doctor trained in Western medicine who had done research in the United States in 1946—was a target because of his foreign, bourgeois connections. Although the family now lives together in a charming traditional house in an extended family arrangement, the father's poor health is a constant reminder of the suffering he was subjected to while in prison during the Cultural Revolution. Yao Zhonghua has said of the armed warfare between the "right thinkers" and the "wrong thinkers" in Kunming, shooting at each other from either side of the main boulevard, "You cannot imagine what it was really like."

In 1972 Yao Zhonghua's luck suddenly changed. One of his paintings, *Peasant Listening to a Radio*, was accepted for a national art show. In 1973 he was transferred to the Yunnan Cultural Bureau and began to paint again. His large oil paintings hang in Beijing's Museum of Chinese History and the Revolution as well as in the Great Hall of the People. Every year he goes to a national minority area to paint.

An Expressionistic painting, *O Earth* (plate 107), had national recognition in the Sixth Chinese National Exhibition of October, 1984, and a similar bull was reproduced on a postage stamp. He also paints straightforward, naturalistic landscapes. In the search for his own special vehicle, Yao still experiments with many styles. Despite his recent output, Yao says that since he was criticized he has had serious problems in expressing himself in art.

Modern Heavy Color

Some of the Shen She artists call themselves Modern Heavy Color painters because they use the rich, opaque coloration of the Dunhuang murals and decorative Ming dynasty painting. Yao Zhonghua believes what Dong Xiwen taught, that a new art style can be achieved through using gouache, and he frequently employs opaque watercolors that are not burdened with the Western overtones of oil paint. Unlike Yao Zhonghua, most Modern Heavy Color painters use a technique developed by Huang Yongyu, Yuan Yunfu, and others that involves painting Chinese colors on both sides of a Korean paper called *gaoli zhi* to create intense color effects. These artists include Jiang Tiefeng, Liu Shaohui, He Neng, He Dequang, and others.

The Modern Heavy Color movement has been centered in Kunming, although there are artists living elsewhere who are still considered part of the group, such as the Beijing muralists Liu Bingjiang, Zhou Lin, and Qin Yuanyue. In 1982 some of these painters exhibited in Singapore and in Hong Kong at the First Institute of Art and Design.

JIANG TIEFENG *(b. 1938, Ningbo, Zhejiang Province)*
Jiang Tiefeng, a leading member of the Modern Heavy Color group, was one of the ten Yunnan artists to exhibit in Beijing's National Art Gallery in October, 1981. One cadre exclaimed that Jiang Tiefeng's work looked like "a nightmare."

109. *Liu Shaohui poses in front of a Xishuangbanna jungle masterpiece done with bamboo pen. In a pleasant and peaceful way, he transmits a sense of enlightenment. 1983.*

110. Jiang Tiefeng. *Daughter of the Sea.* 1983. Ink and color on paper. Exhibited at the Eric Galleries, New York, 1985

The artist created a voluptuous fantasy featuring a giant, supine nude intimately engaged with a ship between her thighs. The joyous scene is set in a field of floating, flower-like forms, interlaced with patches of auspicious rain that suggests a ship's rigging. A red moon hangs against a black ground.

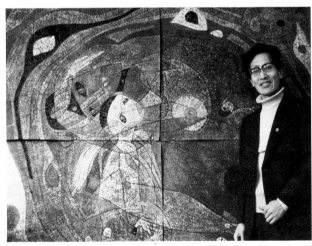

111. *Jiang Tiefeng stands beside a large* Mother and Child *composition. He used four of the largest sheets of* gaolizhi—*a Korean paper—available in China. 1983.*

Liu Shaohui, a colleague in the Modern Heavy Color group, quipped: "If I could have such a nightmare, I would want to dream it every night."

From 1959 until 1964, Jiang Tiefeng studied at Beijing's Central Academy of Fine Arts in the studio of Huang Yongyu, who introduced him to heavy-color technique. Jiang's graphic approach to design in painting reflects his training as a printmaker. His work is characterized by linear definition and shallow space filled with figures and landscape imagery. A prize-winning illustrator, Jiang has to turn down jobs to find time to paint. He has illustrated two delightful children's books—*The Ugly Duckling* (1981) and *Little Red Ridinghood* (1982)—both published by the People's Fine Arts Publishing House. In his illustrations Jiang uses his decorative style to convey the narrative directly; in his paintings he uses the same stylized vocabulary but multiplies selected parts, weaving them into mazelike compositions.

Jiang Tiefeng's favorite subject is women who look like fertility goddesses, with big breasts, tiny waists, and broad hips (plate 110). He also paints children and animals with a joyous energy. Jiang is a strong colorist, whose palette ranges from the intense red, blue, and yellow of Joan Miró to more subtly resonant grays and pinks.

Upon graduation from the Central Academy of Fine Arts, Jiang Tiefeng was one of seven adventurous classmates to volunteer to go to remote Yunnan Province to work. He was assigned to the Kunming Enamel Factory, and during the Cultural Revolution he earned money for his unit by painting large portraits of Chairman Mao. After the Cultural Revolution, he was transferred to his current position as a teacher at the Yunnan Art Institute. In 1983 Jiang Tiefeng came to the United States as a visiting artist at the University of Southern California, and he has had numerous successful exhibitions in the States.

LIU SHAOHUI *(b. 1940, Yongxing County, Hunan Province)*
Liu Shaohui is the theoretician who helped the Modern Heavy Color painters define their goals. He may also be the most gifted and profound artist—if not the most productive—among this remarkably prodigious group. Passionately committed to exploring wall-painting concepts and techniques, folk art, paper cutouts, theater, national-minority dancing and stories, and indeed the landscape itself, he has experimented widely with subjects and techniques. Like Jiang Tiefeng, he is a graphic artist whose work in that field is widely admired.

After graduating from the Central Academy of Arts and Crafts in 1965, he worked at the Yunnan People's Publishing House until 1984. Each year Liu Shaohui, like other professional artists, is given time to go to the countryside and paint. He has used this time profitably, studying the tribal people, sketching their dancers, and illustrating their legends. In his travels to the remote and lush autonomous region of Xishuangbanna, near the Burmese border, he sketched the dense jungle foliage with a so-called bamboo pen, actually a piece of cane cut diagonally to a sharp point, which is dipped in ink. The delicate and forceful lines pulse with jungle rhythms (plate 109). Among his most successful

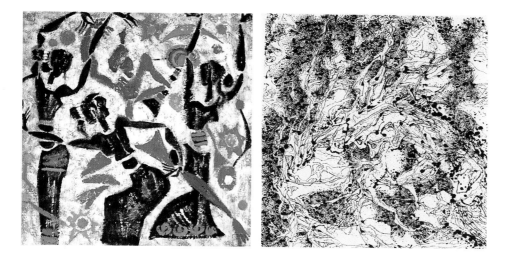

productions are several enormous scroll compositions, which are awesome in energy and vast in conception.

In 1984 Liu Shaohui went to Shenzhen University Academy of Painting in the Special Economic Zone to view the world from that window, but, disillusioned with the area's growing pains, he moved to Guilin in 1986.

HE NENG *(b. 1942, Chengdu, Sichuan Province)*

He Neng and Jiang Tiefeng are colleagues at the Yunnan Art Institute, where He Neng has taught since 1965, when he graduated from the Sichuan Academy of Fine Arts in Chongqing. He Neng participated in both the Shen She and the Ten Yunnan Artists exhibitions. The latter ran concurrently with a Boston Museum of Fine Arts exhibit, which was the first show of American paintings in China since 1949, and which included some twentieth-century abstract work. He Neng says that for him the exhibit represented a turning point from realism to a more decorative style. He says, furthermore, that he wants to distance himself from the group of Heavy Color painters and develop a more individual style.

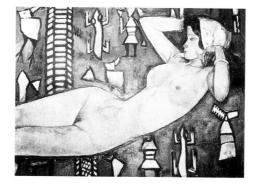

QIN YUANYUE *(b. 1940, Beijing)*

Qin Yuanyue, a painting teacher at the Central Institute of Nationalities art department, visited Yunnan in 1978. After seeing landscapes from the home of his minority students and meeting the Kunming artists, he became part of the Modern Heavy Color movement.

FAR LEFT:

112. Liu Shaohui. *Dai Dancers.* 1982. Ink and color on paper. Private collection

Lithe dancers move in a mesmerizing, circular pattern, expressing the syncopated rhythms of Dai drummers. The figures look like rubbings from a carved relief and are not wholly joined. The composition of brown-black figures is enriched by floating flowers and starlike medallions, which heighten the joyous dance. The proximity of the tribal people to the Kunming-based Liu has been a major source of inspiration to the artist. Moreover, a national policy that encourages artists to portray these folk legitimizes the search for the primitive and the exotic.

LEFT:

113. Liu Shaohui. *Pine Trees.* 1981. Ink and bamboo pen on paper. Exhibited in *Painting the Chinese Dream,* The Brooklyn Museum, 1983

This painting is one of a series of monumental pieces the artist composed in the remote jungle paradise of Xishuangbanna. The area is wondrously and abundantly endowed with Eden-like climate, flora, and fauna. Liu's incredibly facile lines, dots, and dashes are bursting with life-force energy.

BELOW LEFT:

114. Qin Yuanyue. *Nude.* 1980. Oil on canvas

Qin Yuanyue's voluptuous beauty is set against a curtain-like backdrop of primitively sketched men and beasts. Qin found a rejuvenating energy in these forms, which set the tone for the Expressionist composition.

115. Qin Yuanyue. *Dai Dancers.* 1980. Oil on canvas

The Dai dancers are frozen in a surreal setting. The figures appear to be bifurcated sculptures analyzed with an X-ray. Qin used heavy color to create this striking composition.

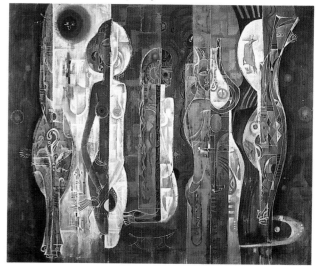

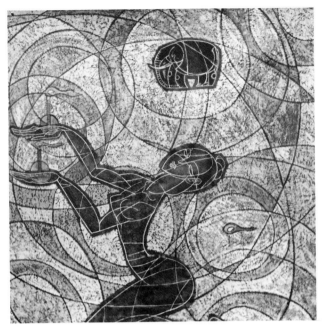

116. He Neng. *Candle Dancing*. 1983. Ink and color on paper

To express the circular dance on a flat surface, He Neng has decoratively integrated round patterns in a unifying motion. Following the vocabulary of the other Modern Heavy Color painters, he pictures elongated, voluptuous dancers, using warm, opaque coloration and the decorative composition of an illustrator.

117. *An animated conversation about art is a usual part of the Contemporaries' meetings. From left: Wang Huaiqing; Sun Weimin; Li Zhonliang; a foreign student; Zhang Hongnian; Zhang Hongtu; Zhang Jianping; Zhang Hongnian's wife, Li Xin; and Jiang Dahai. Members take turns playing host to the group. On this occasion, they met in Jiang Dahai's apartment. 1982.*

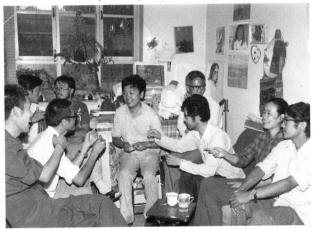

Qin Yuanyue is interested in Expressionism and abstraction. He sees the geometric designs on ancient Chinese pots as Abstract Expressionism. He also recognizes that his ideas on art are controversial in China. He thinks the government criticism of Yuan Yunsheng's airport nudes is "silly": "Dai people do bathe nude," he says. Among his own works there are many nudes, but he has avoided criticism by not showing them in China. He is currently living abroad.

There are other noteworthy Modern Heavy Color painters, including young Kunming painters Su Jianghu, a member of the minority Tujias, and his wife, Yang Huangli, who is also of a minority people. They say that despite the fact that there is no chance to exhibit experimental work because it does not conform to official standards, they continue to experiment.

Contemporaries

Beijing is the center of the Chinese art scene, just as New York is the center of the American art scene. Similarly, Beijing's artists know of few artists or groups from other parts of the country, even from such major centers as Shanghai or Guangzhou, except, of course, artists who went to school in Beijing or exhibit there frequently.

One privately formed Beijing group that gained national prominence with its first exhibition at the National Art Gallery in July, 1980, calls itself the Contemporaries. It began as an oil-painting group of thirteen men, ranging in age from the twenties to the forties. Since most of them were classmates at the high school affiliated with the Central Academy of Fine Arts, they were old friends and shared similar views on art. Liberating themselves from their Soviet-style art education, they have produced accomplished works in a vernacular that is fresh to China but uses a vocabulary adapted from Post-Impressionism, Expressionism, and Symbolism. All are part of the wave of New Realism. Since their work is neither abstract nor satirical, the scope for official criticism is narrowed. They concede, however, that some of their work is too imitative of Western models, and they are trying to correct this tendency.

The public response to the Contemporaries' exhibit was enthusiastic; officials at the National Art Gallery pronounced their work "healthy," and Huang Yongyu called it a breath of fresh air. The Contemporaries were the first private group allowed to exhibit in the National Art Gallery, and that institution purchased nine paintings from the exhibition to be included in the newly reestablished permanent collection. That move transformed the musings of young artists into "official art."

In contrast to Star Star, most of whose members had no formal art education, Contemporaries is made up of professional artists, all of whom have art-related jobs. Almost all had at least attended the high school affiliated with the Central Academy before the Cultural Revolution. Some attended an art academy or enrolled in graduate programs later, but many of them lost the possibility for university-level study.

WANG HUAIQING *(b. 1944, Beijing)*

One of the best paintings to be purchased from the Contemporaries' exhibition was by Wang Huaiqing. *Bole, a Wise Old Man Who Knows How to Choose Horses* (plate 120) was inspired by an ancient story. This highly symbolic subject refers to China's potential—after the oppression and waste of the Cultural Revolution—to create a modern nation. Although painted realistically, the figures are not set in the typical illusionistic, deep-space landscape. This kind of narrative style is more appealing to the younger generation than Socialist Realism.

Wang Huaiqing worked in the army as a set designer for a song-and-dance group until 1980, when he won a place as a graduate student in the wall-painting department at the Central Academy of Arts and Crafts. The teachers there liked his work and that of a fellow Contemporary, Li Zhongliang, so much that both were invited to join the prestigious faculty. However, the army prohibited both artists from staying on at the school because of a technicality in army discharge rules. It is not easy to change jobs in China; these artists succeeded eventually, not only because of their artistic gifts but also because of their ability to deal with the complex Chinese bureaucracy. They were then invited to join the Beijing Painting Academy, a municipal art unit that provides studio space and has no teaching obligations. On the surface, a job free of teaching obligations appears to be better than a Central Academy of Arts and Crafts position. But teachers from the Central Academy point out that work for the central government offers more prestige, more funds, and more mobility. Municipal enterprises, they say, never have enough money. Nonetheless, the artists have more time to paint and more freedom of action than they had in their army jobs.

ZHANG HONGTU *(b. 1943, Gansu Province)*

Zhang Hongtu, originally from Gansu Province, may have been the only student in the high school affiliated with Beijing's Central Academy of Fine Arts whose father had been declared a rightist in 1957. Zhang Hongtu's family was Moslem. As China's leading Arabic scholar and interpreter, Zhang's father was well versed in the Koran and had traveled to Egypt. Despite his strategically important skill, the father was denounced as a rightist. He and his family were humiliated, and he lost most of his salary.

Zhang Hongtu graduated from high school in 1964 and from the Central Academy of Arts and Crafts in 1969. He and his classmates were then sent to the countryside in Hebei Province for three years, to plant rice and be reeducated. In 1973 Zhang was assigned to the Beijing Jewelry Company, where he designed precious objects such as ornamental boxes, birds, and flowers. He only had time to paint at night or on Sundays.

Zhang Hongtu has made a brilliant series of small Beijing scenes in gouache, simplifying the urban forms with a Cubist vocabulary that combines both international and native strains. Zhang's images of the city, with their gray and red colors, remain literal (plates 121 and 122). The harmonious

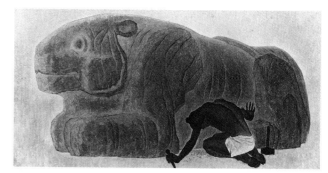

118. Zhang Hongtu. *Eternity*. 1980. Oil on canvas. Purchased from the Contemporaries' 1980 Exhibition for the National Art Gallery Collection, Beijing

In this patriotic celebration of the continuity of Chinese culture, Zhang portrayed an ancient craftsman carving a stone tiger—similar to one recently excavated from the tomb complex of the Han dynasty general Huo Qubing, near Xi'an. General Huo's stone tiger is roughly lifesize, but the tiger in the painting seems as monumental as an Egyptian sphinx because the figure of the sculptor is so small. The work also echoes the visions of nineteenth-century Romanticism.

119. Zhang Hongtu. *Orchard*. 1981. Oil on canvas

The artist poses with his cheerful canvas, which is filled with red lozenge fruits. 1982.

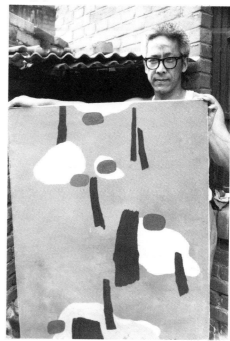

120. Wang Huaiqing. *Bole, a Wise Old Man Who Knows How to Choose Horses*. 1980. Oil on canvas. Purchased from the Contemporaries' 1980 exhibition for the National Art Gallery Collection, Beijing

In this post–Cultural Revolution Liberation narrative, wise old Bole recognizes the great potential in the white horse, which had been harnessed to a millstone. Bole's ascetic lines convey his experiential wisdom; the raised chin and searching eyes of the frontal image suggest his continuing quest for truth. The power and nobility of the horse are indicated in a tersely modeled, energetic profile. The images appear against a flat, textured ground. A faint inscription, brushed in red oracle-bone-style characters, is written across the top on a black ground.

RIGHT:
121. Zhang Hongtu. *Home*. 1982. Gouache on paper. Exhibited in *New Directions in Chinese Painting*, New York, Hammerquist Gallery, 1983

In this charming little genre scene, the house and courtyard are simplified to such an extent that they seem flattened. The flatness and the homely details give the work a primitive look. This faithful urban document has great energy, rich, true colors, and the intimacy of the traditional family courtyard.

FAR RIGHT:
122. Zhang Hongtu. *Lane*. 1982. Gouache on paper. Exhibited in *New Directions in Chinese Painting*, New York, Hammerquist Gallery, 1983

Part of a series of intimate Beijing neighborhood scenes, this gouache shows the observant artist's simplification of images into Cubist forms. Zhang's work is highly descriptive, yet it is remote from the stage sets of Socialist Realism. He has evolved a personally abstracted vocabulary that is both narrative and decorative.

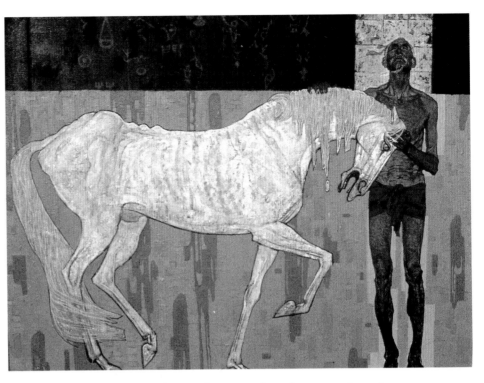

compositions are accurate, but at the same time the scenes have been transformed into works of art.

In 1982 Zhang Hongtu went to New York to study at the Art Students League, where he had won a scholarship. He has exhibited frequently in the United States, and while working there he has explored abstract forms more directly and with profound feeling.

SUN JINGBO *(b. 1945, Shandong Province)*
Sun Jingbo says that when he was a child, "the first time I saw a picture of a man with a hammer and sickle was the first time I saw 'art,' and I became very excited. There was no art teacher in the primary school of a remote Heilongjiang town,

but from time to time itinerant artists would come to teach. I had no money for lessons, so I peeked through the window to see how pictures were made." His family moved frequently, and from an art teacher in Hebei Sun heard about the high school affiliated with the Central Academy of Fine Arts. Against his father's will but with his mother's blessing, Sun applied for admission to the high school and was accepted.

After his graduation in 1964, he was sent to Yunnan along with two older alumni, Yao Zhonghua and Jiang Tiefeng. At first he was thrilled with Kunming's beautiful landscape and its fascinating minority groups. His enthusiasm diminished, however, as the horrors of the Cultural Revolution were

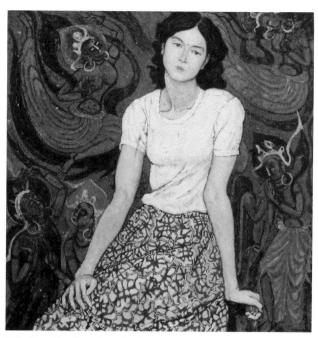

123. Sun Jingbo. *Dawei*. 1982. Oil on canvas

This appealing portrait of the artist's wife is painted in a dreamy mode, with a backdrop of the flying Apsarases of the Dunhuang murals. It reflects Sun Jingbo's foremost concerns of that time: his wife and the Dunhuang murals. When Sun Jingbo was transferred from Kunming to Beijing to attend graduate school and then teach, his wife had to remain in Kunming because of her job. She could not obtain a permit for residency in Beijing, and the separation was painful.

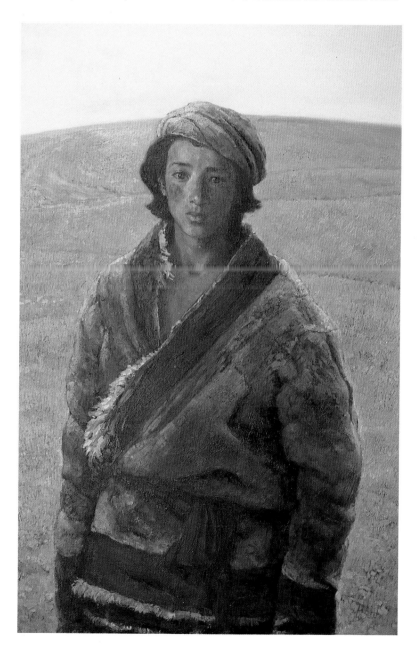

124. Sun Jingbo. *Tibetan*. 1983. Oil on canvas

Sun has spent months in Tibet: touring, sketching, and photographing these handsome people and that remarkable place. This herd boy is presented straightforwardly, with a precise beauty based on naturalism. The painting also reflects the Magic Realism of Andrew Wyeth. The particularly Tibetan aspects include the youth's features, the great sheepskin coat that almost overwhelms the figure, and the earth's curve seen in the clear air of the horizon.

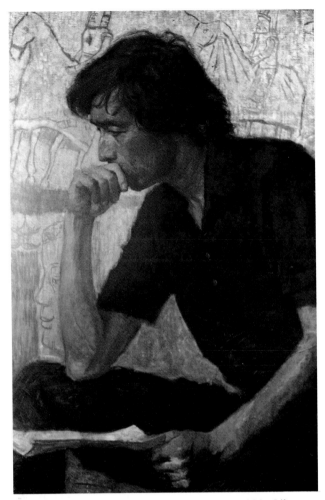

125. Bai Jingzhou. *The Thinking Generation.* 1980. Oil on canvas. Shown in the Contemporaries' Exhibition, National Art Gallery, Beijing, 1980

The brooding figure symbolizes Bai's peers, who are dubbed the "thinking generation." They, more than the first generation of Chinese Communists, have questioned the system and Marxist theory. These young people, now in their late thirties, lived through the chaos of the Cultural Revolution, and many lost the opportunity for a university education. Bai's unglamorized realism contrasts sharply with romanticized propaganda painting.

OPPOSITE, ABOVE:
126. Jiang Dahai. *Field of Flowers.* 1980. Oil on canvas. Purchased from the Contemporaries' 1980 Exhibition for the National Art Gallery Collection, Beijing

This handsomely painted academic composition of flowers and field, a path and a bridge, has the relaxed air of the New Realism. The world of Jiang and his generation is rooted in a clear vision of the current scene, expressed here in a landscape of livable scale. For them, it has been a great relief to escape from the overblown, larger-than-lifesize propaganda vision of their student days.

played out in pitched street battles. Four years of labor and reeducation in the countryside followed. Sun Jingbo had an especially bad time because he had been accused of being part of a counterrevolutionary group. But by 1972 Sun was cleared, and he returned to Kunming, where the local art association needed paintings to submit for a national exhibition. His piece was Socialist Realist propaganda, with healthy, smiling, exotically costumed young Ashi women planting rice against the deep space of rice fields, mountains, and blue sky.

Sun Jingbo missed going to an art academy because he graduated from high school just as the Cultural Revolution was about to start, but in 1978 he was able to enter the postgraduate course—somewhat comparable to a Master of Fine Arts program in the United States—at the Central Academy of Fine Arts. Upon completion, he was invited to stay on as a teacher in the mural-painting department.

Much of the subject matter of Sun Jingbo's work refers to his stay in Kunming, and he has maintained close ties with the Kunming artists—particularly the Shen She group. He has been given several commissions to do large murals in Kunming, Qufu, and Wuhan, and he frequently uses the minority people as subjects because they are colorfully costumed and officially approved of, and because he has lived among them (plate 124). Many other artists are sent to paint these exotic folk during their annual month-long art field trips. Sun's figures have an academic solidity that is a combination of romantic and earthy elements with the monumental quality of Mexican Socialist Realism. In addition to being a muralist, Sun is part of the generation of New Realists. He wears many hats, but perhaps none more important than his Contemporary one. Sun Jingbo has also experimented with a variety of Post-Impressionist and Expressionist styles. He is spending the years 1986–87 as a visiting artist in Paris.

BAI JINGZHOU *(b. 1947, Lanzhou, Gansu Province)*
Bai Jingzhou is an oil-painting member of the Contemporaries, but he is better known nationally for his frequently published serial-form picture stories, which are richly drawn in a narrative style that is both informational and dramatic. In a contest among serial illustrators, Bai was awarded the first prize for his illustrations in *The Last Lesson,* a parable widely used in Communist education that tells the story of a little Alsatian boy who was late for French class and hadn't done his homework. Just at that moment, French Alsace became German. It was his last French lesson. Even though the dramatic story was full of anti-imperialist sentiment, the authorities subsequently revoked Bai Jingzhou's first prize and gave him the second—because the subject matter was not Chinese. He was told that no picture book with foreign subject matter could win the first prize.

This was not the first time that Bai Jingzhou had faced adversity. His father had been declared a capitalist because in 1949 he had owned some trucks. In reality, his father had been a ricksha-puller and menial worker who went into the trucking business two years before the Communists took over. When Bai won a scholarship to the high school affiliated with the Beijing Central Academy of

Fine Arts, he had to declare his family background. Since his father was a "capitalist," the scholarship was not renewed. This put an impossible economic burden on Bai's father, who earned eighty yuan a month (approximately thirty-six dollars at that time) and had to support a wife and six children. In spite of the financial problem, Bai worked terribly hard and scraped through. After the Cultural Revolution, he completed the postgraduate course in the graphics department at the Central Academy of Fine Arts and was invited to join the faculty. In 1981 Bai Jingzhou successfully competed for one of the first two Chinese government scholarships for artists to study abroad. He won, and in 1982 he enrolled in a three-year Master of Fine Arts program at the University of Southern Illinois at Carbondale. In 1985 he continued his graduate education in New York.

The tone and technique of his portrait *The Thinking Generation* (plate 125) are different from those of his crisper, more idealized illustrations.

JIANG DAHAI *(b. 1947, Nanjing)*

Jiang Dahai teaches at his alma mater, the high school affiliated with the Central Academy of Fine Arts, which many Contemporaries attended. His own works, portraits and landscapes, have a fresh look, but in style, they are poised between Barbizon School painting and Post-Impressionism (plates 126 and 127). He notes that some students at the high school long to experiment in abstract art, but they are not allowed to do so in class. Apparently, students are expressing their dissatisfaction with the limitations of Chinese art education and with the lack of a museum of foreign art for study. They discuss these issues at school and paint in experimental styles at home. In 1900 Jiang attended the postgraduate program at the Central Academy of Fine Arts and went to Paris on a study tour.

SUN WEIMIN *(b. 1946, Hulin County, Heilongjiang Province)*

Sun Weimin is also an alumnus of the high school affiliated with the Central Academy of Fine Arts as well as a faculty colleague of Jiang Dahai's. Sun spent much of his life in the countryside, and that is where he loves to be. Invariably, he paints peasants in their villages with great sympathy. His ability to express on canvas the nature of country folk and the primitive life earned him a medal in the Sixth Chinese National Exhibition of 1984 (plates 128 and·129). In 1982 Sun Weimin married Nie Ou, a leading young painter at the Beijing Painting Academy, who is discussed in the chapter "Chinese Ink Painting" (pp. 135–138). In 1984 Sun entered the postgraduate program at the Central Academy of Fine Arts.

First Exhibition of Modern Art in Xi'an

The First Exhibition of Modern Art in Xi'an was one of the last private groups to have a public exhibition of modernist art in the liberalized Hundred Flowers period of 1978–80. It occurred in March, 1981, shortly after the ban on private

127. Jiang Dahai. *The Forest.* 1982. Oil on canvas

Experimenting with Post-Impressionist strokes and techniques, Jiang constructed a forest-like pattern on an undefined ground. Although the trees blow in a single direction, the work conveys the Surrealistic impression of a windless composition. This painting shows the exploratory attitude of the new generation: to work with subjects that are personal, emotional, and painterly but still recognizable.

128. Sun Weimin. *Old Man in the Mountains.* 1980. Oil on canvas

This successful young painter uses his painterly skills to record the ambiance of the countryside in a charming and somewhat naive way. His old mountain man is sagelike and the naked little grandson is a mischievous wood sprite. The green-eyed black cat is an added symbolic element. The style shares the sweet tone of Pre-Raphaelite painting, but without the trite subjects or the slick technique.

ABOVE RIGHT:
129. Sun Weimin. *Beach Boys.* 1980. Oil on canvas

Sun Weimin takes an obvious beach scene—three young boys sunning on the sand—and paints it in a way that transforms the subject into a metaphor: the muses of youth, water, and sand. Even the boy in the center, who has lost a tooth and whose smile is a smirk, does not ruin the mood.

group exhibitions and the showing of abstract art. The abstract works shown in the Oil Painting Research Association exhibition at the National Art Gallery in November, 1980, had provoked so much criticism that they became the focal point of the conservatives' aim to exclude abstract art officially from public exhibitions. Another indication of an official swing back to propaganda painting was the December, 1980, National Youth Art Exhibition, in which only works with patriotic, political subjects were included.

Xi'an is apparently far enough away from Beijing and party-line pronouncements that the local authorities did not block such an exhibition—despite the clear signals. Instead, they allowed the experimental young artists to hang by their own rope.

The group consisted of seventeen artists and poets, all in their twenties. Some of them were students at the Xi'an Academy of Fine Arts; others, including workers, teachers, and administrators, were amateurs. The only requirement for joining the group was "being true to oneself." The members were interested in creating a new art and a new literature that went beyond the prescribed forms of Socialist Realism and traditional Chinese painting and poetry. The artists expanded on the modernist styles that they knew of from books, such as Cubism, Surrealism, and even Abstract Expressionism.

Their first exhibit was to have opened on February 25, 1981, in a park pavilion. However, the necessary official approval from the Xi'an Academy of Fine Arts was not forthcoming. In March the artists were able to obtain a "small, poorly lighted hall at 339 East Street" and hold their exhibition.

130. Huang Guanyu. *Persimmon Trees*. 1979. Oil on canvas. Purchased from the Contemporaries' 1980 Exhibition for the National Art Gallery Collection, Beijing

Huang Guanyu's (b. 1949) beautifully painted orchard scene combines Post-Impressionist pointillist vocabulary with academic realism in recording the topographic details of the scene. At the time it was exhibited, it was among the first landscapes painted in a formerly taboo style to be given the official seal of approval by being purchased for the newly forming National Art Gallery Collection.

131. Zhang Jianping. *Sunset*. 1978. Oil on canvas. Purchased from the Contemporaries' 1980 Exhibition for the National Art Gallery Collection, Beijing

Zhang Jianping's (b. 1943, Beijing) handsome landscape, which features the blues and yellows of a rural sunset scene, could have been painted in homage to Renoir. It seems strange that the People's Republic has excluded Renoir's so-called sketchy style, which caused a scandal in the 1870s in Paris and was pejoratively named Impressionism. Soviet ideologues had rejected Impressionism as an approved Communist style in the 1930s because they said the Impressionists were Bohemians and therefore morally inferior. In the post-Mao period, when some would say that Impressionism is too old-fashioned for new art, it finally became an acceptable style and left everyone wondering what all the fuss was about!

132. Liu Xiaodi. *Mystery of Black.* 1980. Oil and tar on canvas. Shown in First Exhibition of Modern Art in Xi'an, 1981

In a studio storage area at the Xi'an Academy of Fine Arts, the artist stands next to his composition. Inspired by Abstract Expressionism but not understanding its medium, he has tried to express his feeling freely by dripping tar onto canvas. This work and many others were painted outside school hours and could not be considered for credit, exhibition, or publication because they are abstract.

133. Kong Changan. *Sitting.* 1981. Watercolor on paper

Kong thinks of himself as a sculptor, and his paintings show his interest in structure. Here he plays with the remnants of a skeleton and the surface and shadow of flesh. He said, unself-consciously, "I'm told my work resembles that of Henry Moore." Kong's artistic explorations are carried out in a lonely setting, where proper sculpture is defined as oversize labor or military heroes.

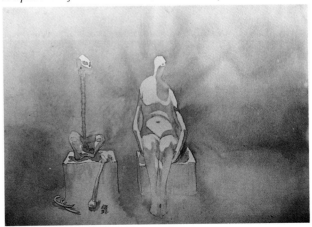

LIU XIAODI *(b. 1954, Lanzhou, Gansu Province)*

Painter Liu Xiaodi has said about his own work: "I relied on my subconscious and my usual brushstroke and color selection. I had little consciousness of composition and I didn't know what I was going to paint or when to finish. I had a strong desire to paint whatever feeling I had at that moment."

Liu Xiaodi's painting *Mystery of Black* (plate 132) was made by dripping boiling tar onto a piece of canvas that had been painted red. One colleague said that "his purpose was to express his feelings. This was the way Jackson Pollock had done it." Although it is true that Pollock "dripped," he didn't use tar. The comment highlights China's isolation from Western learning—and the potential for misunderstanding.

KONG CHANGAN *(b. 1953)*

Kong Changan, who is a sculptor, wrote of the exhibition: "Except for a few works, all of them puzzled the audience. They found it difficult to understand what the artists wanted to say. In fact, some of the paintings puzzled the artists themselves."

The First Exhibition of Modern Art in Xi'an provided five notebooks for visitors' responses. The books were filled with comments, some encouraging, but some mocking, such as: "This is not art at all!" "There is no beauty in your work; how can it be called art?" "Nightmare!" "Degenerate art." "This is China, not the West! China should have its own modern art, not this kind of trash picked up from the West!"

The young artists mused: "It is a strange phenomenon that people can be silent to thousands of new changes in most fields, but when they see new art, they have so much to say."

The artists presented their view of art: "Art is a kind of social activity, a process of high communication between the artist and his audience. The artist creates a form out of his experience or idea, which sends certain messages—and the audience is touched by these messages." They went on to observe that man explores the universe and himself; man is a complex animal with "moods, self-conscious impulses, aggression, or even, as Freud says, sexual urges. The record of man's life is the subject of art."

Upon hearing this view of the exhibition, a commentator observed: "Now I think those who just said you were from a lunatic asylum have no grounds at all."

It must be understood that Chinese society is pre-Freudian, so every aspect of this group's theory and practice was considered scandalous.

The exhibitors noted that throughout its long history, Xi'an had been famous for conservatism and slowness in accepting change, and they pointed out that the exhibition had "served as an unexpected stone thrown into a still pond." Although most of the professional artists were shocked by the exhibition and some wouldn't attend, others thought it was wonderful. Some called it trash, but others admired not so much the art but the artists' dauntless spirit that "they themselves lacked."

Members of the group were in a state of euphoria—at least for the duration of the exhibition—because of the opportunity to express themselves. They confessed to immature styles and to too much borrowing from the West, but, according to one member, they had fulfilled a passionate need to communicate the idea that "art is a product of the times; art is true and innocent and not necessarily beautiful." Nevertheless, soon after the close of the exhibition, the group was severely criticized and was not allowed to exhibit again.

Experimental Painting Exhibition

In the winter of 1983 ten young Shanghai artists, ranging in age from the twenties to the forties, all from the Shanghai Drama Academy except for one from the Shanghai Teachers College, participated in the Experimental Painting Exhibition. The group had been given official permission to exhibit, but the show was closed down by the authorities after only one and a half days. Fudan University had been selected as a venue because the artists had friends there with whom they wanted to exchange ideas about modern art and science. But, in fact, no discussion was allowed.

The exhibition was criticized in the newspapers, with some works being singled out as "imitations of capitalism." The artists became targets in the Anti-Spiritual Pollution Campaign and, had the exhibition been allowed to continue, they would have suffered gravely. That this event, which had been organized to exhibit abstract art, was carried on contrary to public policy, indicates the great pressure artists put on the establishment in order to experiment with abstract art.

In 1985, the addition of some younger art leaders and a more relaxed atmosphere encouraged the Experimental Painting group to plan another exhibition.

Two of the ten artists are discussed here. Both Li Shan and Zhang Jianjun are graduates of the Shanghai Drama Academy, and they are fine oil painters.

LI SHAN (b. 1944, Lanxi County, Heilongjiang Province)

Li Shan uses oils to paint many of the same ancient motifs that fellow Shanghai artist Qiu Deshu, organizer of the Grass Grass group, favors. Li has studied ancient Chinese pictographs, calligraphy, ceramics, and Neolithic wall paintings, all of which he has used in new combinations with international styles, especially Expressionism and Abstract Expressionism (plate 136). He is a very powerful painter—his bold strokes infuse tremendous energy into the pigment. Although he has been successful in China, except for the Experimental Painting Exhibition, he has had few opportunities to show his abstract work.

Li Shan was one of six children. Born into a poor peasant family living north of Harbin near the Soviet border, he was the first in his family to go to school. He was an outstanding student and an attractive person, and after graduation from middle school in 1963, he went for one year to Heilongjiang University in

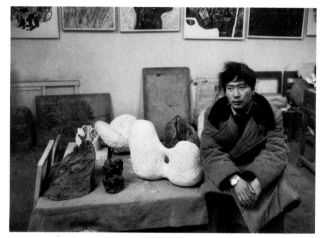

134. Li Xiaoming. Sculpture group. 1980. Plaster and wood. Shown in the First Exhibition of Modern Art in Xi'an, 1981

Li (b. 1958, Xi'an) sits next to a group of sculptures in a studio storage area at the Xi'an Academy of Fine Arts. The art establishment says that abstract pieces such as these are not understandable by the masses and therefore are not acceptable.

135. Ma Hua. *My Dream.* 1980. Ink and color on paper. Shown in the First Exhibition of Modern Art in Xi'an, 1981

Ma Hua (b. 1954, Xi'an) poses next to his Surrealist vision of hands reaching from water. Because the party does not acknowledge Freud's theories concerning dreams and the subconscious, a painting such as this is officially without meaning for Chinese and therefore not acceptable.

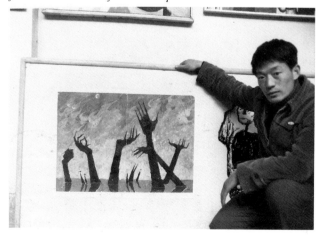

136. Li Shan. *Abstraction #1*. 1980. Oil on canvas. Exhibited in *Painting the Chinese Dream*, Smith College Museum of Art, Boston City Hall Gallery, The Brooklyn Museum, 1982–83

Li Shan's forceful gestures appear vaguely calligraphic against the undefined ground. Few Chinese artists use pigment with such authority and rhythm.

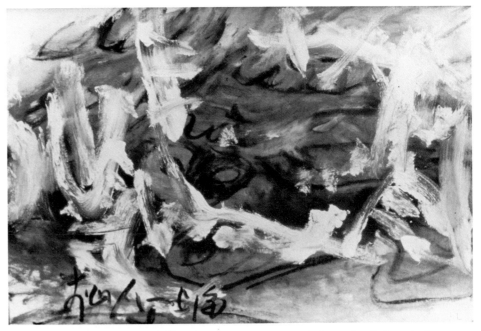

137. *Li Shan and his wife stand beside his 1980 oil painting,* Abstraction #2, *which was exhibited in* Painting the Chinese Dream, *Smith College Museum of Art, Boston City Hall Gallery, The Brooklyn Museum, 1982–83. The markings are inspired by the scroll designs found on ancient cast-bronze vessels from the Shang and Zhou dynasties. The artist has expressed these designs in a calligraphic mode.*

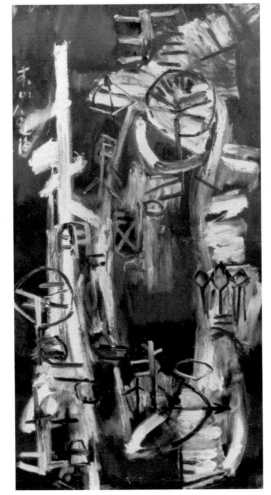

138. Li Shan. *Oracle-Bone Script*. 1980. Oil on canvas. Collection C.C.I.C. Finance Company, Hong Kong

Finding form in the most ancient Chinese script, used three thousand years ago, Li Shan created a viable painting that has inner meaning. This ancient script was found scratched on ox scapulae and tortoiseshells and it dealt with questions of sacrifice, shelter, and war.

Harbin to study Russian. But he longed to study art, and so in 1964 he applied to the only school with an art program that was admitting new students—the Shanghai Drama Academy. It is unusual in China to give up a precious place in a university; moreover, admission to the Drama Academy was uncertain at best. But in the end, Li Shan was one of three students accepted from his province.

Li Shan had seen only local folk art and a few art books before he went to Shanghai. But he already felt that "art is life itself," a variation on the Marxist line that says art comes from life and forms part of the "superstructure." Li Shan studied oil painting in the stage design department of the Drama Academy, and after graduation he joined the faculty. Since he believes that art is a "genuine expression of the artist himself," it is not surprising that his individualistic approach conflicted with Chinese art education, which conforms to the official line.

In 1969, during the Cultural Revolution, the Drama Academy's faculty, students, and staff were sent to a military farm in Zhejiang Province for almost two years of physical labor and study of Communist theory. Li Shan, despite his peasant background and the fact that he had spent his youth working in the fields, suffered, along with others of different class backgrounds, for being an intellectual.

Even though, according to Chairman Mao's criteria, he is a member of the masses, he wonders how to paint for them. He says that an artist does not paint to be appreciated; an artist must paint to express himself.

ZHANG JIANJUN *(b. 1955, Shanghai)*
In the pamphlet published for the Experimental Painting Exhibition with artists' names and statements, Zhang wrote: "I say nothing: 0)." He explained that the

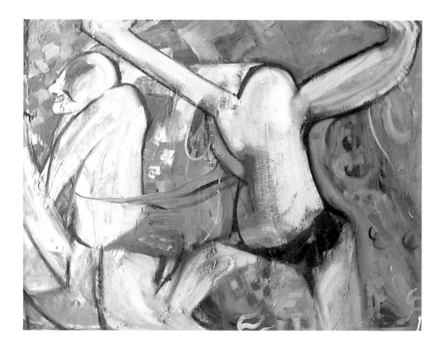

139. Zhang Jianjun. *Childhood Dream.* 1980. Oil on canvas

For several years after Zhang Jianjun graduated from the Shanghai Drama Academy, he painted his childhood dreams in a series of surreal visions of a child reaching for the stars. He says he remembers being a happy youngster, planning to study meteorology until his hopes died during the nightmare of the Cultural Revolution.

140. *Artists discuss art in the apartment-studio filled with work by Zhang Jianjun. From left: Tang Muli, Zhang Jianjun, Kong Boji, and Liu Tianwei. 1981.*

141. Zhang Jianjun. *Dao #96.* 1984. Oil on canvas

Using an austerely muted black, white, and sandy palette and a version of Synthetic Cubist vocabulary, Zhang has composed his elements with strength and balance.

circle expresses the limits of human knowledge and that the arc beside it indicates a universe beyond, as well as the interaction between the sun and moon. Zhang studies Daoist and Chan (Zen) Buddhist theories as well as modern physics, and he expresses those ideas on canvas. Like Li Shan and Qiu Deshu, he takes on the universal riddles of existence and change. At Fudan he exhibited *Time and Space*, a large, multilayered abstract canvas that was subsequently criticized.

Zhang Jianjun says that traditional Chinese painting is "too yin," too feminine in its beauty. As a man, he has to express his roaring temperament. His work reflects his intense nature, and his energy is seen even in his Dunhuang copy, *Buddha's Parinirvana* ("Introduction," plate 6).

When asked how he was able to paint abstractly and still be successful both at the Drama Academy and as a painter in the Shanghai Art Gallery, Zhang said that for a long time he painted the abstract works only at home, but that now he could be quite open. He said that he had a good relationship with his unit, and the other members don't interfere with his work.

The Twenty-eight Painters' Association

In May, 1985, Wu Xiaochang became the founding president of the Twenty-eight Painters' Association, a group of twenty-one young oil painters from the Zhejiang Academy of Fine Arts and seven from other leading art schools throughout China. Most of the painters were about twenty-five years old, but the senior member was fifty-one. Wu suggested forming the group during their month-long seminar with the famous Chinese-French painter Zhao Wuji at the Zhejiang Academy of Fine Arts. In 1981 Zhao had painted exquisite but controversial mural-size works for I. M. Pei's Fragrant Hills Hotel in Beijing.

They chose their name after Zhao Wuji declined to have the group named after him, but he remains an inspiration to all of them. From the works produced during their month together, Zhao Wuji selected fifty-eight paintings, which will be exhibited in many Chinese art academies and in Paris. The group plans to exhibit annually. Wu Xiaochang will edit Zhao's lectures for publication, and the group will write a semiannual newsletter to keep the far-flung artists in touch. The group adopted an inspirational motto, which translates awkwardly as "creation, respiration, and space."

WU XIAOCHANG *(b. 1940, Shougang County, Shandong Province)*
In a photograph taken at the age of six, Wu Xiaochang is seen dressed in a miniature army uniform. He was called a "little red devil." After Wu's father joined the People's Liberation Army in 1944, life improved for the family and they were able to settle in Shandong's liberated area. During World War II, they had been forced to leave home and wander in search of food. At an early age, Wu learned to draw in the sand because there was no paper. Wu's school taught propaganda activities, so he studied all the arts, including writing and performing plays and operas.

142. Wu Xiaochang. *Reclining Uighur Lady.* 1983. Oil on canvas

Wu Xiaochang says of this Uighur lady: "She was really a sick beggar woman whom I found beautiful. I made a two-line sketch of her in my book. When I returned home, I dressed a model in the Uighur costume and had her pose. I finished the color composition and tone from memory, but then painted gray over the whole background and told the model to go. I began again and finished in half an hour, feeling I had painted what was in my mind."

Wu Xiaochang talks of the two factors most important in the development of his art. The first was his discovery of the transparent potential in light and materials. This occurred because he had never seen a real painting or sculpture before he had academic art training. The second was inspiration from a poem about a dream of beauty by the famous revolutionary poet Ai Qing. That poem awakened childhood memories of his home in Shandong.

His paintings begin in a straightforwardly realistic way, but then they undergo a transformation through transparency and become the vision he dreamed of (plate 142).

Wu Xiaochang does what he calls "spontaneous memory painting" in oil and feels it is inspired by the muse of traditional Chinese painting.

CHINESE ART: REALISM AND BEYOND

ABOVE LEFT:

143. *Gesturing Female.* Han dynasty funerary figure.
Ceramic. Palace Museum, Beijing

*The immediacy of this kimonoed lady, one of many funerary
substitute figures with similarly authentic lifelike qualities, testifies
to the vitality of ancient Chinese realism. The lady was part of a
funerary entourage that accompanied the master into the afterlife;
she is called a substitute figure because, according to the ritual
prescription of an earlier era, humans were sacrificed for such
purposes.*

ABOVE RIGHT:

144. Xu Beihong. *Horse.* 1944. Ink on paper. Collection Mr.
Low Chuck-tiew, Hong Kong. The painting is inscribed:
"To Shao An, my elder brother. After your illness you
asked me to give you a painting. I hope this will make you
smile."

*The galloping horse, whose anatomy and foreshortening are
painted according to the canons of Western art but who is brushed
in a flowing Chinese ink style, epitomizes Xu Beihong's idea of
combining the best of East and West. Although cited as the founder
of Socialist Realism in China, Xu Beihong is best known for this
kind of painting.*

90

Realism has a long tradition in Chinese art. Seen in its earliest form as cows and deer on Shang dynasty bronze vessels, realism was fully developed by the time of the Han dynasty anthropomorphic funerary substitute figures, which were fashioned from a variety of materials (plate 143). So remarkably lifelike are those figures that it would seem as if Chinese craftsmen had always had the gift of transforming flesh into clay. For two thousand years Chinese realism was cultivated and refined into a style that bears little relationship to the Han version, though it provides authentic sources for twentieth-century forms.

The Chinese refer to Xu Beihong (1895–1953)—who in the 1920s and 1930s painted a few narrative works, gigantic in size, with large noble peasants—as the founder of Socialist Realism in China. In 1949, when the Chinese Communist party came to power, Soviet Socialist Realism became the official style of painting. The party officials then traced the origin of Socialist Realism to a "native" master, Xu Beihong, which was vital to its legitimacy.

Ye Qianyu, a famous Shanghai cartoonist of the 1930s, and Huang Zhou, of the next generation, pioneered another painting style, called Illustrator Realism, that combined Socialist Realism with popular-illustration technique.

In the early 1950s, the Chinese imitated Soviet formulas, learning how to paint darkly histrionic scenes, scenes of noble peasants, and academic landscapes based on muddy Barbizon School models. Many Chinese did not like these works; they were too gloomy. So in 1959, when Mao, through his cultural czar Zhou Yang, called for revolutionary realism and revolutionary romanticism in art, artists interpreted this to mean more color and more dynamic narrative action (plate 145). A particularly Chinese version of propaganda painting evolved, which combined the noble peasants of Xu Beihong with Illustrator Realism. Communist Chinese propaganda painting aims to educate the masses. Although, of course, if given a choice, a large number of artists would choose not to create works for propaganda.

The Chinese Socialist Realist models are brilliantly colored, grouped compositions of larger-than-life, red-faced heroes of war and peace. *The Liberation of Nanjing* (plate 146) is a quintessential example of the new revolutionary style. Columns of victorious troops march with red flags into the Nationalist capital of Nanjing. *The Liberation of Nanjing* is a collective work of artists, faculty, and students of the Nanjing Academy of Art.

The Chinese version of Romantic Realism lived side by side with Xu Beihong's

145. Liaoning Provincial Propaganda Artistic Group.
Chairman Mao Views Fushan Coal Mine. 1972. Oil on canvas

This political propaganda ideal of the Cultural Revolution shows the heroic scale and dramatically built-up grouping of Socialist Realist heroes adopted from the Soviet style. But it also shows how the Chinese have followed their own taste by adding color. The painting leaves no doubt about the perfect virtue of their heroes, able to triumph over any obstacle. This work is an official response to Mao's call for romantic and revolutionary realism.

LEFT BELOW: Comp # 169
146. Collective work by students and faculty at the Nanjing Academy of Art. *The Liberation of Nanjing.* 1970s. Oil on canvas. Nanjing Museum

This glorious recounting of history illustrates the liberation of the Nationalist capital. It occurred on a bright sunny day, carried out by spotlessly neat soldiers who cast shadows on the vanquished presidential palace, which they have mounted. The victorious soldiers profiled against the blue sky, the perfectly formed marching columns, and the vivid red flags accent the baroquely angled composition, in which the sense of deep space is balanced by the sky, which occupies one-third of the canvas.

147. *One of the standard cast-Fiberglas sculptures of Chairman Mao Zedong, this stands in the center of the Shanghai Drama Academy campus. The inscription on the base reads: "The great leader and teacher, Chairman Mao, will never die." Modeled on Soviet Socialist Realist prototypes, Mao's massive form suggests his strength, and despite the difference in the angle, his outstretched hand recalls the Buddha's gesture of reassurance. During the height of the Cultural Revolution, virtually every work unit in China had an image of Chairman Mao, which seemed to be worshiped in the manner of a cult image. As the tides of revolutionary fervor receded, especially after Mao's death, a more earthly reassessment took place, and the number of his images decreased dramatically.*

more academic vision of Socialist Realism. In Xu's well-known ink painting of 1940, *Yu Gong Moving the Mountain*, one can identify the features: Scantily clad Atlas-like mountain movers reveal their muscle-bound anatomies in a huge narrative painting of a dozen people. The hardy labor heroes have beards and body hair—the earthy qualities of peasants—yet the sizes and poses suggest that they are extraordinary giants. They and their progeny have been called upon by a "foolish old man" to achieve the awesome task of moving a mountain. This folktale of man's determination over nature became a political call to action when Mao Zedong used it as an example of how generations of Chinese Communists would overpower imperialism, bureaucratic capitalism, and feudalism.

ABOVE LEFT:

148. Zeng Shanqing. *Fisherman.* 1962. Charcoal on paper. Exhibited at the Central Academy of Fine Arts Gallery and the National Art Gallery, Beijing, 1962–63

Charcoal sketching to create chiaroscuro effects of modeling in light and shade and the illusion of three-dimensional space is the most basic skill learned by all Chinese artists. Achieving a likeness to record nature accurately is also emphasized. Moreover, the peasant subject is a must; according to Mao, the Communist revolution is to be portrayed through the working classes. Despite his skillful offerings, Zeng was severely criticized in 1963 for making his subjects "ugly."

ABOVE RIGHT:

149. Zeng Shanqing. *Tibetan Woman.* 1980. Ink on paper

Brush and ink have been used for almost two thousand years and have come to be the most characteristic Chinese materials. A natural extension of calligraphy learned by all cognoscenti, brush-and-ink technique is understood to be an expression of character. All artists develop this skill in their basic art education. Using minority people as subject matter, especially those enjoying the fruits of modern life such as watches, is national policy.

FAR RIGHT:

150. *This giant stone soldier is a replacement for one destroyed during the Cultural Revolution. It was rebuilt in 1980 by Pan He (b. 1926, Guangzhou) and Liang Mingchen (b. 1939, Nanxiong County, Guangdong Province) and stands in the middle of Guangzhou's Haizhu Square. The sculpture embodies the super-strong socialist hero, who fought the oppressors with his gun but could graciously accept a bouquet of flowers acknowledging his success.*

The spirit of Xu's painting has been taken up by politically active artists. Liu Chunhua, for example, is often described as "the only painter in China during the Cultural Revolution," when almost all other painters were in the countryside being reeducated. In a 1982 painting of a porter climbing a mountain while carrying two large baskets on a bamboo pole, Liu depicts, in monumental size, a peasant with a powerful, athletic physique. The peasant climbs at a sharp angle, with the ends of his loincloth flying behind in a dramatic flourish. Liu's brushstroke suggests the porter's anatomy in a style unseen in traditional Chinese paintings.

ZENG SHANQING *(b. 1932, Beijing)*

Zeng Shanqing, a professor at the Central Academy of Fine Arts, studied with Xu Beihong, who had taught charcoal sketching in the French academic manner. However, in the Soviet system, adopted by the Chinese, a far more precise and detailed pencil-sketching method was required. Both systems

emphasized the evocation of rounded forms, using chiaroscuro technique. Zeng's work demonstrates the two drawing styles taught to all Chinese artists. *Fisherman* (plate 148) is a charcoal sketch and *Tibetan Woman* (plate 149) is done in the traditional Chinese ink-drawing style. Zeng is a master of both techniques, and he portrays the officially encouraged subjects: peasants and minority people.

Socialist Realist painting has also been used to bolster the political leadership. Chairman Mao is virtually the only Chinese political leader whose portrait was shown during the Cultural Revolution, along with his spiritual—but foreign—ancestors, Marx, Engels, Lenin, and Stalin. Mao was pictured at his ideal and romantic best: as a dashing young man with a dreamlike countenance, in long gown and flying scarf, or as a vigorous, red-faced leader of the masses.

The double portrait of the dying Premier Zhou Enlai visited by his chosen heir, Deng Xiaoping, legitimizes the transfer of power. *Old Friends and Revolutionaries* (plate 154) was painted by Xiao Feng in 1979 when he was the head of the Shanghai Painting Academy, before he became deputy director of the Zhejiang Academy of Fine Arts in the early 1980s. In 1978, before Deng's accession to power in December (at the Third Plenum of the Eleventh Meeting of the Central Committee of the Communist party), similar political-succession portraits of Mao Zedong with Hua Guofeng were current. One version illustrated the famous phrase supposedly uttered by Mao: "With you in charge, I'm at ease." One of the first signs of Hua's fading star was the removal of these paintings.

151. Jin Shangyi. *Qu Qiubai in Prison.* 1984. Oil on canvas. Shown at the Sixth Chinese National Exhibition, Shenyang, 1984

This outstanding example of academic painting by the deputy director of the Central Academy of Fine Arts and OPRA member Jin Shangyi (b. 1937, Jiaozuo County, Honan Province) features a historical subject. Qu Qiubai was considered a renegade during the Cultural Revolution, thus this recently rehabilitated hero was a favored historical-political subject for a national exhibition. Qu was one of the founders of the Chinese Communist party and was its first chairman, before Mao. He was imprisoned by the Nationalists, and later he stayed in Fujian to fight them while Mao and his followers escaped on the Long March. Qu was captured and shot. Here he is shown in prison, thoughtful and leaning off-center, symbolic of the psychological drama. The grayed composition suggests the austere circumstances and the gloomy tale. The figure, shadows, surfaces, and hands are all handled with consummate skill, a testament to the sinicization of academic oil painting and to the artist's mastery.

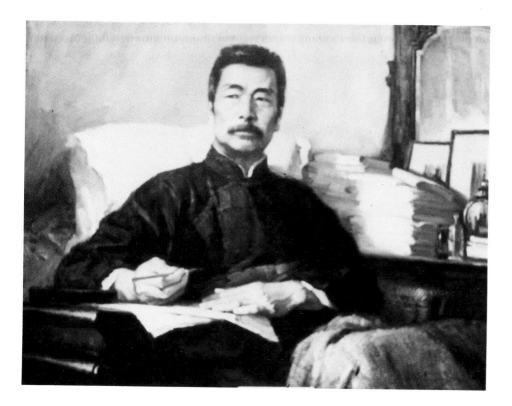

152. Tang Xiaoming. *Never Stop Fighting.* 1972. Oil on canvas

During the 1920s and 1930s, Lu Xun, the subject of this portrait, wrote biting parodies attacking the evils of the Chinese feudal system. In his crusade against social and political oppression, he encouraged artists and writers to use their crafts to popularize the cause. After his premature death, he became canonized as the Communist art muse. The viewer looks up at a square-jawed visionary, cast in the Socialist Realist formula for heroes.

159. Zhu Weimin. *Poor Peasant's Daughter.* 1979. Oil on paperboard

Zhu Weimin (b. 1932, Shanghai) was accused of being a rightist in 1957 because of his interest in Post-Impressionism and was sent to prison for ten years. He escaped and spent the next ten years wandering all through Xinjiang, where he met many Uighurs who befriended him. He came to admire them, and he painted their houses and their portraits. When he was rehabilitated and restored to his teaching post at Beijing's People's University, ironically, his Post-Impressionist portraits were completely acceptable due to the change in the party line.

154. Xiao Feng. *Old Friends and Revolutionaries.* 1979. Oil on canvas. Exhibited at the Shanghai Painting Academy, 1980

The artist Xiao Feng, currently deputy director of the Zhejiang Academy of Fine Arts, painted this formula political piece when he was at the Shanghai Painting Academy. It is the visualization of the legitimate transfer of the revolutionary mantle from Zhou Enlai to Deng Xiaoping. The beloved Premier Zhou is painted as firm and wise in spite of his mortal illness, and the elderly Deng Xiaoping is made to look like a youthful successor.

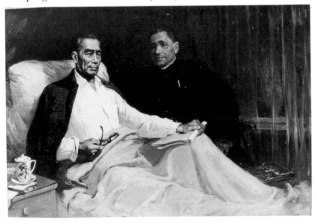

Illustrator Realists

Illustrator Realism was a significant component in the sinicizing of Soviet Socialist Realism. Considering the origins of Chinese Communist art, it is not surprising to find that the principal artists were revolutionaries who fought with ink as well as with guns. Their popular narrative style, drawn from newspaper and magazine illustrations, is romantically realistic.

YE QIANYU (b. 1907, Tonglu County, Zhejiang Province)

The genial and extraordinarily successful Ye Qianyu is chairman of the traditional Chinese painting department at the Central Academy of Fine Arts as well as vice-chairman of the Chinese National Artists Association. Such high leadership posts reflect his long-standing devotion to the Communist cause, beginning in the 1930s, when he was a popular Shanghai cartoonist.

Ye Qianyu had no formal art training; he developed his natural ability through sketching from life. He became famous in the 1930s for the cartoon serial *Mr. Wang and Xiao Chen*, which featured two ordinary city dwellers confronting the backward, semifeudal, semicolonial conditions of China. Another famous series, titled *Notes from Heaven*, is based on observations made during travels to the United States in the 1940s. In 1947, Ye Qianyu returned to China to teach traditional painting at the Beiping Art College.

Ye Qianyu gave up cartooning in 1949 and applied his skills to making quick sketches from life. His rich knowledge of popular graphic art helped him develop an energetic, cartoon-like style that has the flavor of naive art. In a patriotic work called *Celebrating National Unity*, done in traditional ink and color, he depicted a panorama of Beijing's ceremonial square, Tiananmen, crammed with political leaders, ardent flag-wavers, and masses of paraders. As Ye refined his style, he incorporated aspects of fashion illustration. His subjects include posturing Indian dancers (plate 156), Chinese dancers with flying sleeves, and gesturing Tibetan scarf-dancers. All of the figures are handsome specimens, gracefully elongated, with generalized features. The naturalness and immediacy of his quick sketches are frozen in the final painting.

Today, Ye has ideas about reforming the teaching of traditional painting. He feels that too much educational time and emphasis are spent on learning chiaroscuro pencil drawing, which, he says, inhibits the development of Chinese-style painting.

Ye Qianyu's cheerful paintings belie his suffering during the Cultural Revolution, when he was kept in solitary confinement for seven years, from 1969 until 1976. He was accused of being an agent of the Nationalists and the Americans, but these charges were based on guilt by association: Ye had worked with an anti-Japanese propaganda team in collaboration with Nationalists, and during the 1940s he had visited the United States on a cultural-exchange program. Nevertheless, Ye said that the abuse he suffered from the Red Guards at the Central Academy between 1966 and 1969 was worse than being in prison.

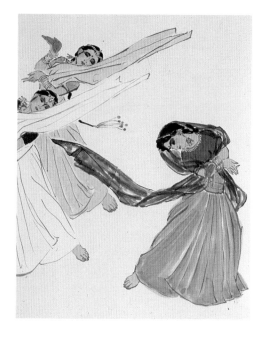

Twice, the Red Guards had forced him to kneel while he was beaten in public, and he was frequently kicked and pummeled in private. Ye was forced to crawl on the floor and was beaten with belts, as in the scene in Zhang Songnan's painting *Peasants Look Back on Half a Century: 1966* (plate 166).

HUANG ZHOU *(b. 1925, Lixian County, Hebei Province)*

Huang Zhou, like Ye Qianyu, had no professional art-school training; he also sketched from life and was influenced by 1940s magazine illustrations and by traditional painting. His use of traditional Chinese brush and ink technique and his political background helped him to become a part of the select circle of modern masters of traditional painting. Huang Zhou is a very popular artist. Masses of people mob his exhibitions to see the dark-eyed beauties with big breasts and small waists, dressed in the costumes of minority people (plate 157).

155. *Ye Qianyu uses traditional Chinese brushes, ink, color, and paper in the manner inherited from the old masters. 1980.*

ABOVE LEFT:
156. Ye Qianyu. *Indian Dancers.* 1982. Ink and color on paper

Ye Qianyu seeks the decisive moment of action in the dance and suspends the instant in an illustrative composition. The immediacy of his sketches from life is formalized into a decorative painting. Ye visited India in the 1940s, and Indian dancers—as well as other dancers—have been his favorite subject.

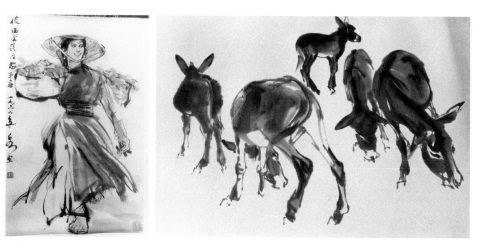

FAR LEFT:
157. Huang Zhou. *Southern Peasant Woman.* Ink and color on paper. Private collection, Hong Kong

This smiling beauty carries her yoke with such energy and style that she seems like a fashion model on a runway. Her broad shoulders, body angle, and toothy smile suggest that her prototype was a 1940s glamour girl as seen in Soviet movie magazines. But the straw hat firmly identifies the figure as being from South China. That she is a peasant is indicated by her big bare feet.

LEFT:
158. Huang Zhou. Detail of *One Hundred Donkeys.* 1979. Hand scroll; ink on paper

Huang Zhou selected donkeys as his hallmark just as Xu Beihong used horses. This version, similar to the scrolls he made to be presented as state gifts, shows donkeys in every imaginable position.

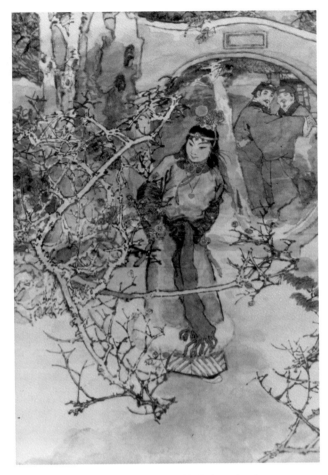

159. Dai Dunbang. *Jia Baoyu.* 1980. Ink and color on paper

This illustration was made for an edition of The Dream of the Red Chamber, *a classic of Chinese vernacular literature. Dai infuses his old-world scenes with lively figures and a wealth of carefully researched details. Such illustration puts an indelible mark on the conscious images of history.*

In 1978 party officials chose his paintings of donkeys to present as state gifts to President Tito of Yugoslavia and Emperor Hirohito of Japan.

Although Huang Zhou did not go to art school, he did have some lessons in Chinese painting while he was growing up in Xi'an, a sad and difficult time because of the death of his father when Huang was only fourteen. In 1949, he joined the People's Liberation Army and sketched while traveling in the Northwest among national minorities such as Tibetans, Kazaks, and especially Uighurs, a Turkic group who settled in that region two thousand years ago and who are his favorite subjects. In 1956 Huang rose to prominence when his painting *Snow Storm in the Desert* won the gold medal in the Communist International Youth Festival. In later years, in Beijing, he expanded his vision by studying the traditional Chinese masters, and he also became an avid collector of old paintings. He chose the donkey as his trademark, just as Xu Beihong had chosen the horse as his (plate 158). Ironically, during the Cultural Revolution, Huang was forced to drive a donkey cart while collecting night soil. He also had to clean lavatories and sweep streets during his seven years of forced labor. Huang has never regained his health since this experience, and he remains a semi-invalid.

His painting of a girl and a water buffalo was denounced in the 1974 Black Paintings exhibition because the girl is looking at wildfowl flying west, which supposedly implied that China's youth admire Western things. Despite his difficulty, Huang Zhou said the charge was so silly that he couldn't help laughing about it.

DAI DUNBANG *(b. 1938, Shanghai)*

Dai Dunbang attended the high school affiliated with the Shanghai Teachers College and began his artistic career as a book illustrator. He does research for the theater and sketches directly from historical materials. He is famous for his illustration of an edition of a Chinese classic, *The Dream of the Red Chamber* (plate 159), and for *Outlaws of the Marsh*, in which he created authentic historical settings. Dai Dunbang is recognized as a leading figure painter whose style ranges from disembodied moon fairies to earthy warriors. Because all his subjects have such a credible quality, he is included among the Illustrator Realists. Dai participated in the Grass Grass exhibition at Spring Festival, 1980. He teaches at Jiaotong University's Institute of Technology but dreams of devoting full time to Chinese painting.

Realism and the New Generation

ZHANG SONGNAN *(b. 1942, Shanghai)*

Zhang Songnan's Socialist Realist Expressionism is inspired by the Mexican muralists. In 1982 he took leave from his teaching post in the wall-painting department of the Central Academy of Fine Arts, his alma mater, and studied in Europe. After his graduation in 1964, Zhang was assigned to teach at the high

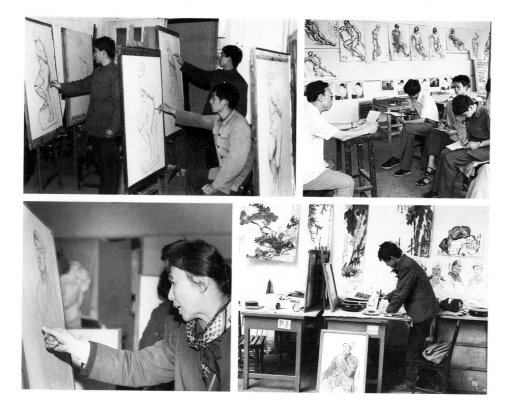

160. *These students at the Central Academy of Fine Arts sketch from plaster casts of classical Greek sculpture as part of their art education. Such practices, required of all Chinese art students, are adapted from the traditional European academic methods. Mastery of chiaroscuro drawing and deep-space perspective is deemed essential. The educational debate revolves around the selection of materials and areas of concentration. The Soviets emphasize precise pencil sketching, whereas in the Western European technique, charcoal is favored. How to employ these exercises—for how many hours a week, and for how many years—continues to be debated. 1979.*

161. *Art students take notes at the Guangzhou Academy of Fine Arts, one of the four regional art academies established in the People's Republic. Samples of their work from a life-drawing class show a high standard of skill in this exercise.*

162. *Students specializing in traditional Chinese painting receive basic training similar to that of students who specialize in oil painting; they learn deep-space perspective, chiaroscuro drawing, drawing from models, and rendering a likeness in portraits. These skills were alien to Chinese ink painters of the past, and their introduction has completely transformed the nature of contemporary traditional painting.*

163. *Artist-teacher Zhao Youping gives her students criticism during a drawing class at the Central Academy of Fine Arts. Accurate anatomical rendering and getting a likeness in portraits are key points in Chinese art education.*

school affiliated with the Central Academy. However, upon reporting for work, he was sent to a Beijing district propaganda unit, where he worked from 1964 until 1978. In 1964 he had passed the examination for the graduate program at the Central Academy, but the program was canceled as Mao's forces prepared for the Cultural Revolution. In 1978 Zhang had to take the examination again to enter the same course when it was reinstituted after fourteen years. Finally, he was able to complete his art education.

Zhang Songnan says that during the fourteen years he spent doing propaganda work, he learned a lot about how to make his work understandable to the masses. Because peasants had made him realize how hard it was for them to understand Chinese history, he adopted a sequential format for the painting that marked the culmination of his graduate training, *Peasants Look Back on Half a Century* (plates 164, 165, 166, 167, and 168). He divided the painting into six round-topped rectangular panels, each representing a decade, starting in 1936.

Each panel contains a deeply hued foreground group of figures that set the theme; other scenes in muted tones are arranged in back and above. The figures in the flashbacks have been reduced to single planes and have a quasi-Cubist quality.

Zhang Songnan feels the greatest disadvantage for Chinese artists is the lack of regular access to foreign art. He and his peers long for the opportunity to see art from beyond China, but few have a chance to tour and study abroad. Zhang Songnan courageously states that officials would block the establishment of a

164. Zhang Songnan. *Peasants Look Back on Half a Century: 1936*. 1980. The first of six panels, oil on canvas. Shown in the Graduation Exhibition, Central Academy of Fine Arts Gallery, Beijing, 1980

This first of six panels representing six decades of Chinese history shows the terrible conditions in China in 1936. Begging for survival, a starving and homeless mother and child wander in a landscape torn by civil war and foreign invasion.

165. Zhang Songnan. *Peasants Look Back on Half a Century: 1946*. 1980. The second of six panels, oil on canvas. Shown in the Graduation Exhibition, Central Academy of Fine Arts Gallery, Beijing, 1980

After World War II, with China rid of the foreign invaders, the wounded and impoverished peasants present a pitiable picture in the foreground. However, beribboned Communist heroes, standing in the background among the masses, promise a brighter future.

166. Zhang Songnan. *Peasants Look Back on Half a Century: 1966*. 1980. The fourth of six panels, oil on canvas. Shown in the Graduation Exhibition, Central Academy of Fine Arts Gallery, Beijing, 1980

In this panel, Red Guards have whipped an intellectual with a belt. The crouching victim wears a plaque stating that he is a Black Labor Hero, which means that he is identified as a capitalist counterrevolutionary, the class enemy to workers, peasants, and soldiers. It is a cameo portrait of the violence and inhumanity that characterized the Cultural Revolution. The strong images of villain and victim are on the front of the picture plane while the action-filled crowd in the background is depicted in a quasi-Cubist manner.

167. Zhang Songnan. *Peasants Look Back on Half a Century: 1976*. 1980. The fifth of six panels, oil on canvas. Shown in the Graduation Exhibition, Central Academy of Fine Arts Gallery, Beijing, 1980

The Monkey King defeats the White Bone Demon in the foreground, a favorite scene in a popular Chinese opera. It is performed before keenly appreciative peasants who are transformed into a parade of children, workers, and soldiers with lanterns and commemorative wreaths. The Demon symbolizes Jiang Qing and her fall from power following her arrest as part of the Gang of Four. The Chinese people enjoy their own identification with the Monkey King, a cunning and powerful antiestablishmentarian.

168. Zhang Songnan. *Peasants Look Back on Half a Century: 1986*. 1980. The sixth of six panels, oil on canvas. Shown in the Graduation Exhibition, Central Academy of Fine Arts Gallery, Beijing, 1980

The youth of China dream of the future of new China.

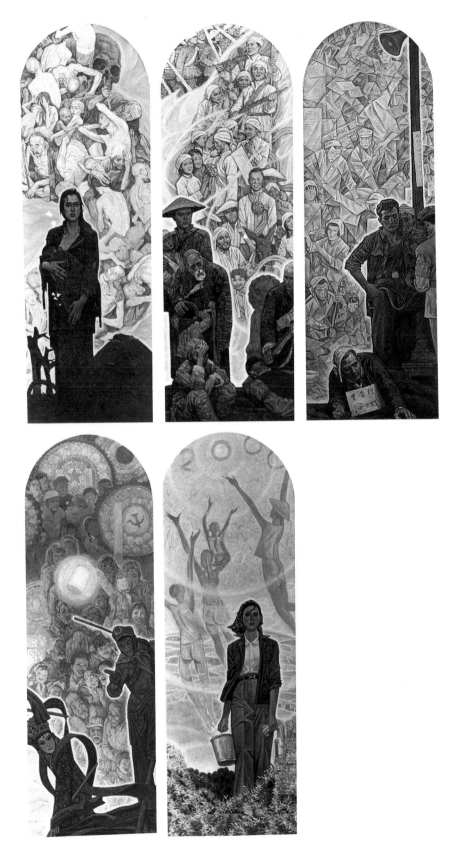

museum of foreign art in China. Yet his views on art in China generally correspond with the political line. In commenting about the post–Cultural Revolution art scene, Zhang says private groups are acceptable, but he doesn't like the Star Star group because their artists are too pessimistic about society.

CHEN YIFEI *(b. 1946, Zhenhai, Zhejiang Province)*

Oil painter Chen Yifei is an outstanding example of a new-generation realist. A rising star of the Shanghai Painting Academy, Chen Yifei went to New York to study for his Master of Fine Arts degree at Hunter College and is currently enjoying success in the United States. During 1983, 1984, and 1986, in one-man shows in New York and other American cities, his paintings sold for extraordinarily high prices.

Chen Yifei's technique is remarkable. At the Shanghai Painting Academy, he was trained in the academic style by Chinese masters who had studied in France in the 1920s and 1930s and also in the Socialist Realist style adapted from the Soviets. His portraits are incisive, with psychological depth and a crisp style.

A true child of revolutionary China, Chen Yifei spent most of his life in Shanghai and had never been outside China until his arrival in the United States in 1981. "My father said artists are always poor. He wanted me to study chemical engineering and follow in his footsteps," Chen remembers. But his parents, both intellectuals, were unable to discourage him from pursuing his artistic interests.

Chen Yifei demonstrated his talents at the Shanghai Painting Academy, and after his graduation in 1965, he was one of the founding members of the oil-painting and sculpture section of the academy. The other section is devoted to traditional Chinese painting and calligraphy.

According to Chen's account of the Cultural Revolution, he found refuge in his dormitory at the academy and painted by day. But, he says, at night he returned to the home of his parents, who were being hounded by Red Guards and accused of capitalist crimes. A few years after the Cultural Revolution ended, they both died as a result of this harassment.

Yet Chen Yifei's optimism and patriotism were not snuffed out. In 1972 he produced a large canvas, *The Yellow River,* inspired by a piano concerto of the same name. In Chen's painting, a lone soldier stands on the Great Wall as the Yellow River flows across the distant plains. The work looks like the perfect Socialist Realist painting, epitomizing the romantic realism and revolutionary spirit called for by Mao. But in 1972, the painting was rejected for exhibition because the Yellow River's color was too gray—thus, not sufficiently idealized. It wasn't publicly exhibited until 1978.

Chen's other paintings from that time were also criticized because his depiction of soldiers was too realistic, too gritty. But Chen Yifei stuck to a style he thought was right. In 1977, after the fall of the Gang of Four, the Military Museum in Beijing commissioned him and his colleague Wei Jingshan to paint *The Red Flag* (plate 169), to celebrate the victorious flag-raising that took place after the liberation of Chiang Kai-shek's Nanjing residence. The painting

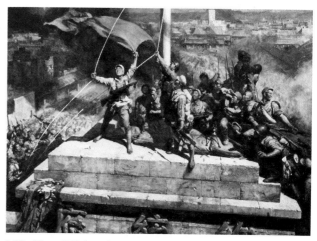

169. Chen Yifei and Wei Jingshan. *The Red Flag.* 1977. Oil on canvas. Military Museum, Beijing

In a fluent version of Socialist Realism these two promising young artists created a propaganda painting for the Military Museum to commemorate the liberation of Nanjing and the raising of the flag on Chiang Kai-shek's former residence. When the painting plan was reviewed some officials tried to interfere, objecting to the soldiers' dirty uniforms and the peasants' shaved heads. They said that "art should be higher than life," but Chen completed the picture without compromise.

170. Chen Yifei. *Man with Glasses* (portrait of Wu Jian). 1979. Oil on canvas. Shown in the Spring Festival Exhibition, Shanghai Artists Association, 1980; *Painting the Chinese Dream,* Smith College Museum of Art, Boston City Hall Gallery, The Brooklyn Museum, 1982–83

Chen Yifei's remarkable gift for capturing a likeness and his bravado brushwork combine to produce a strongly alert, appealing image.

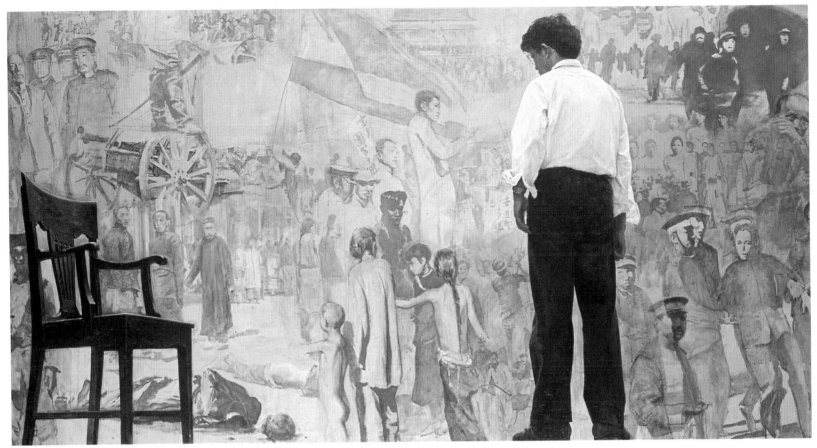

171. Chen Yifei, assisted by Han Xin. *Looking at History from My Space.* 1979. Oil on canvas. Exhibited at the Shanghai Painting Academy, 1980; *Painting the Chinese Dream*, The Brooklyn Museum, 1983; Hammer Galleries, New York, 1983

The strongly painted image of the artist and his chair stands on the picture plane while he watches video-like scenes from modern Chinese history. The events are painted in a patchwork of pale, translucent scenes that resemble faded documents. Chen Yifei allows history to reveal itself through authentic photographic images, yet that the artist put himself into history, even as a viewer, was controversial. It was thought to be egotistical by hard-liners.

provides a useful comparison to the rosiness of *The Liberation of Nanjing* (plate 146). The difference between the two paintings exemplifies the continuing controversy over just how real realism should be. Chen Yifei's *Looking at History from My Space* (plate 171) is free of the superpatriotic formulations of Socialist Realism. The artist steps aside to allow history to reveal itself through authentic photographic images.

Chen's surfaces have changed dramatically since he has been in the West and studied Western masterpieces firsthand. His brushstrokes are more discreet and he uses thinner paint. For example, his 1982–83 landscapes of Chinese canal cities, especially Suzhou, incorporate the peaceful vision of the Barbizon School with the glowing colors of the Impressionists.

TANG MULI *(b. 1947, Shanghai)*

A gifted survivor of the Cultural Revolution, Tang Muli studied at the Central Academy of Fine Arts as a graduate student in oil painting from 1979 until 1981. He was subsequently awarded a Chinese government scholarship to study abroad, and he then received a British Council Fellowship to attend the Royal College of Art in London from 1981 until 1984.

While in China and under the spell of Russian Grand Manner painting, Tang

Muli concentrated his energies on academic compositions, complete with romantic flourishes, as well as on bravado portraits in the mode of John Singer Sargent. At the Central Academy, he painted from standard models with such energy and enthusiasm that the work conveys a refreshing quality (plate 172).

At Tang's graduation exhibition, his melodramatic painting, *Shang Yu Mourning the Death of Yu Ji,* attracted more attention than any of the other student work because of its fantastic qualities. The Baroque composition features an alluring—but dead—concubine who lies horizontally across the foreground. A filmy gown enhances her voluptuous form. In anguish, the defeated king bends over his lost love, forming a central triangle in the composition. Overturned bronzes and lacquer bowls lie in the foreground, and in the background, smoke and fragments of cloth emphasize the devastation.

Tang Muli comes by his predilection for drama naturally: his parents are filmmakers. Tang's father, a well-known director, was badly beaten during the Cultural Revolution while more than ten thousand people watched, including young Tang, who was forced to witness his father's humiliation.

Because of the Cultural Revolution, Tang Muli had no chance to attend an undergraduate art college, and he was assigned to work first in a dairy-farm commune outside Shanghai and then as a designer for the Shanghai Agricultural Exhibition.

During his time in London, Tang Muli immersed himself in his studies, and later he traveled in Europe, the Americas, Asia, and Africa, taking the opportunity to visit as many museums as possible. He did not know whether this trip might be his only opportunity to see the rest of the world before returning to his teaching post at the Central Academy of Fine Arts. In fact, he returned to the United States in 1985 to become artist-in-residence at Cornell University in Ithaca, New York.

ZHANG HONGNIAN *(b. 1949, Nanjing)*

Zhang Hongnian, a leading oil painter in China, is a member of the Beijing Painting Academy, where he devotes all of his time to painting. Like the Shanghai Painting Academy, the Beijing Painting Academy has both oil-painting and traditional ink-painting sections; it is also a municipal government work unit. In addition, Zhang Hongnian is a member of a prestigious private group, the Oil Painting Research Association, as well as of the up-and-coming Contemporaries group. Zhang went to the City University of New York as a graduate student in 1985. His work has been widely shown and published in China and abroad and was very successful in New York in 1986.

Zhang Hongnian excels in oil portraits as well as in paintings with historical subjects. In many ways his work parallels that of Chen Yifei. In fact, about 1978, both artists simultaneously developed distinctively different "flashback" styles for historical paintings. At that time, the flashback as a storytelling device became popular in literature, film, dance, and drama. Zhang Hongnian's *Deep Feeling for the Land* (plate 173), exhibited on October 1, 1979, in honor of the thirtieth anniversary of the PRC, exemplifies his flashback style.

172. Tang Muli. *Nude with Apples.* 1979. Oil on canvas

At his best when painting in the academic style and from a model, Tang gives new life to the old formula. Here he gave rein to his fantasy, endowing the young woman with nymphlike qualities, yet still recording a brilliantly accurate likeness. He strives for a flourish as well as a likeness.

173. Zhang Hongnian. *Deep Feeling for the Land*. 1979. Oil on canvas. Shown in the Thirtieth Anniversary Exhibition, National Art Gallery, Beijing, 1979

Two young people at the right survey the dam site. The dam, lower left, has made possible a bountiful harvest, shown in center and upper right. In the upper left is a flashback vision of people dying because of drought before the dam was built. This painting has quintessential post-Mao features. Giant labor heroes have been replaced by earnest urban types: an eye-catching sweater girl and a male in a long coat, which is what cadres wear. The heroine presents a dramatically feminine contrast to Jiang Qing's insistently unisex, red-faced labor heroines of the Cultural Revolution.

RIGHT:
174. Zhang Hongnian. *Thinking of the Source*. 1981. Oil on canvas. Shown in Beijing Painting Academy Twenty-fifth Anniversary Exhibition, National Art Gallery, 1982

In this autobiographical painting the central scene honors the artist's mother as creator. She holds the glowing baby—the protagonist. Other scenes are fitted into the simultaneous narrative in a distinctive flashback style: above center, the mother holds the baby; he walks with his parents and siblings by a river on the left; on the right, the artist as a young man sits in a field with the woman who will be his wife; in the upper right corner, a tree symbolizes the family. The painting is skillful and touching.

FAR RIGHT:
175. Zhang Hongnian. *Portrait of the Artist's Wife*. 1981. Oil on canvas

Zhang poses with his wife, Li Xin. A notable ability to convey a likeness, fine technique, and a slightly off-center, concentrated composition all work to make this an outstanding performance.

CHEN DANQING (b. 1953, Shanghai)

Chen Danqing paints with objectivity and forthrightness. The youngest member of the Contemporaries, he is admired not only for his paintings but also for his spirit. He has survived overwhelming adversity. The realism in Chen Danqing's oil paintings is both freshly observant and classically composed. His figures, painted in rich earth tones, have a haunting beauty. Chen records his Tibetan subjects; he does not glamorize them. They are naturally endowed with unusually handsome features, and their daily wear is an exotic combination of furs and jewelry (plates 176 and 177).

Chen seeks to reveal life's hardships as well as express an earthy humor. He has created scenes of the high Tibetan plateau—coming to town, marketing, worshiping, herding sheep, and reaching out, shyly and awkwardly, to a would-be mate—that make the viewer feel as if he were really there.

Chen's father was labeled a rightist in 1957. Because of this disgrace, young Chen was discriminated against in many ways. He was a promising swimmer, but he was told not to return for team practice. He was also denied access to the local Children's Palace, which offered art classes and other extracurricular instruction to the children of the elite. But his father taught him many things about art and culture that enriched his education. When the Cultural Revolution began in 1966, his home was wrecked by the Red Guards, who seized the family's possessions, including all their books and personal papers.

Along with thousands of urban youths, Chen was sent to the countryside in 1970 to work with the peasants, but he never stopped painting. Eventually his talent was recognized. After three years of decorating coffins in rural Jiangxi Province, he was able to move close to Nanjing—with the help of a fellow art student, Huang Suning, who recognized his gifts. A woman of unusual

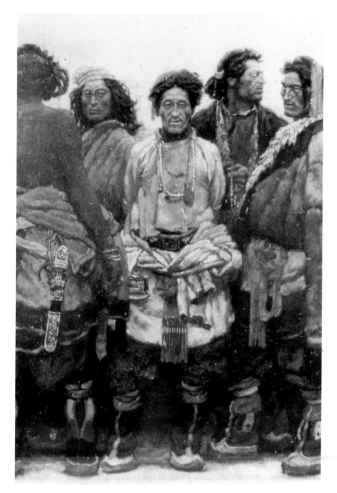

176. Chen Danqing. *Five Tibetan Cowboys.* 1980. Oil on canvas. Exhibited at the Central Academy of Fine Arts Gallery, Beijing, 1980. Purchase prize

These cowboys are from the Kangba section of Tibet and are shown grouped as they "hang out" in town. The carefully observed features and costumes have been respectfully recorded, as if in a formal photograph. But Chen uses a brush in the academic tradition of Ingres.

177. Chen Danqing. *Tibetan Mothers and Children.* 1980. Oil on canvas. Exhibited at the Central Academy of Fine Arts Gallery, Beijing, 1980

In this Tibetan genre scene Chen depicts three mothers feeding their children. Each detail—their black braided hair, glowing skin, colorful jewelry, voluminous fur coats, and their cooking pots—is rendered skillfully in the tradition of nineteenth-century realism. Many Chinese embrace Chen's vision as an appropriate national style because it is both dignified and down-to-earth compared with the overdramatic, posed Socialist Realist compositions of smiling minorities. The artist is obviously impressed by the beauty of the Tibetans as well as by their exotic customs—such as wearing a fur coat without underclothes.

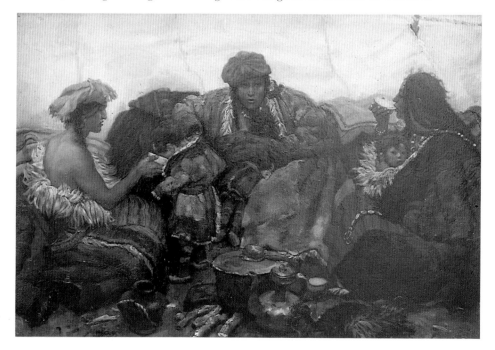

103

178. Han Xin. *Violin*. 1980. Oil on canvas. Exhibited in
Painting the Chinese Dream, Smith College Museum of Art,
Boston City Hall Gallery, The Brooklyn Museum, 1982–83

*Han Xin had seen a small black-and-white reproduction of an
American painting of a violin, which inspired this composition. The
artist actually plays the violin, and at the time when he was
painting the work, a good friend had gone abroad to study music.
He says he was thinking of her and of his longing to go abroad to
study. He expresses his deep feelings in a precise, romantic realist
manner.* Violin *is a charmingly fresh and polished painting.*

determination and imagination, Huang Suning managed to go to Tibet and,
once there, arranged for Chen to join her work unit, where his art flourished—
as did their romance. They finally got permission to marry in 1978, when the
rightist label was removed from Chen's father. Chen was admitted to the
graduate program of the Central Academy of Fine Arts, where, upon
graduation, he was invited to teach. In 1982 he traveled to New York to study at
the Art Students League. Chen Danqing's work has been shown and published
frequently in China as well as in France and the United States.

HAN XIN *(b. 1955, Shanghai)*

Han Xin is a gifted academic oil painter who is self-taught because of the
Cultural Revolution. His mastery of *trompe-l'oeil* painting is demonstrated in
Violin (plate 178).

In 1974, Han Xin gained celebrity status in Shanghai as the youngest artist to
be accused of creating Black Paintings. He also worked for two years as an
apprentice at the Shanghai Painting Academy, where he assisted Chen Yifei in
his 1979 masterpiece, *Looking at History from My Space* (plate 171).

In 1980 Han entered the Central Academy of Fine Arts in Beijing, where he
met his future wife, an American art historian. In 1984 he received a Master of
Fine Arts degree from the Oakland College of Arts and Crafts in California.
Han Xin's work has changed somewhat since his arrival in the United States. He
now uses larger formats, bolder colors, and looser strokes to depict landscapes
and figures, but he continues to use subjects similar to those he painted in China.
He has also used Photorealism in a series of New York subway scenes, which
have won prizes and were successfully exhibited in many places in the United
States.

Realism in Sichuan: The Barbizon School, Post-Impressionism, Photorealism, and Magic Realism

Many young Sichuan realists—especially the admirers of Andrew Wyeth, the
most popular American painter in China—have received national attention.
Under the leadership of President Ye Yushan, officials at the Sichuan Academy
of Fine Arts in western China have been particularly open-minded about foreign
styles and have encouraged experimentation. Wang Datong and other faculty
members, together with their students, have explored Post-Impressionist modes.

Perhaps this has occurred because Chongqing, in Sichuan Province, was the
wartime capital from 1938 until 1945 and, at that time, experienced an influx of
sophisticates, including artists from the East Coast. Thus Chongqing had an
introduction to outside influences before Socialist Realism became the national
style in 1949. Sichuan artists, of course, developed within the artistic guidelines
set by officials in Beijing. Their geographic isolation, however, allowed them a
degree of relative independence. As a traditional Chinese phrase describes the
situation, "Heaven is high, and the Emperor is far away." Moreover, according

179. Cai Zhenhui. *Misty Morning*. 1984. Oil on canvas. Shown at the Sichuan Artists Exhibition, National Art Gallery, Beijing, 1984

This landscape was inspired by the European academic painting Cai (b. 1938, Sichuan Province) saw when he was a visiting artist in Belgium in 1980. More frequently, Cai paints narrative Socialist Realist propaganda works and thus is an ideal product of the first thirty-five years of art education in the People's Republic. The new generation of Sichuan realists have found their own vision beyond these two officially sponsored styles.

180. Wang Datong. *Shining After the Rain*. 1979. Oil on canvas. National Art Gallery, Beijing. Permanent collection

In this political allegory the sunny day that has dawned refers to the newly liberalized climate following the turmoil of the Cultural Revolution. Wang combines fine technique with high political consciousness. The appealing young woman in white professional dress wipes the window with a naturalness that is quite different from the posed Socialist Realist mode. There is a human scale to this work—compared with the oversize labor heroes of the Cultural Revolution—as well as a new level in adapting international influences.

to one Sichuan artist's assessment, there is no single towering figure whom everyone copies, and they are not jealous of each other.

The Sichuan artists tackled the problem of the oil medium with noteworthy success. Despite a seemingly insurmountable disadvantage—most Chinese have never seen an original Western oil painting—the artists made concentrated efforts to simulate what they had seen only in reproduction—a singular achievement. As a group, teachers and students alike show a fluency with oil paint that was lacking in earlier generations.

The Sichuan artists' selection of earthy subjects has won them kudos and popularity in many Chinese publications. In 1982 veteran art critic Wang Zhaowen wrote: "The experience of life points to what artists should draw as well as to how to draw. If the painting is a true reflection of life, it is easier to recognize than life itself. It depends on how profound the life experience of the artist is." Wang praises many of the young Sichuan artists, saying that they have succeeded in communicating life and conveying their own unique views.

WANG DATONG *(b. 1937, Anlong, Guizhou Province)*

Wang Datong is a leading realist from the first generation of artists trained in the People's Republic. Born into a Buyi minority group in remote Guizhou, Wang studied at the Sichuan Academy of Fine Arts and was invited to stay on and teach. He moved easily from Socialist Realism into Post-Impressionist styles, but he continues to use his masterful skills of *trompe l'oeil*, as seen in *Shining After the Rain* (plate 180). Wang Datong also explores Expressionistic techniques, using

181. Luo Zhongli. *My Father.* 1980. Oil on canvas. Prizewinner in the National Youth Art Exhibition, National Art Gallery, Beijing, 1980; exhibited in the Spring Salon, the Louvre, 1982

The giant size of this old peasant makes him a hero. Luo was the first Chinese painter to use the Photorealist style and to be nationally acknowledged and rewarded. Luo Zhongli depicts every wrinkle, hair, and drop of sweat with microscopic accuracy, as if they were exclamation points marking the old man's hard life. His soup bowl represents his meager rewards. Because his image was so timeless, critics in China urged the artist to tuck a ball-point pen above the subject's ear so the viewer would know that this was a People's Republic labor hero, not just an illiterate peasant.

thick pigments and energetically gestured strokes while depicting traditional subjects such as flowers, but in a manner that is distinctly Post-Impressionist.

LUO ZHONGLI *(b. 1950, Sichuan Province)*

Luo Zhongli is an enormously gifted and productive painter who has chosen to live in the remote Daba Mountains of Sichuan and portray peasant life. This distinguishes him from most other artists, who are urban dwellers at heart and go to the mountains or to farms to sketch once a year but have no enduring involvement with the countryside. Luo married a native of the region, and he comes closer than most to fulfilling Mao's dream of artists living with peasants and undergoing a class change. Upon graduation from high school in 1968, Luo requested work in the Daba Mountains area. He lived there until 1977, when his wife begged him to compete for entry to the first post–Cultural Revolution class at the Sichuan Academy of Fine Arts.

In 1980, Star Star organizer Ma Desheng visited the academy. Inspired by the Star Stars, Luo, some of his classmates, and some amateurs formed a group of almost forty painters, called Wild Grass. Most of the painters worked in oils and in an Expressionist mode. In February, 1980, they held an exhibition. According to Luo's account, the exhibition was closed down by the Public Security Bureau after two weeks because "the paintings showed the dark side of Chinese life."

Luo Zhongli employs a style of painting that combines romantic and realist elements. He particularly admires Millet, who ennobled peasants in France more than a century ago, and he follows Millet's academic approach. But Luo's greatest artistic triumph in a contemporary mode is as a Photorealist. He saw a painting by the American Photorealist Chuck Close reproduced in a Chinese art magazine, and, noting its dimensions, he experimented and created the oversized face called *My Father* (plate 181). According to Pei Minxin, writing in the *China Daily* (June 30, 1983, p. 5), Luo apparently met this man "on the eve of Spring Festival five years before. [He was] a half-frozen peasant, watching the latrine that contained the manure which was to fertilize the man's meager plot." Luo Zhongli wrote in a letter to the art magazine *Meishuyuekan* (*Fine Arts Monthly*), published in February, 1981, that "the peasant's immobile figure— silent, staring, and anesthetized—impressed him." Luo was moved by the man's sincerity and unquestioning acceptance. The artist realized the peasant wouldn't speak for himself, so he would shout for him and others!

My Father won first prize in the Second National Youth Art Exhibition in December, 1980. The painting demonstrated how the magnified, Photorealist style can satisfy the party's demand for uplifting subjects that indicate "love for the motherland, socialism, and the party." Yet, *My Father* and Photorealism are controversial. Critics complain that the style is ugly and even obscene. And indeed, it is ironic that Photorealism, as practiced in the West, is positively frank and unsympathetic in its pseudoscientific revelations. In the cultural transmission, Luo has transformed the original implications of the style.

Luo Zhongli studied in Belgium, where he concentrated on copying works by

Western masters in order to learn their styles. He is enormously stimulated by the art he saw in the West.

Many in the new generation have done work with photographically detailed surfaces of people and landscape similar to the magnified Photorealist technique. However, the spirit of Magic Realism is different. The figures and animals have a wistful quality and the atmospheric effects are softer and more luminous than in Photorealism. Moreover, the Magic Realists, unlike the Photorealists, do not depend on the special effects of a huge canvas or on the shock value of magnification. Among the significant group of Magic Realist paintings from the Sichuan Academy of Fine Arts, those of He Duoling and Yuan Min typify this style.

HE DUOLING (b. 1948, Chengdu, Sichuan Province)

He Duoling completed the graduate program at the Sichuan Academy of Fine Arts in 1981 and is now at the Chengdu Painting Academy. He won instant recognition for *Awakened Spring,* a dreamy pastoral work that borrowed from the Wyeth mode, picturing a girl, a buffalo, and a dog. It was sent to Paris for the Spring Salon in 1982. French officials wanted to purchase it for the Louvre along with paintings by two other New Realist artists, Chen Danqing and Luo Zhongli. The artists were all disappointed that the Chinese officials would not consider the sale.

 He Duoling distinguishes his brand of realism from that of his peers Chen Danqing and Luo Zhongli, noting that they are careful observers and recorders. He says, "I wasn't very healthy as a child and I painted my own dream world.

182. He Duoling. *Old Wall.* 1982. Oil on canvas. Shown at the Sichuan Oil Painters Exhibition, Chengdu, 1983; Hong Kong Art Centre, 1983; Sixth Chinese National Exhibition, Shenyang, 1984; Beijing, 1985

He Duoling won a prize for this painting in the Sixth Chinese National Exhibition. He says the wall is widely misunderstood. It is thought to be keeping the boy and the cat out, yet in fact the wall is crumbling and old, a nostalgic landmark of his time in the countryside. He shows outstanding technique in his faithful reproduction of flesh, cat hair, and mud wall. All elements painted in muted yellows and tans are concentrated in the front of the picture plane. A strip of peerless blue sky frames the dreamy-eyed boy and the cat, which looks away in a classic pose that seems perfectly natural.

183. Yuan Min. *Earthline*. 1984. Oil on canvas. Shown at the Sichuan Artists Exhibition, National Art Gallery, Beijing, 1984

Yuan Min (born c. 1963) was a student at the Sichuan Academy of Fine Arts when he exhibited the widely admired and frequently published Earthline. *Inspired by Andrew Wyeth and Chinese artists such as He Duoling, Yuan depicted a nubile young Tibetan herdswoman. Windblown and glamorous, standing on the high plateau, which appears convex in the clear distance, she is as beautiful as a movie-magazine star. Yuan Min built up layers of oil pigment and then varnished the surface to make it crisp and clear. The associate dean of the Sichuan Academy, Cai Zhenhui, explained the essential narrative: "The poor herd girl is happy because the day has gone well. Her dreamy expression suggests her vision of new China; she is thinking about China's development and prosperity and how herders like herself will have a better life."*

RIGHT:
184. Pan Chuyang. *Worship*. 1981. Collage; mixed mediums

Pan Chuyang (b. 1953, Guangdong Province) creates advertising designs in Guangzhou, close to Hong Kong. This witty composition parodies Chinese worship of foreign things and uses a Pop Art vocabulary. The painting was made just at the time when foreign drinks such as Coke and American beer first became available in China. His realism is literal. Pan is a member of the Guangzhou Fine Arts Studio.

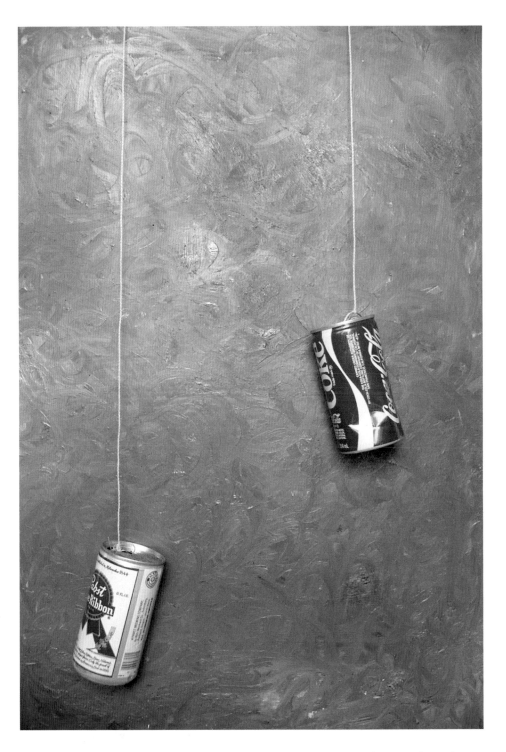

I loved Andersen's *Fairy Tales* and as a child I wanted to articulate my fantasies—my childhood dreams. And now, no matter how much one changes I feel one must always grapple with those images. My own romantic art didn't really take form until I went to the countryside, separated from my usual urban environment. [From 1969 until 1972 he was a porter and farm laborer in the

Liang Shan Yi autonomous region.] I lived among the Yi, but when I paint them, neither am I the host nor are they the guests. They are simply the vehicle for my vision.

"I am not interested in narrative art. I had my first quarrel with my professor about *Awakened Spring*; he said that every painting must have a story to instruct the viewer, but I was interested in painting nature's harmonious patterns."

He Duoling visited the United States in 1985 for a few months and was very stimulated by what he saw. However, he couldn't wait to return to China to paint.

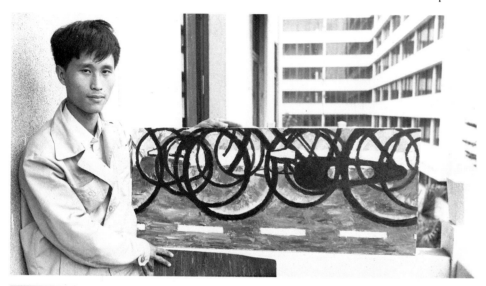

185. Chen Xiaoqiang. *Bike Wheels.*
1981. Mixed mediums on canvas

By isolating elements, Chen (b. 1955, Guangzhou) achieves an adventurous quality and, arguably, his work could be classified as art for art's sake. Nevertheless, Chen's work is firmly based in realism because he uses recognizable objects.

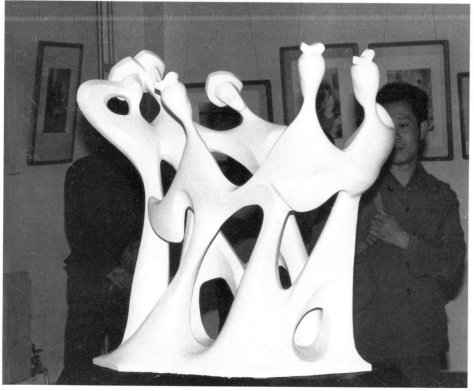

186. Liu Jilin. *Dancers,* 1980, Fiberglas, Shown in the Graduation Exhibition, Central Academy of Fine Arts Gallery, Beijing, 1980

By attempting to define the reality of the dance rhythm and movement of this group, sculptor Liu (b. 1938, Tianjin) has gone beyond photographic images into a kind of Expressionistic form. It represents the most adventurous sculpture among the academic and Socialist Realist offerings of the 1980 class of graduate students.

CHINESE INK PAINTING

After Liberation in 1949, Qi Baishi, the most famous of all traditional artists, known for his intimate and lively paintings of shrimps, crabs, and flowers, was given full honors. But shortly thereafter, the party leadership set new guidelines for revolutionary art. Qi Baishi's followers, who also painted birds and flowers, were disciplined for being "decadent." Qi's disciple Li Kuchan and two other accomplished flower painters, Hu Jieqing and Xiao Shufang, were not afforded the recognition they deserved until after the Cultural Revolution. Only a flower painter such as Guan Shanyue could maintain his high status—because of political connections and his skill as a landscape artist. Most artists tried to integrate Socialist Realist effects with traditional ink techniques. Only a few major figure painters, such as Cheng Shifa and Fan Zeng, still kept links with the Chinese classical past. Landscapes recording the glory of the motherland were the most popular of the revived types of traditional painting.

The area of traditional painting that was pronounced most worthy of development after 1949 was figure painting, especially if the figures were engaged in building the new society. However, it is worth noting that in the post-Mao era, enduring success in this genre goes to those who followed in the footsteps of Xu Beihong, whose horses had become his trademark: Wu Zuoren became known for his yaks and Fang Jizhong for his goats.

The party decisions of the early 1950s on such limited prospects for Chinese painting were changed as the forces of nationalism and conservatism gathered strength and the Soviet ideological star waned. During the 1956–57 Hundred Flowers period, when academies of traditional painting were finally being established all over China, all the old subjects were revived. However, political prestige continued to be linked to landscape and figure painting.

Most artists looked to the old masters for guidance: Innovators, like Li Keran, who portrayed current scenes in a classical context, and Fu Baoshi, who developed a new texture technique, were most admired and imitated, along with the more traditional masters, Lu Yanshao, Qian Songyan, and Zhu Qizhan.

Because they assimilated aspects of Post-Impressionism in their work, Liu Haisu and Lin Fengmian were considered ideologically "impure" until after the Cultural Revolution, when the party line changed. They were unappreciated until the post-Mao era, when Liu Haisu began to receive honors, but Lin Fengmian chose to leave and resettle in Hong Kong.

The innovative and creative spirits Zhang Daqian, Wang Jiqian, and young

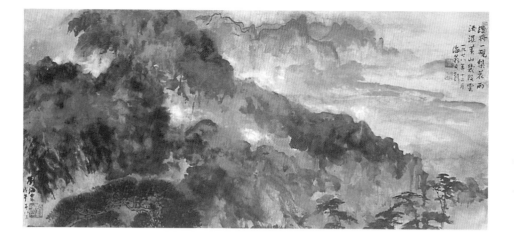

187. Liu Haisu. *Clouds at Mount Huang.* 1978. Ink and color on paper. Collection Hong Kong Museum of Art. Inscribed: "The rain is like pear-blossom petals. I used water from the rain to paint the Yellow Mountain mists. [A poem by the Qing dynasty painter Shi Tao.] 1978 December. Hai Weng [Old Man Hai]." Four seals

The brilliant hues evoke the richly colored pigment style of the Dunhuang cave paintings as well as the Expressionist colors of the Fauves. Liu Haisu painted this just after he had been rehabilitated, following twenty years of disgrace and oblivion. Basking in his renewed perquisites, he went to China's most scenic mountains, famous for their mists, rock faces, and windblown trees.

Zhao Wuji left China in 1949, but they continued to be leading overseas-Chinese artists. Some artists in China, such as He Haixia, had secretly admired their work and were influenced by it even before the post-Mao era, when it became legitimate to appreciate their achievement.

The Older Generation

LIU HAISU *(b. 1896, Changzhou, Jiangsu Province)*

Liu Haisu shares with Xu Beihong the mantle of father to Chinese modern art. During the almost forty years of his prerevolutionary career, Liu probably trained more Chinese artists than any other teacher in his Shanghai Fine Art Institute. His style combined Post-Impressionist coloration and Expressionist strokes with traditional Chinese painting techniques. However, his disagreement with Xu Beihong about how to modernize Chinese art, as well as his lack of political acumen in dealing with the party, kept Liu in a subordinate position for the first thirty years of the People's Republic.

He had a brief moment of glory during the 1956–57 Hundred Flowers period, when he was accorded a one-man show in Shanghai—and pronounced the visiting Soviet artist Maximoff "third rate." But shortly after, he was called a rightist and lapsed into disfavor.

It was not until the 1978 liberalization that Liu attained his place in the sun with a 1979 retrospective exhibition at the National Art Gallery in Beijing, as well as with exhibitions in Hong Kong and Japan in 1980 and 1981. If Liu had by then forgotten the pain inflicted when he was branded a rightist in 1957, he was not allowed to forget his quarrels with Xu Beihong, although it had been twenty-six years since his adversary died in 1953. Xu Beihong's widow picketed the National Art Gallery, carrying a placard denouncing Liu. Even after Liu's reputation was restored in 1978, he was slandered by jealous colleagues for "meeting with foreigners" and "being a garrulous old man." Repressed hostilities from previous political campaigns prevail in China's art world, reminiscent of the court intrigues of traditional China.

Liu Haisu persistently introduced new ideas to Chinese art, such as drawing from live models. In *Chinese Art in the Twentieth Century*, Michael Sullivan says that in 1926, when Liu undraped the models for sketching, there was a tremendous furor. The local warlord threatened to close the school and arrest Liu if such practices were not stopped. Liu Haisu took up the call to battle and carried on an intense campaign in the Shanghai newspapers, making the case for the use of nude models in artistic training. However, Liu's success at that time can be traced to the Nationalist defeat of the outraged warlord. Teachers in other art schools who had been too timid to use nude models began to use them after Liu's courageous stand.

During the 1920s and 1930s Liu visited Europe several times. There he finally saw the masterpieces he had emulated. He lectured about Chinese art, held exhibitions, sold works of art, and became a mentor to the Chinese students who were busily copying old masters. Mayching Kao, in her Ph.D. dissertation, *China's Response to the West in Art: 1898–1937*, translated some of Liu's writings: "My days in Paris—a great part are spent in visiting museums and galleries," he wrote. "From Giotto to Botticelli, from Titian to Fragonard, from Poussin to David, from Ingres to Cézanne.... After visiting the Louvre I go straight to the Luxembourg Palace to look at modern paintings. Every time I visit several galleries, inevitably I feel an infinite change in my heart: sometimes I feel lost, other times I feel enlightened."

Liu's interest in nineteenth-century academic painting as well as in twentieth-century Western trends is reflected in his oil painting and also in some of his Chinese paintings. The most distinctive aspect of his Chinese style is the use of intense, bright colors—as in the Dunhuang-type blue-green landscapes—rather than traditional light-color washes. He is a master who commands a broad range of strokes, bold black-ink gestures, pointillist clusters of dots, and precisely drawn, outlined subjects.

QIAN SONGYAN *(1898–1985, b. Yixing, Jiangsu Province)*
Qian Songyan, with his twinkling eyes and wispy beard, was the epitome of a distinguished traditional scholar. Apparently, he had none of the early-twentieth-century yearnings to explore beyond the world of traditional Chinese painting or to venture out of his native area. He grew up in a region with a long tradition of scholar-painters, a provincial setting far away from the cosmopolitan ways of Shanghai. His education in poetry, painting, and calligraphy was fitting for young Qian, who was born into the fifth generation of a family of scholars. His father was a tutor who trained the elite youth of old China in the Confucian classics, the essence of learning in the dynastic era.

After the Revolution of 1911, young Qian went to the Jiangsu Provincial Normal School in Wuxi. He then taught history, geography, Chinese language, and traditional painting at schools in Suzhou and at the Wuxi School of Fine Arts. Reflecting a compromise between the modern mode and the forces of tradition, the school not only taught ink painting, calligraphy, and poetry but

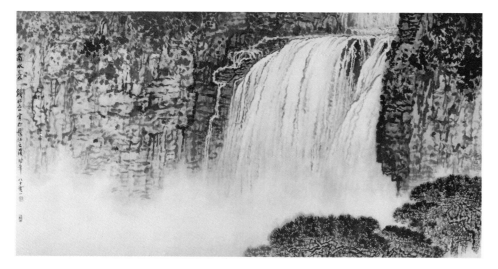

188. Qian Songyan. *Waterfall.* 1979. Ink and color on paper

The most remarkable part of this work is the powerfully painted brown-and-black rock face, punctuated by an occasional tree or flower. Black rock lines are rhythmically syncopated with brown strokes. For this effect, Qian used an ancient brushstroke called a "folding bands" texture stroke. This outstanding painting is well known because another version, from the same Waterfall series, was mounted on a screen and exhibited in the east wing restaurant of the Beijing Hotel from 1979 until 1982. Few large-scale traditional works succeed as well as this one does.

also offered study in oil painting and watercolor. "I learned by looking at old paintings," he recalled. "Fortunately I had friends who were collectors in Wuxi, and so I saw a lot of good painting. There were no public collections, so you had to know collectors."

After Liberation in 1949, Qian stayed on as a teacher in Wuxi. Only then, he said, was he able to travel to see the mountains and rivers of his dreams for the first time. "I had never seen the Yangzi [River]. . . . People couldn't travel before Liberation. Now the government sends artists to see these scenic spots, and they paint from nature. Conditions have improved. I envy the young. They are luckier and happier than I was."

In 1957 Qian Songyan was invited to be a member of the newly established Jiangsu Traditional Painting Academy, where he became director. He said he changed his painting style by applying a "dialectical" technique. In effect, in his landscapes he applied Socialist Realist conventions, including deep-space perspective and the use of factories and other landmarks of modernity. There are examples of this work at the Nanjing airport. Qian claimed that his work is both romantic and realistic, a response to Chairman Mao's exhortations.

Yet, in spite of his efforts to create a new Communist art, Qian, along with most of the other senior artists, was relegated to the "stinking ninth" category (intellectuals) during the Cultural Revolution. His painting was called "black and sinister," and he was compelled to live in a cowshed for three years. He was repeatedly forced to confess to crimes he had not committed. Subsequently, he was sent to the countryside for another three years to perform physical labor, including breaking ice with his bare hands. His "souvenir" of the Cultural Revolution, he said, was the pain he felt in his hands when he painted. But now, Qian declared, "artists are free to choose style and subject and they are ideologically emancipated."

At Qian Songyan's one-man show at the Nanjing Art Gallery in April, 1979, which commemorated the thirtieth anniversary of the PRC, the artist chose not to include any of the industrial landscapes inspired by Socialist Realism. His

189. Li Kuchan. *Fish.* 1979. Ink on paper. Inscribed: "With an innocent heart I play with black and white. Eighty-one-year-old man Kuchan, painted in Beijing, Sanlihe [district]."

The humor with which Li Kuchan's fish are painted is refreshing. They are perhaps his most successful creations, sleekly brushed and often swimming out of the picture.

exhibited works were characterized by misty mountain landscapes, sometimes washed with intense colors: granite cliffs of intense azure, rocks and soil of burning red, and fields that are illuminated with a brilliant harvest yellow, punctuated by bands of mist.

A few of these landscapes included figures, such as a group of workers carrying picks and the ubiquitous red flag while climbing a narrow mountain path or a line of straw-hatted peasants crossing a field, carrying buckets attached to yokes. These figures are small in relation to the landscape. Indeed, the relative scale is similar to that found in traditional painting. And the figures are discreetly placed; they are not automatically given the central space of the painting. They have neither the scale nor the position required by Socialist Realism. Rather, they recall the traditional formula, where an occasional traveler or a young herdsman meanders through the vast landscape. Here, nature is the dominant force.

LI KUCHAN *(1898–1983, b. Shandong Province)*
Li Kuchan, the outstanding student of Qi Baishi, carried on the tradition of bird and flower painting. Qi once wrote: "I have as many as a thousand pupils. Most learn my technique, but Li Ying [later called Li Kuchan] has touched my heart." (Fan Zeng, "Li Kuchan, Painter of Flowers and Birds," in *Chinese Literature*, April, 1979, p. 103.) For a painter of such joyful subjects, Li Kuchan had more than his share of trouble in spite of his auspicious contact with a classmate, the young Mao Zedong. Li Kuchan studied Chinese literature at a university in Beiping, but he really wanted to study in France. Lacking the funds to travel, he entered the Beiping Art College, where he studied Western painting by day and, to support himself, pulled rickshas at night. During this period, Li studied charcoal drawing with Xu Beihong, the famous painter of horses, and with the traditional master Qi Baishi.

In 1945, at the end of World War II, Li Kuchan was asked to join the faculty of the Beiping Art College as a professor. After Liberation in 1949 he, like most other professors, stayed on at what would come to be called the Central Academy of Fine Arts, where he studied Marxism-Leninism and underwent ideological transformation. Li Kuchan became a classic victim of the regime when bird and flower painting was condemned as bourgeois in the early 1950s. Li was demoted to a position as gatekeeper and suffered a year of humiliation. Then he regained his teaching position, but his salary was reduced from 30 yuan (approximately $20) to 6 yuan (approximately $4) a month. This placed Li and his family in an impossible situation; they could not even eat on such a small salary. Finally, after selling his furniture and art collection, he appealed to his former classmate, Chairman Mao, who helped a little.

"My art was often interrupted before and after Liberation," Li said. During the Cultural Revolution, at age seventy-three, he was sent to the countryside to do physical labor and study Marxism-Leninism-Maoism. After he was recalled in late 1971 by Zhou Enlai, he painted *Lotus Pool* for the new wing of the Beijing

Hotel. But in 1974 that painting was seized and exhibited in the Black Paintings exhibition. Because there were eight lotus flowers in the painting, the Gang of Four claimed it was an attack on the eight model revolutionary operas.

Li Kuchan had political problems because he never hesitated to express his personal views. While others remained discreetly silent, he persisted in saying what was on his mind. In one interview with a foreigner, he even dared to say that "art and politics are different. Art cannot serve politics; a real artist cannot serve politics." Presumably, other Chinese artists agree, but to say so openly, and to a foreigner at that, is at least heretical if not suicidal, even in the more relaxed post–Cultural Revolution climate.

Li's outspoken manner infuriated the party promoters of oil painters who worked in the official Socialist Realist style. "The brushstroke is above all the heart and soul of painting," Li said. "Brush and ink are the essentials of Chinese painting. No foreigner can possibly understand." His xenophobia reflected the prevailing attitude of the Chinese toward their country and their art.

Despite his outspokenness, in the post-Mao era Li Kuchan was acknowledged with exhibitions, the publication of a book of his works, and a place in the Chinese National Artists Association. At the end of his life, he had the perquisites of a high cadre, with a good apartment and even a private telephone.

His special gifts were his mastery of the freely brushed, Impressionistic traditional ink technique *(xieyihua)* and his deep understanding of nature through observation. He drew strength from nature, but selectively, with an artist's eye. His eagles, symbols of strength and freedom, have vigor, and his lotus flowers have a languorous grandeur. The intensity of his images allows them to be enlarged on a monumental scale.

HU JIEQING *(b. 1905, Beijing)*

Hu Jieqing, a distinguished flower painter, recalls growing up in old China. In 1926, she entered the Beiping Normal College, where strict segregation between the sexes was enforced. "Mother forbade any contact with boys, but later she was

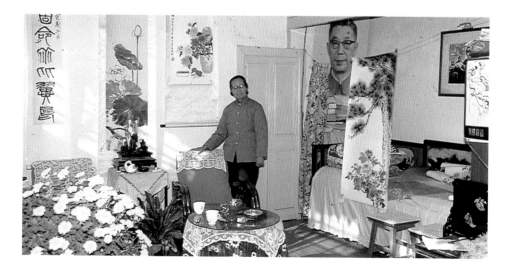

190. *Hu Jieqing in her room. Paintings, from left, are* Calligraphy *in seal-style script,* Lotus *by Wu Changshuo, and* Flowers *by Qi Baishi. Hu's own painting hangs from the bed alcove, on the right. A poster-size portrait of her late husband, Lao She, hangs over her bed. A free translation of the calligraphy is: "It does not matter how high or fast lovebirds fly as long as they are together."*

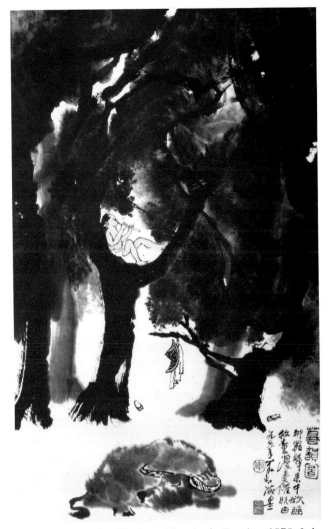

191. Li Keran. *Boy Playing a Flute in the Evening.* 1978. Ink on paper. Signed: "Keran splashed ink." Dated: 1978. Two seals: Li Keran. Inscribed: "Evening Melody. After plowing, the buffalo sleeps—the herd boy plays a lullaby."

Li Keran uses a most ordinary subject from the countryside, a favorite theme of Chinese painters for a thousand years. His swiftly calligraphic line depicts the flutist with economy and humor, the texture-washed ink suggests the buffalo's hairy hide, and the rich blacks of the forest evoke a verdant knoll.

eager for me to marry. The brother of one of my schoolmates introduced me to Lao She [who later became the internationally acknowledged author of *Ricksha Boy* and *Teahouse*], who had just returned from England. We were both Manchurian and from the same banner [their ancestors both served with the same military unit, called a "banner," when the Manchus conquered China in 1644]. We both loved literature," she says. "He didn't want to marry because of heavy family obligations, but his friends pressed him, hoping to improve his temper."

After Hu Jieqing and Lao She were married in 1931, they went to Shandong Province and both taught at the same university, but Lao She said "it was not proper for us to teach at the same university because of gossip. Indeed," she recalled, "when we wanted to walk somewhere, I had to walk in front of him. If we were seen together, people would make fun of us. When we first married, it was so feudal that a girl of eighteen could marry a boy of nine. If you wore new style clothes, people stared at you. If you wore high-heeled shoes, they thought you were a demon." Because Lao She feared gossip, Hu Jieqing returned to Beijing in 1934 to teach in a middle school, and in pious Confucian fashion, she stayed there to care for Lao She's mother and for their three little children. Husband and wife were not reunited until 1942, in the wartime capital, Chongqing.

When Hu returned to Beijing after the war, she met Master Qi Baishi and became his student. After 1949, she devoted full time to painting and became a founding member of the Beijing Painting Academy. During the Cultural Revolution, she suffered severely because her husband was one of the many intellectuals who died during that period. Officially, his death was called suicide, but there is evidence that he was beaten to death. He was found floating on a pond in Beijing. In 1969, the family was dispossessed of their old courtyard house. It was returned to them in 1978, when Lao She was posthumously rehabilitated.

Hu Jieqing's paintings do not reflect the trials of her life, but rather, the vivid coloring and decorative quality of her master, Qi Baishi. Her work is distinguished by her extraordinary precision.

LI KERAN *(b. 1907, Xuzhou, Jiangsu Province)*

Li Keran is probably the best-known and most revered older artist living in China today. In recent years, the master has specialized in black-ink paintings of mountainsides. However, in the earliest days of the People's Republic, he made his reputation as a painter of the new China with charming pictures of water buffalo and herd boys. Li was born into a poor family and grew up in the countryside. Neither of his parents was literate. His work still recalls the buffalo and peasants of his youth.

At age thirteen, Li found a teacher in his hometown with whom he studied the principles of landscape painting. In 1923 he went to study oil painting at Liu

Haisu's Shanghai Fine Art Institute, and in 1929 he studied at the West Lake Art School in Hangzhou under the pioneer modernist Lin Fengmian. In his work, Li has tried to synthesize Eastern and Western elements.

Official biographies note that during World War II, Li Keran organized teams of artists to spread anti-Japanese propaganda and that eventually he went to Chongqing, where he taught traditional Chinese painting. After Liberation in 1949 Xu Beihong—then president of the Beiping Art College—invited Li Keran to join the newly established Central Academy of Fine Arts. Li went to the academy, where he met the aging traditional masters Qi Baishi and Huang Binhong, who took him into their prestigious circle.

Li Keran became a leading exponent of traditional landscape painting. As he wrote in *Chinese Literature* (August, 1959), "Landscape paintings are the artists' odes to their land and home." This was an important step in reestablishing the credibility of landscape painting within the Communist theoretical framework. Li also criticized the officially sanctioned Socialist Realism: "It is idiotic to imitate nature slavishly in the style of those who tend toward naturalism. It should be noted that the artist paints not only what he sees but what he knows."

In the 1960s Li Keran developed his own personal landscape style. Building from a base of traditional painting, he freely adapted Western conventions of perspective to record his scenes. In his Yangzi Gorges series of paintings, he uses deep-space perspective to dramatize the line of boats as it recedes under the towering cliffs. Rock faces are powerfully etched in black ink, a rich image that washes to gray in the distance. An intensely inked surface became Li's trademark. He has also painted misty-gray landscapes, highlighted with pink-blossomed trees. Their lyrical mood is quite different from that of the intensely black landscapes, though, intriguingly, the grays are no less inky.

Li Keran, like the other pioneers who modernized traditional painting, filled many landscapes with revolutionary and historical sites. In 1957, he was not accused of being a rightist, despite the fact that his views were controversial. But during the Cultural Revolution, he was severely criticized and sent to the countryside for a year of labor reform, and his children were exiled to remote areas to labor for many years.

In late 1971, on the eve of President Nixon's visit, Zhou Enlai recalled a few senior artists, including Li Keran and Li Kuchan, from the countryside to decorate hotels and guest houses. In that phase of the Cultural Revolution it was still necessary for Li Keran to intensify the political content of his work—for instance, by applying a red-orange wash to a landscape in order to give it a revolutionary aura. He also portrayed soldiers and red-flag-wavers in his landscapes, and selected lines from Chairman Mao's poetry inspired some of his subjects (plate 192). Still, Li Keran's heightened political content did not save him from accusations of being a Black Painter in 1974. Li's paintings were seized: the blackness of his ink was cited as a revisionist flaw. The artist says he made these pictures to satisfy the political requirements of the time, but now he excludes them from the "important" part of his oeuvre.

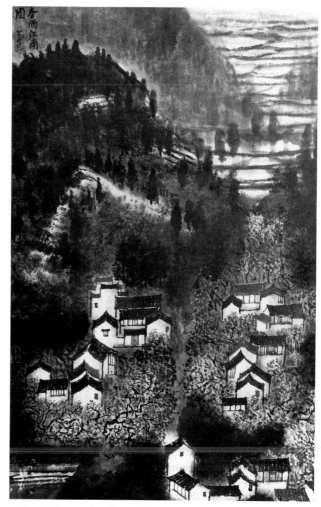

192. Li Keran. *Landscape After a Poem by Mao Zedong.* 1964. Ink and color on paper. Inscribed: "Spring rain in South China." Two seals of the artist: Keran and another. Formerly collection Dr. Ip Yee, Hong Kong

Li's innovative use of deeply saturated ink and color is an outstanding aspect of his work. However, during the Cultural Revolution his inky black surfaces were singled out as a negative example of reactionary art, epitomizing Black Painting.

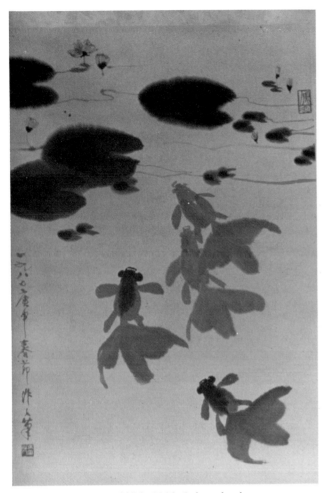

193. Wu Zuoren. *Goldfish.* 1980. Ink and color on paper. Inscribed: "1980. Spring Festival. Zuoren."

Although the fish and flowers are unshaded, they have a lifelike quality. They are crisply painted with glowing colors. Goldfish are highly prized in China, and they are a favorite subject in traditional painting.

Today, Li Keran's landscapes command top prices at home and abroad. He lives in relative comfort in a four-room apartment—spacious by Beijing standards—with his sculptor wife and several children. Two sons are painters: Li Xiaoke (b. 1944), the fourth son, and Li Geng (b. 1950), the youngest of the seven Li children and currently living in Japan. Despite the travails of their father, the children grew up in an artistic community—a courtyard housing complex inhabited by the artistic elite of new China. There they learned traditional painting from their father and sculpture from their mother and also the other styles of the many artists in the community: traditional painting from Li Kuchan, Wu Zuoren, and Ye Qianyu; ceramic painting from Zhu Danian; oil painting from Dong Xiwen and Wu Guanzhong; and wood-block printing from Huang Yongyu. The children constantly painted and held art contests. Artistic achievement was a natural part of their growing up.

WU ZUOREN (*b. 1908, Jingxian County, Anhui Province*)
When Wu Zuoren, the most successful protégé of Xu Beihong, returned from his European studies in 1935, he taught in Nanjing at the Central University and then, during the war, in Chongqing. Official biographies say that "in 1943 he wanted to get away from the oppressive atmosphere," which is a euphemism for dissociation from the Nationalists, their highly politicized capital, and the university. He spent the succeeding years wandering from the high plateau of Tibet to the Gobi Desert in Turkestan. Far from the world of oil painting, he used a brush and Chinese ink to paint the yaks, camels, and eagles that became his trademarks. Only a few of his oils, such as a portrait of the aged master Qi Baishi, are well known in China; he is famous for his ink paintings of desert creatures, goldfish, and the pandas that appear on Chinese postage stamps.

The originality of Wu's desert subjects, the freshness of his technique, and his close observation of nature have given a new life to his traditional painting. He uses ink skillfully, blotting it on absorbent Chinese paper to suggest camel hair and yak fur, and it is just as convincing on his luminously brushed washes of goldfish (plate 193). Wu Zuoren wrote in *Contemporary Chinese Paintings:* "All works of art originate in life but they should never become mere passive copies of life—[art should] exceed the work of nature!"

Wu Zuoren was president of the Central Academy of Fine Arts intermittently from 1958 until 1979, and he is a leading member of the Chinese National Artists Assocation.

XIAO SHUFANG (*b. 1911, Zhongshan County, Guangdong Province*)
The distinguished flower painter Xiao Shufang is married to the artist Wu Zuoren. She, like her husband, was trained in Chinese art schools as well as in Europe. She studied at both the Beiping Art College and the Central University of Nanjing before going to the Slade School in London from 1937 until 1940 to study sculpture. Upon her return to China, she taught at the Shanghai Teachers College and the Beiping Art College. She is now an associate professor at the

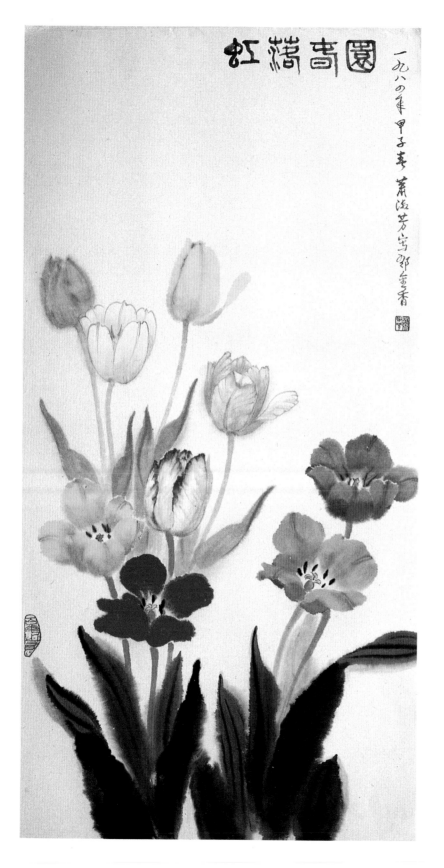

194. Xiao Shufang. *Flowers.* 1984. Ink and color on paper. Inscribed: "Spring 1984. Painted by Xiao Shufang."

Specializing in flower painting, Xiao Shufang uses one of the traditionally favorite subjects. Although her approach embodies the traditional ways of viewing, absorbing the image and communicating the essence, she also applies the Western, so-called scientific methods of shading and foreshortening. Western-style flower paintings were introduced to China in the seventeenth century by Christian missionaries.

195. *Nanjing artist Chen Dayu (b. 1912, Chaoyang County, Guangdong Province) completes his painting* Pomegranates. *The dedicatory inscription, with name, date, and place, is in handsomely formed Chinese characters. It is a traditional practice to brush a poem on as an inseparable part of the word/picture image. In some cases, poems are added later as an appreciation.*

ABOVE RIGHT:
196. *Working in the traditional manner, Guangzhou artist Liu Jirong (b. 1931, Xingming County, Guangdong Province) broadly brushes an area as a first step in creating* Banana Tree. *He and many of his colleagues are periodically invited to Beijing's Summer Palace, where a studio has been set up to create paintings for use as state gifts and to stock the galleries that sell to foreigners and for export.*

Central Academy of Fine Arts and teaches oil, ink, and watercolor painting.

Xiao Shufang's flower paintings reflect nature, but she expresses her own point of view (plate 194). Her work forms a link between traditional painting and Western watercolor painting, and it makes a bright and fresh contribution to flower painting.

SHI LU *(1918–1982; b. Ren Shou County, Sichuan Province)*
Shi Lu had a hero's revolutionary and artistic credentials until the 1960s, when he was attacked for his independent thinking. Raised in Sichuan near Mount Emei, where he frequently sketched, in 1934 he went on to study Chinese painting at Dongfang Art College in Chengdu. There he emulated the greatest of the Qing dynasty painters. Still in Sichuan Province in 1938, he enrolled in the department of history and sociology at West China Union University but dropped out after a year to engage in anti-Japanese propaganda work at a northern Shaanxi Communist base. In 1942 he joined the Shaanxi-Gansu-Ningxia Border Region Cultural Association—a group from which many PRC cultural leaders emerged. His propaganda works included woodcuts, cartoons, New Year's pictures, and serial storybooks.

After Liberation in 1949, Shi Lu became editor-in-chief of *Northwest Pictorial* and, at the same time, resumed Chinese painting. With exceptional vigor, he painted political leaders in historic settings. In paintings such as *Electricity Has Reached the Other Side*, he carried out the challenging task of combining modern subjects with old-fashioned mountain mists and overwhelming natural forces. Tree-dotted mountains rise up on one diagonal axis, while the calligraphic power-line patterns run through the mist on the other.

Shi Lu practiced Qigong, an austere Chinese meditational exercise, which according to some sources, caused him to hallucinate and experience mental disorder. Then, in 1966, the Red Guards removed him from the hospital and criticized him for his work. For several years he lived in a cowshed—a makeshift prison room created by Red Guards and the Revolutionary Committees. Later, he was sent to the countryside, but apparently he escaped twice and lived off the land as a beggar.

Shi Lu created angry poems that were discovered in the repeated ransackings of his house by Red Guards. Some were ultimately published in *China Reconstructs* (September, 1983, p. 47):

> The political players are only a handful:
> Sad is the world when the jackals and wolves hold sway.

LONG POEM BREATHING DEFIANCE

I shall be even wilder than you say,
And search up and down
For miracles in the commonplace.
By what virtue do you call me eccentric?
I'll be no slave, but my own master.
I don't predict chaos,
The unwritten law is more abiding.

I'm not as black as I would like—
That would curdle your blood
And stir your soul.
So I am wild, eccentric, chaotic and black!
Be master of your mouth, and I of mine.
Life brings me its fresh meanings,
And I will reflect them.

Shi Lu said that although it made him uneasy to recall this period of persecution, the suffering had stimulated his work. During his last decade, his subjects no longer had modernizing propaganda content. He turned back to traditional landscapes and flowers (plate 197). In his paintings of the sublime cliffs of the northern landscape, he used hemp-fiber texture strokes to define the austere rock faces.

SONG WENZHI *(b. 1919, Taicang County, Jiangsu Province)*
An acknowledged master of the Nanjing School of landscape painting, Song Wenzhi had little formal art training. In 1957 he became a member of the Jiangsu Traditional Painting Academy, where artists were called upon by the party to "weed through the old and bring forth the new." In 1960 he traveled thousands of li through the countryside with Fu Baoshi, father of the Nanjing School of landscape painting, and two other distinguished Nanjing artists, Qian Songyan and Ya Ming, endeavoring to "learn from nature."

Song Wenzhi uses powerful brushstrokes, but he completely controls the ink. He observes carefully and renders his subjects specifically, yet he also draws on images from the traditional masterpieces. His work vigorously combines realism with echoes of the past (plate 198). In the mid-1980s Song began to experiment more freely with ink spots and color, both of which promise to expand his formulas.

197. Shi Lu. *Pink Lotus*. Ink and color on paper. N.d. Inscribed: "To Comrade Wen Xian. Shi Lu paints a delicately shaded summer lotus. It is refreshing and can quench your thirst like an iced drink. Painted in my reed studio, Chang'an [Xi'an]."

Shi Lu's lotuses have a delicacy of stroke and color unmatched by any peer. His personal calligraphic style positively dances with energy. This painting represents his mature style of the late 1960s, when he created within the conventions of traditional ink-painting styles and subjects.

198. Song Wenzhi. *Clouds Rising at Huangshan.* 1982. Ink and color on paper. Inscribed: "Warm summer clouds rising in the Yellow Mountains. Wenzhi at Jinling [Nanjing]. 1982." Three seals. Exhibited in *Understanding Modern Chinese Painting*, Hong Kong Art Centre, 1985

The hallmarks of Song Wenzhi's style are the powerful and controlled use of his brush and his solidly observed realism. In the foreground, precisely outlined trees and a meticulous cascade set the scene for ribbons of mist that lie between the inky rock faces of sharply rising peaks. The mountains recede into deep space, according to the rules of Western perspective.

199. Wu Guanzhong. *Two Swallows.* 1981. Ink on paper. Exhibited in a one-man show, Beihai Park, Beijing, 1981; *Understanding Modern Chinese Painting*, Hong Kong Art Centre, 1985

In this masterpiece Wu Guanzhong shows how he can contain the energy within the geometry of a black-roofed, whitewashed house south of the Yangzi River. He imagines it is the house of his youth, where swallows were always flying by.

WU GUANZHONG *(b. 1919, Xixing County, Jiangsu Province)*

Wu has long been recognized as one of China's leading oil painters, but only in the last decade has he become a leading ink painter. Taking his cue from Xu Beihong, Wu feels that oil and ink techniques should be interchangeable and notes that oil painting is an international language. "But," he said, "as soon as it is done by Chinese, it becomes Chinese."

Wu Guanzhong has been a courageous and eloquent spokesman for the liberation of Chinese attitudes about the essence of beauty and the permissibility of abstraction. He wrote in "Exploration of Beauty" (*Chinese Literature*, August, 1981, p. 84): "I was brought up in the country and my family were all country people. My schoolmates and I went around barefoot. When we caught sight of a local girl who'd been married off to somebody in Shanghai and had come back fashionably dressed, hair permed and lips rouged, we'd all run giggling behind her. Later on, at the Academy of Fine Arts in Hangzhou, I not only became used to permed hair and rouged lips but also began to appreciate different types of human beauty, even the distorted beauty prevalent in Western modern art."

Wu Guanzhong's attempt to broaden Chinese understanding of foreign ideas and images has met with two major sources of resistance. Traditionally, foreign ideas were deemed worthless and dangerous. This antiforeignism has been reinforced by Communist ideology (despite its foreign origin), which specifies what is correct and disallows all other views.

The party line condemns abstraction as decadent and something that the masses cannot understand. Yet, Wu Guanzhong notes that for thousands of years the Chinese have delighted in the abstract marble patterns used to decorate palaces and mansions. Moreover, Chinese use of garden stones, calligraphy, and the splashed-ink technique are all traditional abstract elements. He argues for broader possibilities for artistic expression.

Wu Guanzhong entered the Hangzhou Academy of Fine Arts in 1937, and he studied at its World War II location in western China. He stayed on as an assistant until he won a national scholarship to study in Paris at the École des Beaux-Arts from 1947 until 1950. He chose to return to China after the Communist victory, although he had been an employee and scholarship recipient of the Nationalist government. He has taught oil painting at a number of schools, and since 1964 he has been a faculty member at the Central Academy of Arts and Crafts. An admirer of the universally appreciated Utrillo, Wu adapts something of the master's tone and combines it with his own remarkable mastery of oil technique, which makes his work appealing both in China and abroad.

Wu Guanzhong has increasingly turned his attention to landscape painting, avoiding figure painting because of the long-standing controversy about painting nudes. Speaking of the landscape, he said, "I had seen the blue water and vermilion buildings [of Qingdao] many times and was no longer interested in painting them. While walking into the forest, I became fascinated by the naked roots interwoven on the forest floor." Frequently he combines traditional ink techniques with the intense gestures and drips of Abstract Expressionism, yet the subjects are always identifiable.

CHENG SHIFA *(b. 1921, Songjiang County [near Shanghai])*
Cheng Shifa, the principal of the Shanghai Chinese Painting Academy, has the most elegant and decorative brush technique in China. Besides his graceful ink painting, he also uses color on foil in a manner similar to that of the great Japanese decorators of the seventeenth century. He is a master colorist who uses unblended hues to achieve the clarity and intensity made possible through direct application of powder pigments.

Cheng Shifa has devoted a lifetime to modernizing traditional painting. Descended from three generations of Chinese doctors, Cheng wishes the modernization of Chinese painting could be as easy as "administering spoonsful of realism." His goal is "to break tradition by using it as a weapon."

Cheng Shifa grew up surrounded by both folk art and traditional painting, both of which continue to be important to his work. While attending the Shanghai Fine Art Institute in 1939, he went beyond the accepted route of copying old masters. His teacher admired his innovations but wondered how a poor artist could sell work that was so different. Indeed, the impoverished artist had to do book illustration to survive.

In 1957 Cheng visited remote border areas inhabited by national minority tribes who have distinctively non-Chinese features and wear exotic costumes. He used these people as models for his evolving figural style, which shares the sweet innocence of folk art. His figure paintings have official approval in China because they link the traditional brushstroke to an image of new China and portray attractive peasant tribesmen, who had been a despised and oppressed minority before Liberation.

Like virtually all older artists, Cheng Shifa suffered humiliation, criticism,

200. Wu Guanzhong. *The Great Wall.* 1981. Ink on paper. Exhibited in a one-man show, Beihai Park, Beijing, 1981

Within this powerful composition, the artist expresses the life forces of the earth as well as the human energy that created the Great Wall. The freedom and control with which Wu paints is singular— certainly a breakthrough of Western-inspired Expressionism into Chinese brush painting. His gestures and drips act as a foil for landscape figuration and inject an abstract energy level at the same time.

201. Wu Guanzhong. *Spring Snow.* 1985. Ink on paper. Two seals. Exhibited in *Understanding Modern Chinese Painting,* Hong Kong Art Centre, 1985

The ink dots dance across this snowscape with an intense energy that is rarely expressed in snow paintings.

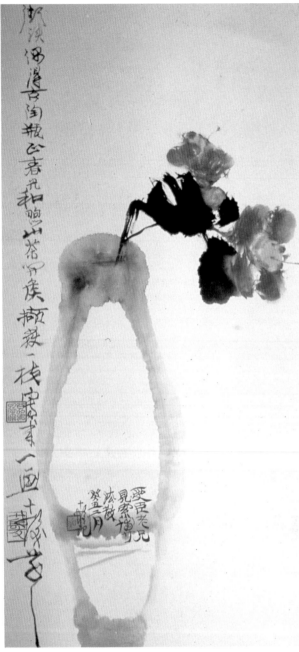

202. Cheng Shifa. *Old Vase, Spring Bloom.* 1973. Ink and color on paper. Inscribed: "By chance I got this old vase in the spring when the sun was shining—so I painted it. Shifa. Kuitso (1973). Camellia." On the vase: "A friend, Shou Chen, wants this painting. Please give me a professional criticism." Exhibited at the Shanghai Art Gallery, 1980

The artist was initially distressed by compositional problems, which he solved by lengthening the vase and then gracefully inscribing over it. Cheng Shifa's brushwork has a richness and elegance unmatched in China today. He inherits and adapts from both the literary and decorative traditions.

seizure of his property, hard labor, and reeducation during the Cultural Revolution. In 1974, just as the situation seemed to improve, a Black Paintings exhibition was organized in Shanghai. Twenty-five pictures were seized from Cheng's house, and he was given a dunce cap with "curious, black, wild, confusing" written on it. His accusers found his brushwork too abstract and confusing, and they blamed the artist's inability to please the masses on his intellectual class background. The cadres who criticized him claimed that he had placed a devil in an illustration of a Tang dynasty fairy tale!

HUANG YONGYU *(b. 1924, Fenghuang, Hunan Province)*

Huang Yongyu is one of China's most dynamic and successful artists. He has pioneered new visions and techniques, and he has tried various kinds of wall decoration. Although he has absorbed a great deal from traditional Chinese painting, including materials and subject matter, he artfully blends Abstract Expressionist techniques with traditional Chinese flung-ink technique. In the tradition of Chinese decorative painting, he uses bright and bold colors, and he, along with others, developed a coloring technique of painting on both sides of the paper to maximize the vibrancy of hues. Moreover, he has repeatedly experimented with wrinkled-paper effects. Both the coloring and wrinkled-paper techniques have been important to many younger Chinese artists and have been adopted by them.

Huang Yongyu's works are sold in art shops in China as well as abroad and are avidly collected nationally and internationally. They are the most highly prized and priced of all contemporary Chinese art. There were major exhibitions of his paintings in Guangzhou and Beijing in 1979, and his works have been permanently installed in public buildings. In 1982 three large ink-and-color-on-paper works were hung in the Beijing Hotel. He has traveled abroad to the United States, Australia, and Singapore, where he has also exhibited.

Huang Yongyu had been a rising star in the art scene of the 1950s and 1960s, so it is a bitter irony that it was the outrageous treatment he received during the Cultural Revolution that assured his later success. Huang, along with most other artists, was subjected to public humiliation. His paintings and other possessions were defaced, destroyed, or confiscated, and, along with colleagues from the Central Academy of Fine Arts, he spent three and a half years at labor reform on a farm. Even worse was the abuse he suffered in the vicious Black Paintings attack of 1974, when followers of Jiang Qing, Mao's wife, raided an exhibition of paintings in Beijing and charged the artists with advocating the restoration of the capitalist line and being secret supporters of Zhou Enlai.

Perhaps Huang was singled out for especially harsh treatment because of the facile wit of his amusing poetry. He shares with his famous uncle, the writer-historian Shen Congwen, a zest for Chinese literature, especially local folktales. For many years Huang Yongyu had written and illustrated poems—in an allegorical form similar to that of the fables of La Fontaine—that poked fun at human foibles. In 1974 he painted a picture for a friend—of an owl with one eye

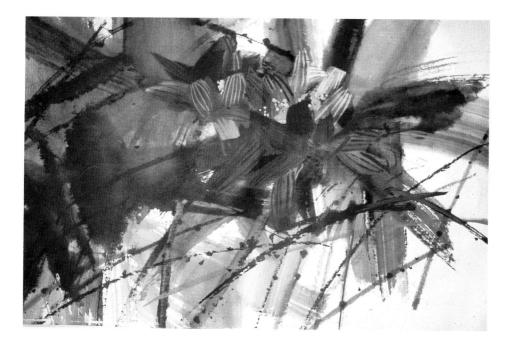

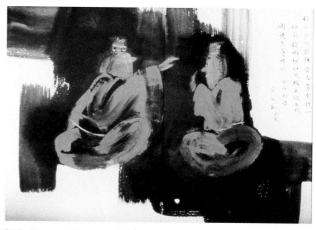

203. Huang Yongyu. *Ancients Heng and Ying*. 1979. Ink and color on paper. Dialogue from the Six Dynasties period, sixth century

Heng asks Ying: "Who is better, you or me?" Ying answers: "Since I've always been me how can I know?" With characteristic Chinese modesty Ying evades a direct answer. However, the Chinese cognoscenti would understand that remark to mean that Ying thinks he is better. Brushed in rapidly expressive strokes, the dialogue is articulated by the outstretched hands and the animated eyes and teeth.

ABOVE LEFT:
204. Huang Yongyu. *Red Lotus*. 1978. Ink and color on paper. Exhibited in *Painting the Chinese Dream*, Smith College Museum of Art, Boston City Hall Gallery, 1982. Collection Chuan Ruxiang, Cambridge, Massachusetts

By combining traditional flung-ink techniques with contemporary Expressionistic gestures, Huang created an intense work. Energetically brushed blue-black water patterns are a background for colorful lotus blooms on stems that are far too wispy.

open and the other closed. This painting was confiscated and exhibited as a Black Painting. Huang was accused of ridicule: "One eye closed to socialism and the Cultural Revolution." Obviously, the verisimilitude to nature was ignored—owls often close one eye—but the entire Black Paintings concept was like *Alice in Wonderland* nonsense. Nevertheless, it meant real suffering for Huang and many others.

Yet no trace of bitterness is discernible in Huang Yongyu's quick laugh and energetic spirit. Nor is his panoramic tapestry for the Mao mausoleum shrouded with gloom. It is a sublime illusionistic background of misty mountains for a sculpture of Mao seated in a Lincolnesque pose. The picture represents many different mountains in various parts of China, bathed in a sea of mists. It is so monumental and all-encompassing that it evokes feelings of immortality, a sensation similar to the one inspired by the film *2001: A Space Odyssey*. One of eight candidates, Huang was awarded the commission on the basis of a small, rough sketch. He was chosen because of his artistic skill, but the unfairness and absurdity of the Black Paintings persecution a few years earlier may well have had some influence in the choice. He enlarged the sketch to about twenty-nine feet and then, with the help of four other artists, expanded it to about ninety feet, the actual size of the tapestry that was made from the sketch. Huang says that he lost a lot of hair during the six months that he worked on the project. Every Tuesday, during the fifty days he spent making the cartoon, Communist Party Central Committee members came to view his progress in order to make sure that Chairman Mao's memory was being properly honored.

Huang Yongyu's large painting exhibition of 1979 featured brilliantly colored flower and bird works, especially lotuses and cranes—traditional Chinese subjects rendered in traditional mediums. *Red Lotus* (plate 204) was painted for

205. *Zhang Meixi shows an album of her own paintings from the Yellow Mountains, with her artist husband, Huang Yongyu, looking on.*

this exhibition. In his richly decorative paintings he employs a variety of styles, from one that defines forms with dots, splashes, slashes, and strokes—which suggests affinities with Post-Impressionism—to a loosely brushed style of large gestures and flung ink.

Huang Yongyu loves to talk about Fenghuang, in the southern Chinese province of Hunan, where he was born in 1924 and grew up as a member of the Tujia people. His parents were both artists and taught school. He recalls spending his childhood days hunting, fishing, and hiding among the lotuses. He says this is how he came to understand the complexity of flowers, reeds, weeds, dragonflies, and frogs. His love of this complexity is revealed in the interwoven patterns so prominent in his paintings, and he compares them to the music of the Beatles, which he also admires. When he revisited his home in the summer of 1979, he did a series of indigo-blue and white dye-resist paintings on cloth in the local factory; they are lyrically decorative and appear to be pulsed into the life of the textile.

At age twelve, Huang Yongyu was sent to live with an uncle and attend an excellent middle school in Xiamen, in Fujian Province. He tells of being fifteen and needing light to study for an examination. When he tried to share the light from a rich boy's candle, Huang remembers with satisfaction, they fought, and as a result he had to leave school. He worked in a porcelain factory for several years, learning how to design, and in 1946 he went to Shanghai to work for the Communist revolutionary cause as a woodcut artist.

In 1948, Huang went to Hong Kong to work as an art editor for the leftist newspaper *Da Gong Bao*. Recognized as an outstanding wood-block printer, in 1953 he was invited to teach graphics at the Central Academy of Fine Arts. Although he remains on the faculty, he has declined to return to regular teaching since the Cultural Revolution. He says he finds it "difficult to breathe the same air" as those colleagues who denounced him. "They won't look me in the eye."

Huang Yongyu is a restlessly energetic artistic pragmatist, always experimenting, with no time for art theory. He is very impatient with what he feels is a widespread misunderstanding of Chinese painting. Although he paints primarily with Chinese ink, he also uses oils and other mediums and says that the medium itself is not the determining factor in painting. He cites Chagall as an example: a Russian who went to Paris, Chagall was influenced by international art trends and developed his own Expressionistic and Surrealistic style. Yet no matter how strongly French art influenced him, Chagall continued to be a Russian painter. Huang Yongyu believes that the Chineseness of his art is not defined by mediums and that exposure to international styles will only enrich him as a Chinese artist.

YA MING *(b. 1924, Hefei, Anhui Province)*

Ya Ming is an ebullient spirit and one of the most successful traditional painters in China. He is best known for dreamy landscapes. After the death of Fu Baoshi

206. Ya Ming. *Seascape.* 1979. Ink on paper. Inscribed: "After singing in the Yangzi River return to the East. [Poem by Zhou Enlai.] Year of the goat [1979]. Painted at Nanjing. Ya Ming." One seal. Nanjing Teahouse

The dreamlike quality of Ya Ming's seascape has touched the romantic imagination of many followers. There is a dramatic evocation of deep space created by close and distant shorelines at the top and bottom of the picture, and the minute sailboats give the impression of great scale. The proportions of his broad horizontal paper are adapted from Socialist Realist history compositions, which is quite new to Chinese ink painting.

in 1965, he inherited the mantle of leadership of the Nanjing School of landscape painting because of his dynamic personality, outstanding revolutionary credentials, close personal association with Fu Baoshi, and high level of artistic expression.

Ya Ming shines like a red star in revolutionary mythology. Born to an impoverished peasant family, he joined the Communist guerrillas at age fifteen. He fought the Japanese and the Nationalists and gained enough reputation and political background to be a leading cadre in new China. After Liberation he was able to cultivate his interest in art through informal training and guidance by various masters of traditional painting. In 1953, he visited the Soviet Union for several months and studied European art in museums there. According to his account, the visit was an occasion for much soul-searching. His personal dilemma was related to the national policy of the time: Should he follow the Soviet model and become an oil painter or should he continue in the traditional Chinese manner but attempt something new? It finally became clear to him that European styles of art were foreign to China and could not flourish far from their sources. He decided that the Chinese must choose traditional painting.

Ya Ming selected three masters: tradition, nature, and the masses. In 1957, along with Fu Baoshi, Qian Songyan, and Song Wenzhi, Ya Ming founded the Jiangsu Traditional Painting Academy in Nanjing. In 1983 Ya Ming retired from the directorship of the academy to paint and pursue his personal interests.

The Middle Generation

WU YI *(b. 1934, Guangdong Province)*

Wu Yi is passionate about painting. "Painting is my closest friend," he says. He pays little attention to the practical aspects of life—such as money—and sometimes even forgets to eat and sleep. Fortunately, he is married to Jiangsu Academy artist Shen Ronger, who is sympathetic.

Wu Yi says he holds images in his mind's eye and goes through an intense period of mental preparation before starting to paint. When he travels, he

207. Wu Yi. *Mountain Landscape.* 1979. Ink and color on paper. Exhibited in *Painting the Chinese Dream,* Smith College Museum of Art, Boston City Hall Gallery, The Brooklyn Museum, 1982–83

Wu Yi dripped and spattered ink and colors on the surface of the painting to express the energy of the mountainside. In his minimal use of the brush, he departs from Chinese tradition, yet he evokes twentieth-century master Huang Binhong's restlessly inky areas.

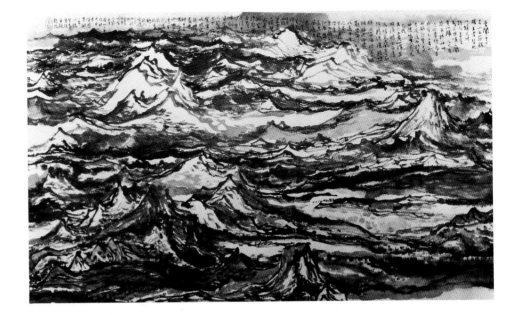

208. Wu Yi. *Kunlun Mountains*. 1984. Ink and color on paper. Inscribed: "In China there are five famous mountains far greater than any temples. These noble mountains possess the power of kingship. Although the Kunlun Mountains have more than two thousand years of history, they are outside the Great Wall and therefore they are not on this list. But, in fact, they also have always been full of power. Artists all flock to Huangshan, thinking it the best. During the time I traveled in China I have tried to understand its history. I went six times to Huangshan and it made my spirits soar. In summer 1983, my wife, Ronger, and I left Nanjing and the Yangzi. Blown by the winds and following the moon, we crossed the Yellow River several times, and finally we approached the Kunlun range. Surrounded by the desert, it was covered by a million miles of clouds. When I stood on its snow-covered peak I thought all of life below seemed so small. My spirits were so high that I sang praises to heaven and earth—both mother and teacher.

"I was on top of Kunlun in the beginning of autumn, October, 1983, with Ronger, Yong Xi, and Luo Sheng. We all went together to the top and were thrilled."

Wu Yi paints the mountain peaks rising from the Central Asian plateau in a rhythmic repetition, as if they were cresting waves in a swirling ocean. The range spans the three Northwest provinces of Gansu, Qinghai, and Xinjiang.

209. Yang Yanping. *Brown Lotus*. 1982. Ink and color on paper. Exhibited in *Painting the Chinese Dream*, The Brooklyn Museum, 1983. Collection Elsie and Nessim Shallon, New York City

The lotus is an enduringly popular traditional flower subject, and Yang Yanping brings to it a new view. Long past florescence, the brown pod, withered leaf and stem of the lotus form a rhythmically delicate pattern that suggests an autumnal mood.

returns to the same place again and again, often to view a particular scene in the rain. When he paints mist and rain, he imagines that they are all around him.

Wu says that he paints only what is real to him, avoiding anything he does not understand. In depicting mountain mists he uses dots and drips more than the conventional brushstroke to express his feelings. Many Chinese do not understand his work because of his unorthodox brushwork.

Wu Yi is a member of the Nanjing Academy of Traditional Painting and Calligraphy. In 1984 and 1985 he and his wife visited Japan and the United States, where they exhibited.

YANG YANPING *(b. 1934, Nanjing)*

An accomplished rising star at the Beijing Painting Academy, Yang Yanping paints in oil and ink with equal ease. She feels that the important thing is not the choice of medium but the expression of her vision. Her finest pieces are in ink and watercolor, which emphasize her distinctively delicate line, the clarity of her images, and her fresh palette. Her moods are naturally expressed in Chinese materials. Although she intently records traditional subjects such as landscape, flowers, and figures, her compositions are unique and original, using both long and short focus. In keeping with the new wave of realism, Yang Yanping's style is a reflective one. The fact that Yang was trained as an architectural designer allows her great compositional freedom and her painter-husband Zeng Shanqing's excellent line drawings may have been an inspiration. Yang recalls that she fell in love with her husband when he taught her art class about Michelangelo.

Yang Yanping has had many jobs since graduating from Qinghua University in 1958. She first taught architectural design, but when her interest in painting crystallized, she created stage sets and then historical paintings for the Museum

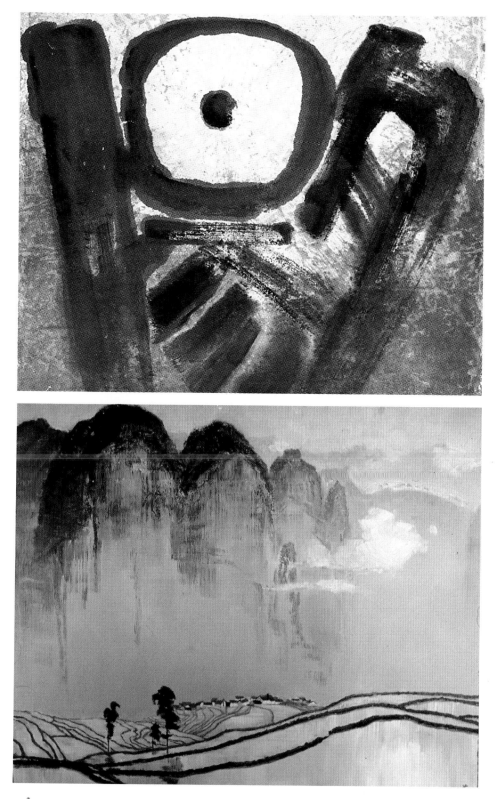

210. Yang Yanping. *Sunset.* 1982. Ink and color on paper. Private collection

This boldly brushed Chinese pictographic character for the sun expresses the artist's intense feelings. Like many Chinese artists who seek to go beyond naturalistic forms yet are uncertain in the sea of Western abstraction, Yang Yanping finds that calligraphy offers a safely Chinese vehicle for a new vision.

BELOW LEFT:

211. Yang Yanping. *Mountain Landscape.* 1979. Oil on canvas. Shown in the Oil Painting Research Association Exhibition, Beihai Park, Beijing, 1979

For a thousand years Chinese artists have painted the awesome mountains of North China in ink. Yang Yanping depicts the same subject in oil, including mist, clouds, and terraced fields. While retaining the subtly hued palette of traditional landscapes, she transforms the spirit of the work into a successful oil composition.

212. Chen Jialing. *Pink Lotus.* 1980. Ink and color on paper. Inscribed: "Early morning sunshine. 1980. Chen Jialing, Shanghai, Long Chuan Yuan." Exhibited in *Painting the Chinese Dream*, Smith College Museum of Art, Boston City Hall Gallery, The Brooklyn Museum, 1982–83. Private collection

This composition embodies the traditional Chinese notion of painting the essence of the flower as well as the spirit of contemporary experimentation in the way that the ink blots are permitted to continue beyond the paper's edge. Using the edges creates a tension new to traditional flower painting.

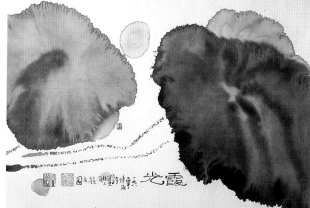

213. Chen Dexi. *Mountain Landscape*. 1985. Ink on paper. Inscribed: "The massive mountain is quiet and remote at sunset. Recently, I've done more landscape painting and find it more satisfying. It is my hope to express my deepest feelings about mountain and river with brush and ink. The image has meaning beyond the form. I define the space and the mountain with my brush. What a joyous task. Spring 1985."

Chen created an inky peak that rises dramatically in solitary splendor. It is densely brushed with a texture stroke learned from Fu Baoshi, yet the vision is Chen's.

of Chinese History and the Revolution. Finally, in 1980 she went to the Beijing Painting Academy, where she had her first professional opportunity to paint her own compositions. A member of the prestigious Oil Painting Research Association, she frequently exhibits and is published in China and abroad. She has also been a visiting artist in Austria and the United States.

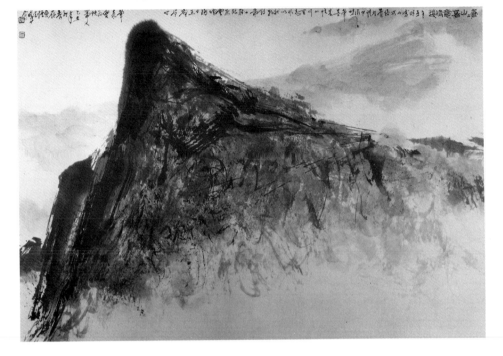

CHEN DEXI *(b. 1936, Shantou, Guangdong Province)*

Chen Dexi is a painter who found his way back to his Chinese roots after leaving China. Studying at the Nanjing Academy of Art during the Sino-Soviet period (1949–59), he was trained as an oil painter in Socialist Realism and learned Russian as well. After the Chinese broke with the Soviet Union, Chen was sent to the Jiangsu Traditional Painting Academy, in line with the national policy that repudiated Soviet-dominated art. He answered the party's patriotic call to paint figures—to record the masses using Chinese ink on paper.

Chen Dexi faithfully painted figures and taught at the Nanjing Academy of Art from 1957 until 1982, when he emigrated to Hong Kong. Now he feels he can paint and teach exactly what he believes and still follow the principles of Chinese painting. He says that technique and skill are not enough; one needs to know the full range of cultural elements, including calligraphy, philosophy, movements, astrology, and medicine. The profound point he makes is that in painting, just as in philosophy, one must see beyond superficial aspects and into the very structure and soul of art. "But," he says, "if you used my approach in China, people would regard you as superstitious."

Because of his Confucian background, Chen Dexi strives for the mean: neither too strong nor too weak. This is evident in his handsome landscapes, which pay homage to his Nanjing master, Fu Baoshi. Chen creates images that

are very much his own, a combination of densely constructed mountains and floating mist that has both lyric beauty and inner strength.

CHEN JIALING *(b. 1937, Hangzhou, Zhejiang Province)*
Chen Jialing says that for inspiration he thinks about four Chinese characters: "true," "spirit," "flow," and "pervade." Chen has committed himself to

214. Chen Jialing. *Bird and Flower*. 1981. Ink and color on paper. Inscribed: "Appreciation of Sunrise. Chen Jialing. 1981. Shanghai. Long Chuan Yuan." Collection C.C.I.C. Finance Company, Hong Kong

Chen Jialing transforms an old subject into a richly colored and highly decorative contemporary mode. He uses a variety of ink techniques such as ink-absorbed paper to print delicate stems and richly hued flowers and birds by applying one color layer over another wet color layer.

transcending the limits of traditional painting to find a new style. Building on his strong traditional foundation as a resource, he moves beyond its constraints. Qiu Deshu (discussed in "Groups," pp. 67–68) was his student, and when in 1979 this gifted pupil formed the Grass Grass group of artists, who were committed to exploring new modes of expression in ink and watercolor, Chen joined them.

Chen Jialing hungers for knowledge and the ability to select discerningly. His work combines the sublime vision of the eccentric Qing dynasty painter Zhu Da with a modernist spirit. He has done outstanding exercises with saturated ink blots that bleed beyond the paper's edge, as can be seen in *Pink Lotus* (plate 212). He has continued to develop ink techniques to blot, seep, and print with superlative control and delicacy. Chen Jialing studied Chinese painting at the Zhejiang Academy of Fine Arts in Hangzhou. After his graduation in 1963, he taught at the high school affiliated with the Shanghai Art College, and currently he is a member of the Shanghai University faculty. Chen Jialing has exhibited in China, Hong Kong, and the United States.

FAN ZENG *(b. 1938, Nantong, Jiangsu Province)*
One of the best-known traditional painters of his generation, Fan Zeng has shown his work in China, Hong Kong, Japan, and North America, and it is

RIGHT:

215. Fan Zeng. *Xie Lingyun*. 1980. Ink and color on paper. Inscribed: "The wind swirled around Xie Lingyun."

The Chinese literati made heroes of officials who were unjustly libeled at court and forced into exile or, as in Xie Lingyun's case, killed. The story of this official from the Six Dynasties period is retold for its political relevance today. In a strongly illustrative style, Fan Zeng portrays the proud poet-official standing firm while controversy swirls around him.

FAR RIGHT:

216. *The artist-poet Fan Zeng is deeply involved with the ancients, whose work he reads and whose images he paints. But he proved that he does more than dream of butterflies when he created a new department of Asian studies at Tianjin's Nankai University in 1984.*

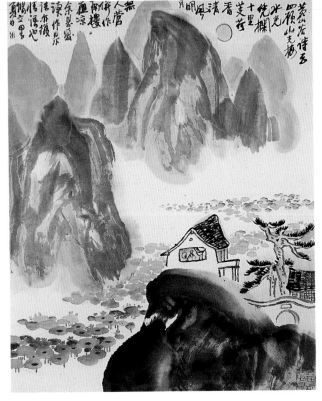

avidly collected. In 1984 a patron created the Fan Zeng Museum in Japan. His work is the only ink-painting composition among the Beijing airport murals.

It seems out of character for this artist, who is the very model of a sophisticated modern man, to consistently select ancient subjects—poets, sages, and mythological figures—and paint in a style that is traditional. He paints with the kind of humor and irreverence that is only possible after a long and intimate relationship with his subjects. A twelfth generation poet, he is well schooled in poetry and literature as well as in calligraphy. His painting, with its linear, illustrative qualities, is closely related to his calligraphy.

In his painting of Su Dongpo (1037–1101), Fan Zeng portrays one of China's most celebrated Song dynasty poets. A scholar-official, Su served the imperial government in the provinces until he criticized some unreasonable new laws and was sent into exile; later, his post was restored to him. His poems read like the diary of a member of the literati—which he was—depicting the scenes and discussing the ideas of his time. Su was an ebullient character who expressed his zest for nature and the world despite his sometimes woeful fate. The poet-official is painted with swashbuckling gusto; he is obviously admired by the artist, who doubtless feels an affinity for his subject.

ZHU XIULI *(b. 1938, Shanghai)*

As a young teacher Zhu Xiuli had a memorable opportunity to travel to scenic spots and paint with the Nanjing masters Fu Baoshi and Qian Songyan. But such good luck ended during the Cultural Revolution, when he was shattered by criticism, warring factionalism, and lack of law. Distressed by the ten years of upheaval in Nanjing, he applied to live in the countryside in Anhui Province, where he could live more peacefully and be reunited with his wife and child. His

wife's work was in Anhui Province, and she was unable to get a transfer to Nanjing. This was an extremely unusual move, because most artists fight to move from the countryside to metropolitan centers. But in time Zhu's painting began to reflect the innocence of his new environment. He became a member of the Hefei Painting Academy, where he felt free to do his own work, and he could travel to the Shenzhen University Academy of Painting as a visiting artist. He observed the artistic limitations that were in effect in 1984: no absurd poses, no suffering, and no unrecognizable subjects. "No one says you can't paint these things but there is social pressure, and people would neither like them nor understand them and they won't be exhibited," he says. He notes that artists who are supported by the state must please their patron!

Zhu Xiuli draws upon traditional subjects and uses techniques in painting that have a freshness unusual in China today. His versatile brush freely strokes figures, mountains, or shrubs. Perhaps it is the artist's sustained observation of the countryside and his own peaceful state of mind that have enabled him to imbue his compositions with an untrammeled nature.

ZHOU SICONG (b. 1939, Hebei Province)

After graduating from the Central Academy of Fine Arts in 1963, Zhou Sicong went to paint at the Beijing Painting Academy. She now has an additional administrative responsibility as deputy chairman of the Chinese National Artists Association.

Zhou Sicong paints figures with traditional brush and ink. But the figures

217. Zhu Xiuli. *Scholar in His Cottage Viewing Moon and Lotus.* 1983. Ink and color on paper. Inscribed: "Huang Shanyu wrote, 'In the mountains by the river no one sees me in the moonlight looking at the lotuses and feeling the soft wind. I feel wonderfully refreshed in this southern retreat.' I always read this poem because of the landscape image and also because of what's in my heart. Xiuli, Summer, 1983." Private collection

Although Zhu paints a time-worn subject there is a freshness in the delicately colored lotus and a delicious humor in the figure of the scholar fanning himself. The artist appears to have achieved the harmony of heaven and earth.

218. Zhou Sicong. *Purgatory.* 1982. Ink on paper. Shown in the Twenty-fifth Anniversary Exhibition of the Beijing Painting Academy, National Art Gallery, Beijing, 1982

In a strongly Expressionist composition, the artist depicts the suffering of the Chinese people who were interned by the Japanese during their occupation of China. Barbed wire stretches horizontally across the surface, imprisoning men, women, and children. The picture is further divided by dark vertical shafts. The effect is a kaleidoscopic view of oppression in bleak tones of black and gray. Some figures are bent over, others look out at the viewer questioningly. A single Japanese guard with bared bayonet looks over his shoulder menacingly.

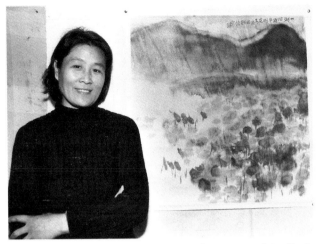

219. Zhou Sicong. *West Lake.* 1982. Ink on paper. Inscribed: "Rain and mist, half-covered with lotus."

Zhou usually paints figures in an Expressionistic style. However, in this more traditional landscape of the famous Hangzhou scenic spot, the artist has evoked an individualistic, passionate experience of nature, just as she expresses her feelings about the people she paints.

have an Expressionist poignancy and power not seen in the work of earlier traditional painters. No doubt inspired by Käthe Kollwitz, Zhou paints figures that express their human burden through their posture. The economy of line and disciplined use of light and dark masses contribute to the overall strength of the work. She endows her figures with humanistic power and reveals the burden of their lot. It is with simplification and the massing of dark tones that she conveys the tense message.

Zhou Sicong discusses the problems that virtually all working women in China face: the responsible administrative job and the family obligations that keep her from painting. She says it takes vast amounts of time and energy to care for her mother-in-law and children, but she makes time to paint at night or on holidays. It is particularly difficult to work at home because of the crowded urban living conditions.

CHEN DEHONG (b. 1936, Kunming, Yunnan Province)

Trained as a sculptor at the Central Academy of Fine Arts, Chen Dehong has created monumental groups of workers, peasants, and soldiers, as well as a portrait sculpture of Chairman Mao. In 1981 he won a government scholarship to study in Paris at the École des Beaux-Arts. He was stimulated by the Western art he saw in Paris, which inspired him to expand his capacities beyond the level of his current work. Chen Dehong wanted to express himself freely, to explore abstraction, but still keep in touch with his soul. Inspired by a strong sense of cultural identity with Chinese ideographs, Chen created a series of word images, using ink and dashes of color (plate 222). With a broad brush and flung ink, he transformed the ideographs from mere means of communication to high expression. Many Chinese and Japanese have tried to do this, but few have achieved such freedom and energy.

ZHAO XIUHUAN (b. 1946, Beijing)

Zhao Xiuhuan is one of the most successful young artists at the Beijing Painting Academy because she transforms her traditional subjects and technique into a modern vision. This is quite a challenge for a bird and flower painter using the old finely outlined style called *gongbi*. Riding the wave of New Realism with her peers, she avoids the inherent clichés by thoughtful borrowing from the past and fresh observation of nature. Zhao says, "I use old compositions to arrange stones." But she goes on to say that she does it from memory and that, moreover, one can look at old paintings, but when one paints, one must use modern eyes.

Zhao Xiuhuan attended the high school affiliated with the Central Academy of Fine Arts, where she learned Western color theory. Now she uses Chinese colors but applies Western methods. She greatly admires Japanese painting, and her work shows affinity to it. Zhao layers colors to produce rich, opaque hues and sometimes she outlines in gold. She uses pointillist dots to create textured rocks and always achieves richly decorative compositions. Her extraordinary technique is very precise, and her work has a subtly romantic air that places her

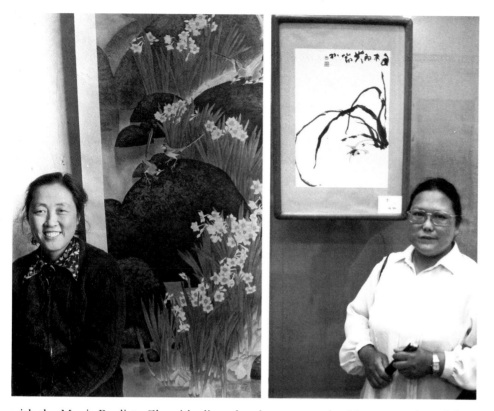

220. Zhao Xiuhuan. *Spring*. 1983. Ink and color on paper

Artist Zhao poses beside her composition in her tiny bedroom/studio. She, like her peers, lives and works in a minute space.

221. Deng Lin. *Orchids*. 1982. Ink and color on paper. Inscribed with her name and an expression of her serene spirit while painting. Two seals. Shown in the Twenty-fifth Anniversary Exhibition of the Beijing Painting Academy, National Art Gallery, Beijing, 1982

Deng Lin (b. 1941, Guang'an, Sichuan Province) is a strong painter who continues to use the traditional vocabulary and composition. She explains her conservatism in patriotic terms that seem especially poignant because she and her siblings were special victims during the Cultural Revolution due to the high position their father, Deng Xiaoping, had held.

with the Magic Realists. Zhao idealizes the elements, and subjects are selected for their perfection. She does not apply the unflatteringly magnified objective vision of Photorealism.

The Younger Generation

YANG GANG (b. 1946, Beijing)

Yang Gang's work conveys his remarkable technical subtlety and vision. His quick sketches are characterized by severity and economy, and his gouache-and-ink paintings have the exquisite finish of the traditional, precisely outlined *gongbi* style. He has mined traditional Chinese painting, adding a touch of humanity in the manner of the Mexican muralists of the 1930s. Drawing on Expressionism, he imbues his figures, such as wrestlers, with a riveting intensity, and there is a warm and appealing Everyman quality about his crowds.

After studying at the high school affiliated with the Central Academy of Fine Arts, Yang Gang went to Mongolia and lived there for a number of years during the Cultural Revolution, an experience that left a deep impression on him. He continued to use the Mongolian people as subjects after his return in 1978 to the postgraduate program at the Central Academy of Fine Arts and subsequently at the Beijing Painting Academy.

NIE OU (b. 1948, Shenyang, Liaoning Province)

Nie Ou is an exceptionally gifted young painter who joined the Beijing Painting

222. Chen Dehong. *Rainbow. 1984.* Ink and color on paper

The form of the Chinese character, or ideograph, for rainbow (虹)—which also means Chan (Zen)—inspired the structure of this composition. Then the artist improvised, expressing his feelings about rainbows.

223. Zhao Xiuhuan. *Spring.* 1983. Ink and color on paper

In this decorative yet monumental composition, the narcissus blooms, bulbs, and birds are depicted with a precision nurtured in the gongbi style of traditional painting. But the microscopically studied subjects depart from tradition by being modeled in light and shade and placed in three-dimensional space. The scene is set with a classic firmness and idealization, showing perfect blooms and leaves, artfully rounded rocks, and playfully patterned water and shadows.

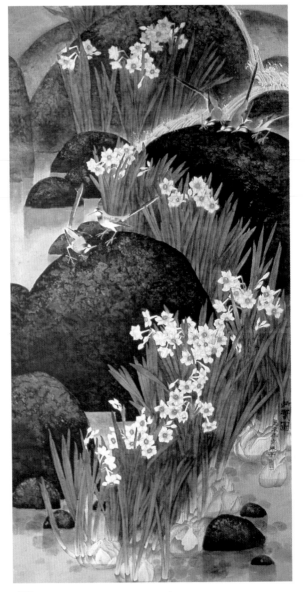

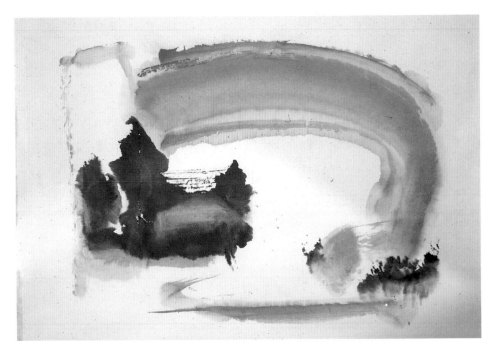

Academy upon completion of her postgraduate course at the Central Academy of Fine Arts.

When Nie Ou was five, her family moved to Beijing, where she learned to paint at a Children's Palace after regular school hours.

During the Cultural Revolution, according to her account, she was sent for some months to the southwestern province of Guangxi to entertain Chinese troops who had been fighting in Vietnam. Then, she and her schoolmates, the so-called educated youth, were sent north to settle in the countryside. For six years, she spent most of her time working in the fields, but she also made propaganda paintings. In 1975 she returned home to Beijing, but not to school or to work. She waited for three years before she could take the entrance examinations at the Central Academy of Fine Arts.

Nie Ou paints in oil or in ink, in a single style suitable to both mediums. Her graduation piece, *The Bronze Age,* in ink and color on paper, is a Socialist Realist work. It is in the typical Grand Manner, wide rectangular format. In this painting, she aimed to show the skill, wisdom, and enthusiasm of the Chinese people during the period the Communists call the Slave Society (twentieth century B.C.–475 B.C.), part of which time Confucian historians refer to as the Golden Age. This large narrative work depicts the process of making bronze vessels. It begins with mining the metal, transporting it, using it to cast vessels, and then employing the vessels in sacrificial ceremonies. It ends with the burial of a human sacrificial victim. In the space normally occupied by the sky is an enormous monster mask (*tao tie*), which symbolizes the world of another age.

Nie Ou inherited her taste for academic anatomical rendering from Xu Beihong, but her figures seem less posed than his. Like Zhou Sicong's, they have

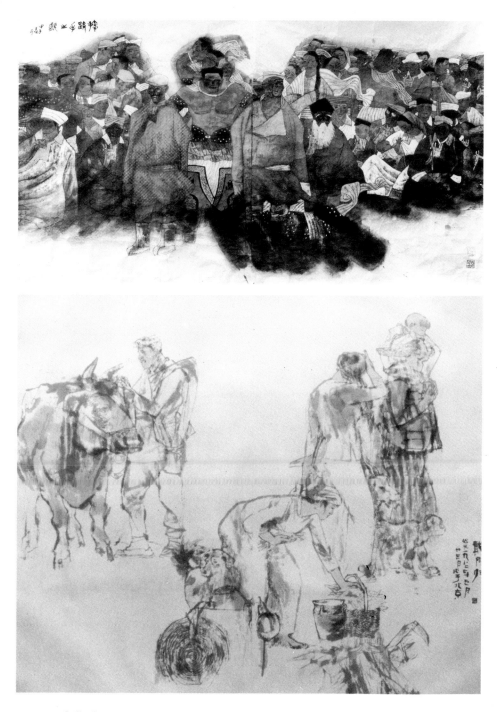

224. Yang Gang. *Song of a Wrestler.* 1983. Ink and color on paper. Shown in the Sixth Chinese National Exhibition, Nanjing, 1984

This large composition has the scale of a mural. The subject of the narrative is a Mongolian fair that features a wrestling contest. The figural style and composition echo elements of the Mexican Expressionist version of Socialist Realism, but at the same time the precisely outlined traditional Chinese gongbi *technique is employed.*

LEFT BELOW:

225. Nie Ou. *Return by Moonlight.* 1982. Ink on paper. Inscribed: "Return by Moonlight 1982, Beijing."

Nie Ou's figures have warmth and humanness and none of the sentimentality of the official propaganda style. She combines her outstanding brush skills with the personal observations she made while living in remote areas. She selects from real life to create genuinely human genre scenes.

226. Nie Ou. *The Journey.* 1984. Ink and color on paper

Nie Ou poses in the courtyard of the Beijing Painting Academy, where she and her colleagues meet every week to discuss artistic issues.

a powerfully human element. Both artists draw upon Socialist Realist roots, but Nie Ou transformed the images of ideal heroes to the world of real people.

From her perspective as a newlywed, Nie Ou adds to Zhou Sicong's comments about the female artist's dilemma. Because of her shyness and the interruption in her education, Nie Ou was still single at an age when most Chinese women are married. She was courted by many, but Nie Ou waited until she found a partner who would understand her commitment to art, someone whom she could

227. Bo Yun. *Suzhou.* 1980. Ink and color on paper. Signed: "Bo Yun."

Whitewashed houses with black-tiled roofs are the typical architectural style of South China. Many artists have been inspired by the graceful patterns of these houses as seen reflected in a Suzhou canal. Bo Yun has expressed this poetic vision in a Post-Impressionist manner, using traditional Chinese materials.

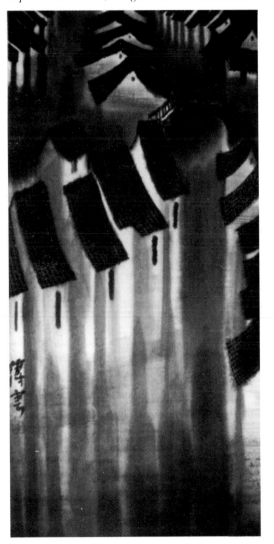

228. Xu Jianguo. *Contrasting Space.* 1981. Ink on paper. Exhibited in *Painting the Chinese Dream*, Smith College Museum of Art, Boston City Hall Gallery, The Brooklyn Museum, 1982–83

Several identifiable calligraphic images move the eye clockwise across an ominously inky sea. The artist says the small strokes represent men struggling against each other and the larger black area refers to the conflicts caused by growth within the city. Xu Jianguo uses the traditional flung-ink technique, but he also draws on international Abstract Expressionism.

admire. In China most famous women artists are married to artists, often to their teachers. In 1982 Nie Ou married oil painter Sun Weimin, a member of the Contemporaries group. She notes that it is unacceptable not to have a child. "Men are luckier," Nie Ou says simply. She quotes an old saying:

> If a woman has no child it is a pity.
> If a woman has a child it is a pity.

Nie Ou says that men always ask her what she will do after she has a child. Clearly, she expects to go on painting.

BO YUN *(b. 1948, Beijing)*

Bo Yun was one of the few professionally trained artists who exhibited with the Star Star group in November, 1979. He attended the high school affiliated with the Central Academy of Fine Arts and the academy itself, where he studied "art theory," a Marxist version of art history. He now teaches art theory at the Central Academy of Arts and Crafts. Bo Yun's work crosses East–West boundaries by combining Chinese ink technique with a Post-Impressionist vision. He has exhibited frequently in China and abroad.

XU JIANGUO *(b. 1951, Shanghai)*

Xu Jianguo is a new-wave painter who delves deeply into Chinese tradition while restlessly expressing himself in modern terms. He wishes passionately to express his inner spirit, in the manner of the internationally acclaimed Zhao Wuji, the

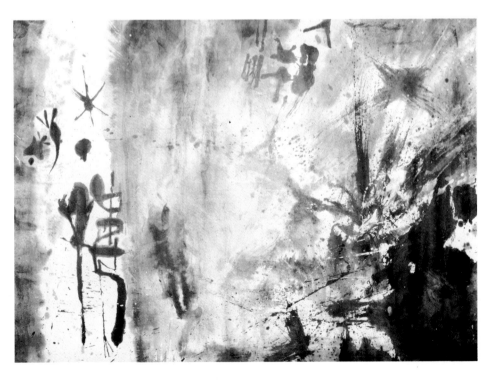

Abstract Expressionist Chinese-French artist, whom he emulates. When he splashes ink and broadly brushes gestures, his work is abstract, but on a smaller scale, it is recognizable as calligraphy. Moreover, the fantastic creatures who appear in his urban environments are based on oracle-bone writing forms. Xu Jianguo has not been able to exhibit such works in China because the imagery is not recognizable as narrative nor is it decorative.

During the Cultural Revolution, Xu Jianguo had an opportunity to study art at the Shanghai Drama Academy, in a special class for workers, peasants, and soldiers. The course was shorter than the usual one, and it had a highly political content. Admission to almost all courses offered during that period depended on the high political consciousness and proletarian origins of the applicant rather than on professional and academic skill. Xu Jianguo's father was a worker in the Shanghai Opera House, and thus the boy was eligible for education. Xu had not studied art at the local Children's Palace because prior to the Cultural Revolution, only the children of cadres were likely to be admitted. But as a youngster he studied traditional painting with a neighbor who ran a bookstore. Later, when Xu was at the Drama Academy, he became so engrossed with oil painting that he couldn't sleep because of his restless search for self-expression. He finally had to go to a doctor to obtain medication, which helped him overcome his extreme anxiety.

Xu Jianguo, who has also been a set designer for Chinese operas, is currently studying art in the United States. He has exhibited in Shanghai, Hong Kong, and the United States.

MA DESHENG *(b. 1952, Beijing)*

A principal organizer of the Star Stars, Ma Desheng showed his expressive wood-block prints in the group's exhibitions of 1979 and 1980. He captured an awareness of suffering in his mostly black, hard-edged compositions, using simplified images of man and beast. His brush-and-ink paintings convey the same intensity, but they contain freely gestured forms that erupt with splashes and blots.

The artist's personal wit and vitality mask his wounds. Born into the generation that was deprived of secondary education, he was doubly handicapped. When he was only a year old, he contracted polio and lost the use of one leg. After the Cultural Revolution, when he applied to take the admission test for the Central Academy of Fine Arts, he was excluded because of his physical problem. In spite of this, he has courageously continued to work independently. The artist who pursues such a course—even without any handicap—encounters such adversity that most are discouraged. The independent artist has no unit to promote his work and pay him while he paints. He has no access to a library, even a municipal one, because he does not qualify as a painting specialist and therefore has no perquisites.

Ma Desheng has exhibited in China and Europe, and he has been a visiting artist in Switzerland. He is a painter of real promise.

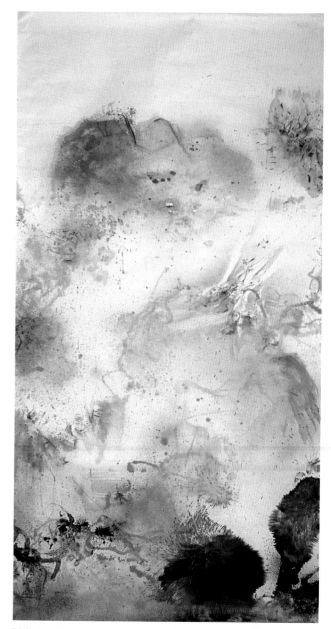

229. Xu Jianguo. *Mountain Landscape.* 1983. Ink and color on paper. Collection C.C.I.C. Finance Company, Hong Kong

The ink blots, dots, and brushed gestures of this mountain landscape explode with volcanic intensity. Yet, the warmly hued configurations make the scene inviting.

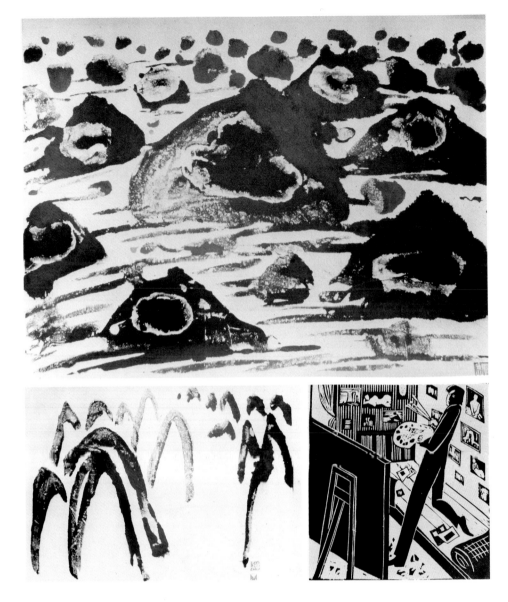

CLOCKWISE, FROM TOP:

230. Ma Desheng. *Mountain Landscape*. 1983. Ink on paper

Using a traditional Chinese subject, a mountain landscape, and the traditional ink techniques of dotting and stroking, Ma Desheng achieved this radically new formulation. The fresh energy of this personal vision is notable.

231. Ma Desheng. *In My Studio*. 1980. Wood-block print

Ma Desheng shows himself in his studio in a stylized expression that evokes Europe in the 1920s. Surrounded by Modernist works in his tiny room, he leans on his bed to view his painting at maximum distance, making a comment about the artist's difficult working conditions. In practice, to view an experimental piece outdoors might start neighborhood gossip, which could lead to questions from the public-security police.

232. Ma Desheng. *Mountains*. 1982. Ink on paper

In this landscape, one of a series, Ma Desheng has brushed what he sees as the bones of the mountains. This shorthand message, created with ultimate economy, relates to international minimalist and conceptual trends.

233. Lang Sen. *Red Blossom Tree*. 1981. Ink and color on paper. Inscribed: "Sunny day in Xishuangbanna, flowers in the botanical gardens…"

A young teacher at the Yunnan Art College who graduated from the Central Academy of Fine Arts in 1981, Lang Sen (b. 1945, Kunming) expresses his admiration for Xishuangbanna's exotic plumeria *in this highly colored, energetically composed work.*

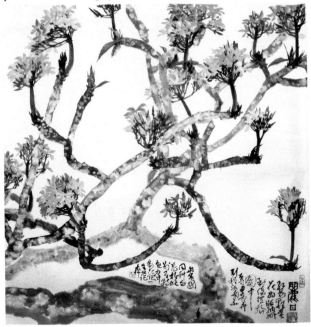

LIU TIANWEI *(b. 1954, Shanghai)*

Liu Tianwei's story is that of many who were schoolchildren when the Cultural Revolution began in 1966. He was twelve years old that year, and his formal education ceased. His school, like most institutions, devoted itself to political activity. Schoolchildren were organized into political gangs of Red Guards. They denounced cadres, demanded confessions, and ransacked homes for books, paintings, antiques, cameras, radios, and anything else declared bourgeois.

Because Liu Tianwei's father, the successful Shanghai artist Liu Danzhai, had been arrested as a counterrevolutionary, the son was not only excluded from Red Guard activity but also was called on to repudiate his father. Then his mother was arrested. When Liu Tianwei went into the street, people threw stones at him.

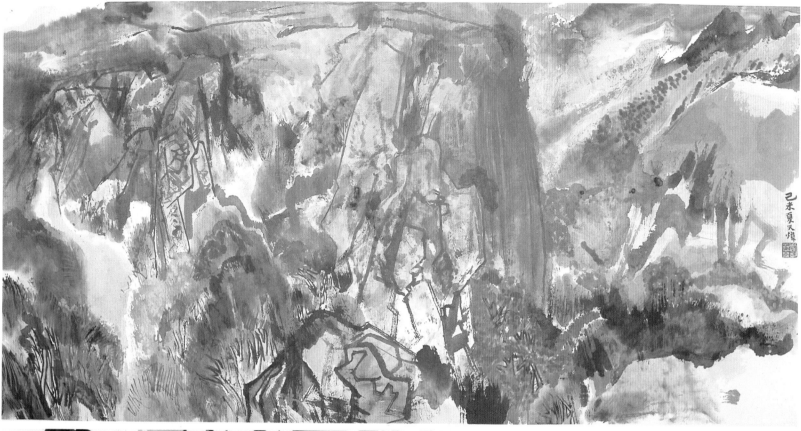

234. Liu Tianwei. *Landscape.* 1979. Ink and color on paper. Exhibited at the Shanghai Art Gallery, 1980; *Painting the Chinese Dream,* Smith College Museum of Art, Boston City Hall Gallery, The Brooklyn Museum, 1982–83

The use of black ink in this mountainous composition follows Chinese tradition closely. However, the brilliant patches of color are reminiscent of the Expressionist color schemes of the Fauves.

LEFT:
235. Liu Tianwei. *Untitled.* 1984. Ink and color on paper. Exhibited at the Chinese Cultural Center, Boston, 1984. Private collection

Liu stepped beyond landscape into a language that draws from the calligraphic tradition of Chinese painting, but the visionary scheme is his own. An admirer of Miró, Liu also makes his forms float and he uses bold primary colors. A very personal set of symbols conveys his feelings.

Although the first years of the Cultural Revolution were most unfortunate for the family, when Liu Danzhai was released from prison his son was very happy to stay home and study with him. As a child, the talented Tianwei had won several art prizes. Liu Danzhai taught his son more than just technique. He gave him the old-style education of the literati, which included art history, philosophy, and connoisseurship.

When Liu Tianwei came to the United States as a student in 1981, he was a

236. Shao Fei. *Tiger & Tot.* 1984. Ink and color on paper

Shao Fei was inspired by an appealing folk-art product—a child's "tiger" pillow that she saw while traveling in rural Shanxi Province. In this freely brushed study, an energetic toddler dances around the tiger's tail with the confidence of a cartoon character.

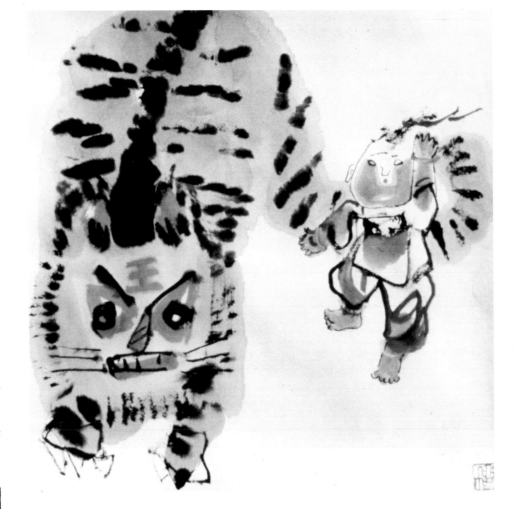

237. Shao Fei. *New Year's Preparation.* 1984. Ink and color on paper

Shao Fei stands beside the large narrative work she created for the Sixth Chinese National Exhibition. In the foreground, peasants produce folk-art toys and decorations in a remote Shaanxi village. The background dances with visions of spirit-like figures. There is official pressure, sometimes subtle and sometimes not, on artists to paint what they have seen on field trips and to use such material to present a positive narrative message.

very accomplished traditional painter, and he has continued to develop. His abstract Chinese painting is striking and confident. The calligraphic configurations show his affinity with Miró, yet go well beyond to express his own images. "The training I received is in the Chinese mode. These works are only an extension of what I did before. The changes are only logical."

SHAO FEI *(b. 1954, Beijing)*
Shao Fei is one of the younger artists at the Beijing Painting Academy. She had only five years of actual education during her nine school years because teaching stopped once the Cultural Revolution began. Fortunately, Shao Fei was able to study art with her mother, who is an oil painter. She joined the army at age sixteen, and during her six years of service she was able to paint and exhibit. When she was twenty-two, she entered the Beijing Painting Academy, but she wants still more education.

Shao Fei was a member of the taboo-breaking Star Star group and participated in its exhibitions of 1979 and 1980 as well as in many other exhibitions in China, the United States, and Japan.

An important work of Shao Fei's was shown in an exhibition, *Contemporary Chinese Painting*, which toured in the United States in 1984 and 1985. In *Last Song of the Grand Historian*, Sima Qian, the subject, is shown as a large, tense, and brooding figure, clutching a bundle of bamboo strips on which he writes his history. His dark figure is lined with inky black wrinkles that articulate his burden. His history is written in ideographs that have the look of rubbings made from stone engravings. Shao Fei has painted on both sides of the paper to build up dense, opaque layers, similar to the surfaces of the Modern Heavy Color painters. The deeply emotional feeling of the artist is conveyed through her Expressionistic devices of composition, stroke, color, and texture.

Fluent and versatile in her quick sketches, Shao breathes life into her scenes, and her figures are accessible and appealing.

HUANG HUIHUI *(b. 1960, Quanzhou, Fujian Province)*
As a gifted young painter, Huang Huihui was included in the National Youth Art Exhibition at age nineteen. Under the guidance of his father, a well-known artist, he had already become a full-blown traditional ink painter. With his confident strokes and dots, Huang creates the expected traditional subjects, but they are so vitally energetic that his work stands out from that of his peers. He is the youngest member of the Southern Fujian Art Group (see "Groups," p. 63).

238. Huang Huihui. *Landscape*. 1980. Ink on paper

While still a teenager, Huang Huihui created fluent and pulsing work that is individual yet well within the conventions of traditional painting.

239. Huang Huihui. *Landscape*. 1980. Ink and color on paper

Ink dots dance over the surface, transforming the traditional composition of mountains, water, and architecture into a shimmering, vibrating creation. Huang's blots have an energy that gives the old formula new vitality.

PEASANT PAINTING AND NEW YEAR'S PAINTING

240. Jinshan peasant artist. *Home*. 1984–85. Gouache on paper

This precisely painted account of a peasant family dining in their house has the naive charm and flat decorative qualities of the traditional embroideries that served as inspiration for the painter. The seated father and children await the mother, who is approaching with a platter of food. They are all pink-cheeked and charmingly defined. A household pet, pink as a piglet, with yellow feathers like a chicken and brown stripes like a raccoon, scampers at the right. Household essentials are carefully recorded. From the left: the door, water jars, a washbasin on a tripod, a whitewashed earthen stove painted with floral patterns and containing two shelves, cooking pots on the circular black stovetop (including two fish in a frying pan), four hanging strands of garlic, and two storage pots. The artist shows a wooden pot top from above, but the pots themselves are shown in profile.

The theoretical basis for a peasant art movement was set following Mao's call for an art of the masses in his Yan'an "Talks" of 1942. Peasants subsequently engaged in painting, and some exhibitions of their work were held, but it was not until the Cultural Revolution, when Jiang Qing designated peasant painting as a cultural model, that peasant art became important. Similarly, New Year's pictures had been made continuously, but both form and content were extensively revised after 1949. Neither genre became important in the art scene until the 1970s, when the art establishment sponsored major exhibitions. In 1980 a department of New Year's painting was established at the Central Academy of Fine Arts.

These two categories, peasant painting and New Year's painting, are linked because both are officially recognized attempts to connect art with popular culture, albeit through different directions.

Peasant Painting

The first peasant painting movement to receive national and international attention was organized at Huxian, about thirty-five miles outside Xi'an, the capital of Shaanxi Province. In 1958 the Huxian peasants organized a group as part of a nationwide peasant painting movement that began during the Great Leap Forward, when high political consciousness was valued over professional competence. Mao argued that emphasis on ideology would lead to miraculously rapid modernization and self-reliance for the Chinese people. Chairman Mao exhorted: "Everyone may participate in artistic creation. Peasants, you may paint."

Many Huxian peasants and some cadres began to paint in their spare time. They painted their own environment, farms and mountains, in a naive, cartoon-like way until, according to Ellen Johnston Laing ("Chinese Peasant Painting, Amateur and Professional," *Art International* XXVII/1, January–March, 1984), they received some unacknowledged professional help. Dr. Laing convincingly argues that the peasant painting of 1958 looked uncoached, quite different from the mature Huxian style of the 1970s, which has academic content such as spatial perspective and figures modeled in light and shade. The peasants needed artistic help to raise the standard of their work to the level necessary for it to become designated as a cultural model. The professional coaching was probably unacknowledged because it would have been an ideological embarrassment to admit that the peasants needed help. The Cultural Revolution's message was that professional artists had created bourgeois art since 1949, and only now would a pure revolutionary art form emerge through the active participation of the unpolluted masses.

Huxian painters produced two basic formulas for their pictures, both of which employ bright colors. One style is for propaganda, portraying local heroes and deep-space landscapes. The other is decorative, with strong geometric organization and repeated patterns. The scenes are populated by happy peasants at work. The designs were inspired by textiles, embroidery, paper cutouts, and cartoons. Huxian peasant painting is propaganda painting with the added naïveté of peasant elements.

In October, 1973, an exhibition of Huxian peasant painting was held at the National Art Gallery. It then became the first show of post-1949 Chinese painting to be sent to the West. De facto, peasant painting became official painting.

The Huxian peasants produced thousands of paintings done in gouache on paper, including multiples of the same work. In addition to these, they produced, with some professional guidance, wood-block prints of their paintings to circulate and sell. In the 1970s, during the Cultural Revolution, some artists left their cities to apprentice with the Huxian group. Professional artists unable to travel to Huxian during the early part of the Cultural Revolution succeeded in going to Beijing to see the Huxian show and "learn from the peasants."

Even in the relaxed political climate of the post–Cultural Revolution era,

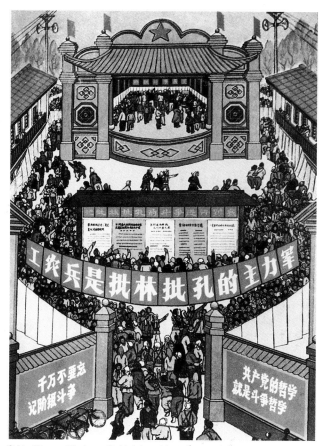

241 Yang Qiyian *Criticizing Lin Biao and Confucius.* 1973. Ink and color on paper

This peasant work from Huxian in Shaanxi Province was painted in 1973 during the political campaign condemning Lin Biao and Confucius, which was actually an attack on Premier Zhou Enlai by Jiang Qing. Slogans in the painting read: "Workers, peasants, and soldiers are the main force in the army of 'Down with Lin Biao and Confucius.' Never forget class struggle. The philosophy of the CCP is force." Bright colors, strongly organized design, and cartoon-like figures characterize this variety of peasant propaganda painting.

OPPOSITE, BELOW:
242. Yijunxian peasant artist. *Mother Goat.* 1984–85. Gouache on paper. Private collection

Figures traced from paper-cut patterns produce this sharply decorative and lively composition. The central mother goat stars in her pregnant and nursing cycles. The artist does not overlook the goat's elimination pattern, either. Another goat and birds admire her while a herd boy in striped pants, carrying a pipe and a prod, walks behind her.

243. *Shellfish Parade.* 1982. Paper cutouts. Spring Festival Folk Art Exhibition, National Art Gallery, Beijing, 1982

A tortoise, a shrimp, a clam, and a crab march smartly to a staccato paper-cut pattern. These partially anthropomorphized seafaring creatures often play roles in popular literature and drama as well as in decorations. These were made for a paper window at Spring Festival time.

RIGHT:

244. Student work from the Central Academy of Arts and Crafts. *Chinese Zodiac Animals.* 1983. Wool tapestry

From the upper-right corner, clockwise, the animals are: monkey, bird, tiger, goat, snake, pig, rat, rabbit, dog, bird, horse, dragon, and bird. Center: cow and New Year's baby. Each Chinese zodiac animal represents one of twelve successive years. The year into which a person is born is believed to be a governing factor in the development of character. The traditional peasant symbols have been integrated and woven into a successfully decorative tapestry.

FAR RIGHT:

245. Doorway to a Chinese house, hung with auspicious marriage inscriptions and pictures in the form of a traditional New Year's decoration. 1981. Guangdong Province. Written inscriptions: Top: "Double happiness." Right side: "If I love you and you love me we will be a good couple." Left side: "Partners should choose each other to make a good union."

The posters on the door picture labor heroes effecting the socialist transformation of China. Done in Socialist Realist propaganda style, they are meant to inspire the couple and their neighbors to be model workers. In the pre-Communist period—and still frequently seen in overseas Chinese communities—wood-block prints of fierce-looking door guardians would hang in those spots to block the entrance of evil spirits.

Huxian painters remained quite inaccessible to strangers until 1983. It is difficult to know whether this was because the Xi'an art community chose to isolate them from visitors or because the county officials didn't like strangers and feared pollution from outside influences. Other hypotheses are that strangers might have learned more about the amateur-professional relationship than officials wanted revealed, or the fear that artists wanted to sell their works privately. All this changed with the new economic policy of "fiscal responsibility," and Huxian officials now welcome prospective customers.

In 1980, a group of Jinshan peasant painters came to the fore with an exhibition at the National Art Gallery in Beijing. The group exhibited in China and abroad, and the work was most enthusiastically received. Jinshan is in the suburbs of Shanghai. The peasant painters emerged from a group of women

who had done embroidery all their lives. They were organized by an artist-worker who helped them develop their own unique style, which has similarities to the Huxian style. Both peasant painting groups create strongly organized compositions, with the multiple patterning of textiles and the joyous animation of workman-peasants performing like cartoon characters.

Other notable peasant groups that have exhibited in Beijing's National Art Gallery are from Ansaixian and Yijunxian in Shaanxi Province. These groups' styles exhibit characteristics of naive composition and repeating pattern similar to those of the other peasant groups. Yet both the Ansaixian and the Yijunxian group produce a distinctively crisp composition based on paper cutouts. In fact the Yijunxian artists—all amateurs—are old women skilled in paper cutting and young girls, working cooperatively. The young women trace the paper cutouts for patterns and add the color to the designs. Over several years, they have been meeting only one or two months a year, during the winter when they are free from farm chores. They have not had fine-arts coaching, so they have retained their rustic qualities more than have the other peasant groups.

The work of most of these peasant groups is very fresh at the beginning, but as the subjects are repeated, the scenes become flatter and more mechanical. As a result, lines are harder and compositions become tightened. The playful quality of the early product gives way to slickness.

The peasant painters were triumphant in the Cultural Revolution, in large part because they fulfilled Mao's call for art from the masses to replace the elitists' work. But these painters also struck a fresh and decorative note, providing an alternative to the warmed-over formulas of Socialist Realist propaganda art and traditional painting.

The questions for the future of peasant painting are: Will the artists be able to reinvigorate themselves? Will they mature without losing their charm to mainstream cartooning and propaganda work?

New Year's Painting

There is a long tradition of New Year's painting in China, but few examples of pre-eighteenth-century work have survived. Originally, painted or printed pictures of the hearth god, fat babies symbolizing an auspicious and abundant New Year, and zodiac-like animals of the year were placed on the walls of a house at the time of the New Year. They reflect the resounding earthiness of the peasants' life, and they serve as a charm to coax the various deities into beneficence. Pictures of fierce generals posted on doors acted as guardians to fend off evil spirits. The figures are bold images, painted in bright primary colors and outlined in black. Usually these images were printed, with the color applied by hand, or printed on ordinary colored paper and produced cheaply for mass circulation.

The Communist presence in Yan'an broadened artistic awareness and appreciation of the existing folk tradition and its exuberant forms. The party's

246. Huang Suning. *Twelve Babies*. 1982. Gouache on paper

In 1982 Huang Suning (b. 1950, Nanjing) graduated in the first class of the New Year's painting department at the Central Academy of Fine Arts. Using traditional motifs, she painted twelve plump babies to project hope for prosperity in the coming months. They are dressed in old-style decorated clothing and charms, and they have traditional hairdos. Organized around a central baby whose hands are held high in a victorious pose, eleven babies gambol in an aura of auspicious symbols, including fish, flowers, grains, and birds. The artist drew upon the traditional palette for her colors.

247. Tiger pillow. 1982. Fabric collage and embroidery. Spring Festival Folk Art Exhibition, National Art Gallery, Beijing, 1982

Tiger pillows are favorite folk-art toys for children and are also used as head pillows. This one from Shaanxi Province features a variety of inventive sewing and pasting techniques. The mythic animal brings a special joy.

248. Liu Shaohui. *Guardian*. 1984. Gouàche on paper

This painting is based on traditional guardian figures featured in the old-style New Year's pictures used on doorways. The sketch was made to serve as a model for reproductions to be etched in glass, and ultimately the guardian would fulfill his historic role in a contemporary Chinese building. The stylized face, sword, posed position, and multitextured costume look more theatrical than warlike, but the guardian was thought to be effective in scaring off evil spirits.

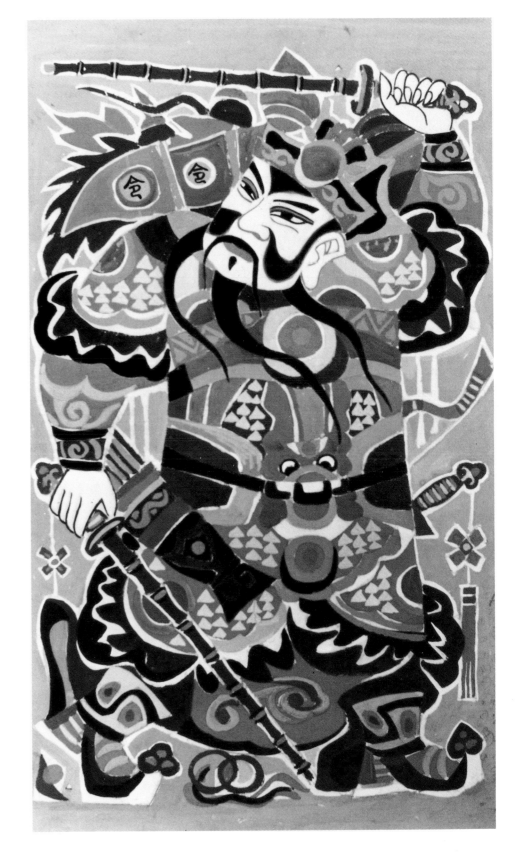

249. Liu Shaohui. *Cloth Tigers.* 1982. Ink and color on paper

Liu Shaohui, one of the Modern Heavy Color painters from Yunnan (p. 74), collects folk art and frequently uses it as his subject matter. He seeks out its primal quality and exploits the decorative aspect in making an Expressionist statement.

interlocking art and propaganda leadership experimented with this traditional medium to adapt the content of the New Year's pictures to bring the message of revolution to the masses. And so after 1949, under party supervision, various local family studios that had produced traditional New Year's pictures now altered the content—from heavenly warriors to labor heroes.

The establishment of a New Year's painting department at the Central Academy of Fine Arts was an important step in elevating the prestige and presence of this form of art. It is hoped that having students learn the old forms will encourage them to retain the authentic features of peasant painting in creating the new Chinese art. The first class to specialize in this genre graduated from the Central Academy of Fine Arts in 1982.

Artists all over China collect folk materials, either as important ethnographic artifacts or as charming exotica. They use dolls, toys, and other items as subject matter. Many Chinese artists believe that the key to a new Chinese art may be found in these folk materials, just as Picasso and other modernists found new vision through African art.

CONCLUSION

That Chinese art has been reinvigorated in the post-Mao era is clear. However, artists continue to face two major problems: political control and the related fear of foreign influences. As long as the party line defines the artistic line, art takes on an artificially inflated importance. To set up criteria for "right art" and "wrong art" is to construct a political time bomb. It is simply not possible to suppress all of the stubbornly independent or naively adventurous artists who will go beyond stated limits. Inevitably, those artists will be harshly criticized, and if any ill-fated person particularly offends the art establishment and does not promptly repent, show respect, and correct his errors, that artist will be somehow punished and his future will be gravely disadvantaged. He may become a dissident or feel forced to go into exile.

When the party line changes—and it does change—even the artist who has not suffered greatly because of a so-called mistake may be punished. One artist's bitter experience during the antirightist campaign of 1957 typifies the problem encountered by any oil painter with an interest in Western painting styles other than party-approved Socialist Realism. The artist confessed: "I listened to my critics and took their words to heart. As a result of my efforts 'to correct my thinking,' I was not labeled a rightist and so avoided reeducation through labor or prison. However, in 1961, as a consequence of my problems, I was sent to work at a less prestigious place than the Central Academy, where the 'best' graduates were invited to join the faculty." The artist wryly comments that China's art magazines in the post-Mao era are "filled with the kind of painting for which I was criticized in 1957."

Occasionally, despite what officialdom wants, "problem" artists and their work become famous. Because the artist's position is official and inflated compared with that of his counterparts in the West, these dissident artists become controversial and have a higher recognition factor than the approved artists and their work. But most artists follow a safer path, which can lead to mediocrity. An artist who strives to conform to official expectations will generally produce repetitively safe work that lacks originality and individuality—qualities that are cherished internationally but are not perceived as crucial values in traditional Chinese painting.

The political problem manifests itself in all aspects of the artist's life. A traditional artist who graduated from an art college in the 1960s recently commented on this persistent issue: "I felt enormous pressure from the party to

conform within the Chinese tradition and to be accepted by the Chinese National Artists Association. It was very difficult for people like me who are apolitical because, although admission to the Artists Association is said to be officially based on the number of exhibitions in which you have shown and on the right-minded nature of your political beliefs, in fact, it is a social and political act that depends upon your success in cultivating the people in power."

The artist's role in a socialist society is another part of the political formulation. With the obvious exception of those who were labeled as rightists in the late 1950s and the large number of artists who suffered during the Cultural Revolution, Chinese artists have generally led a privileged life. It is a remarkable irony that, despite Mao's emphatic call for artists to be of the people, they, along with officials and their families, are among the new elite in China. Generally, major artists have better housing than the masses, more opportunities for entertainment and travel, and they can supplement their salaries through the sale of their works or through publication. Because artists are protected and don't have to struggle with issues of survival or the demands of factory or farm, it is not surprising that their interpretations of those subjects are often superficial or sentimental. This is compounded by the fact that they are instructed to show the positive aspects of the lives of the masses.

Regionalism within China and isolation from foreign influences inhibit the easy exchange of fresh ideas. Moreover, misleading representations, such as the "copies" of Western paintings made by Chinese artists abroad—which are periodically exhibited in China—can further obfuscate understanding. Another crucial factor is that foreign art is viewed out of context, as though it dropped from Mars, so it takes on new, sometimes distorted, meaning in China. The Chinese artist needs stimulation, not a relaxed atmosphere and shelter from the realities of life. The artist who doesn't have to produce enough work for an exhibition each year and sell enough to pay his bills can afford to be relaxed about production *and* experimentation. The Chinese artist's obligation to provide the state with a certain number of works per year requires only that he submit works that are acceptable in style and subject; no quality control is exercised. Artists who sell paintings through their work units keep such a small percentage of the price that they have little incentive to sell their best work through that channel. The party allows artists to be comfortable, but not rich.

The issue of political control will be central as long as the state is the principal patron of the arts. Artists must respond to needs of the state in style, subject, and medium. Many artists understand and accept the benefits of this system. There are no starving artists among those who work within the system. But it would seem that there is no place for individualists who choose unacceptable styles and subjects and who can't or won't try to succeed within the professional structure. A counterculture or avant-garde artist whose work is at odds with party goals will not be tolerated.

Even more inhibiting than political control is the fear, shared by some artists as well as officials, that foreign ideas will subvert and pollute them. The

Communists inherited the xenophobia of old China, and it would appear that the art establishment is most afraid of losing the uniqueness of Chinese culture. Because of this determination to preserve Chineseness and a tradition that promotes copying as a principal educational device, Chinese innovators have a difficult fight. Just as tradition-minded Qing dynasty officials blocked modernizing reforms by arguing that Chinese ways were better, so too modern art theorists in China tend to prefer forms with a legitimate Chinese heritage over "slavishly borrowed" Western techniques. The ultimate criticism of a painting is "capitalist imitation." Marxist class analysis, which has dismissed bourgeois art as unacceptable for the masses, reinforces the traditional antiforeign stance of Chinese theorists. The only major exception to the rule against foreign borrowing is China's importation of Soviet revolutionary and academic forms. Only a minority of Chinese artists, those with a strong sense of self, are able to withstand such pressures.

A manifestation of the problem of the fear of foreign images is the absence of a first-rate, permanent collection of foreign art in China. Many artists and officials avoid the real issue and offer many explanations, ranging from improper timing and poor conservation conditions to insufficient funds to acquire works of art. But some artists view the absence of foreign examples and the presence of political control as the most inhibiting factors in their development. In China artists simply can't study excellent international works except very occasionally and briefly when exhibitions come from abroad.

How to avoid being swallowed up by Chinese tradition remains a serious problem for the Chinese artist. That tradition is overwhelmingly rich and ancient; it is truly awesome. One artist compares the dilemma to that of a frog in a well. It is a life-sustaining environment, but limited. Increasingly, artists know about the world beyond the well and crave to be part of it. Indeed, the Chinese dream is to draw upon their heritage, mine the resources, but create art that communicates outward to the global sphere.

As the new-generation art establishment replaces the old guard there are more real artists and fewer revolutionary leaders trained in political propaganda. There are certain changes to be noted, such as exhibition juries made up of more artists and fewer politicians, and younger artists feel that they get attention at meetings when they talk more about art and less about politics. A major concession to the newest generation of artists, educated after the Cultural Revolution, who have a passionate interest in exploring modernist styles, has been the establishment of an official Beijing Young Artists Association in 1985 and a 1986 exhibition that included Surrealist and abstract compositions. Moreover, there is a more open policy toward foreign exhibitions, foreign students, and foreign visitors (within limits). Visitors to art schools are no longer monitored as if they were spies. The new generation of artists is more professional, less political, more interested in art than propaganda messages.

Artists in China face the peculiar challenges of their time and place. It is hard to equate their situation with that of their counterparts in the West.

Traditionally, the Chinese artist painted tales of Confucian virtue and many other things according to the constraints of an imperial government. Many contemporary artists are content to work within the constraints of the Communist government. Yet there are some who continue to express their individuality outside the limits. Today's crystal ball cannot predict the flexibility of the future party line or the artistic accommodations that may be possible. One can only hope that the innovators will find an increasingly hospitable environment in which to continue their quest for an art that is modern and international but nevertheless uniquely Chinese.

LIST OF CHINESE NAMES

(Alternate spellings and names
are in parentheses)

PINYIN	CHINESE	PINYIN	CHINESE	PINYIN	CHINESE
Ai Qing	艾青	Fang Jiamo	方家模	Huang Suning	黄素宁
Bai Jingzhou	白敬周	(Maria B. Fang)		Huang Yongyu	黄永玉
Bei Yuming	贝聿铭	Fang Jizhong	方济众	Huang Zhou	黄胄
(I.M. Pei)		Feng Guodong	冯国东	Huo Qubing	霍去病
Bo Yun	薄云	Fu Baoshi	傅抱石	Ji Cheng	汲成
(Li Yungcun)	（李永存）	Gao Meiqing	高美慶	Jiang Dahai	江大海
Cai Zhanlong	蔡展龙	(Mayching Kao)		Jiang Feng	江丰
Cai Zhenhui	蔡振辉	Geng Biao	耿飚	Jiang Jieshi	蒋介石
Chen Buwen	陈布文	Geng Ying	耿莹	(Chiang Kai-shek)	
Chen Danqing	陈丹青	Geng Yukun	耿玉昆	Jiang Qing	江青
Chen Dayu	陈大羽	Guan Shanyue	关山月	Jiang Tiefeng	蒋铁峰
Chen Dehong	陈德弘	Guo Runlin	郭润林	Jin Shangyi	靳尚谊
Chen Dexi	陈德曦	Guo Zengyu	郭增瑜	Kang Youwei	康有为
(Chan Tak Hei)		Han Xin	韩辛	(K'ang Yu-wei)	
Chen Jialing	陈家玲	He Deguang	何德光	Kao, Mayching	
Chen Kaiming	陈闿明	He Duoling	何多苓	(see Gao Meiqing)	
Chen Xiaoqiang	陈小强	He Haixia	何海霞	Kong Boji	孔柏基
Chen Yifei	陈逸飞	He Neng	何能	(Kong Baiji)	
Chen Zhangpeng	除章鹏	Hu Jieqing	胡絜青	Kong Changan	孔长安
Cheng Shifa	程十发	Hua Guofeng	华国锋	Lang Sen	郎森
Dai Dunbang	戴敦邦	Hua Junwu	华君武	Lao She	老舍
Deng Lin	邓琳	Huang Binhong	黄宾虹	Li Geng	李庚
Deng Xiaoping	邓小平	Huang Guanyu	黄冠余	Li Hua	李桦
Dong Qichang	董其昌	Huang Huihui	黄辉辉	Li Huaji	李化吉
Dong Xiwen	董希文	Huang Qingqi	黄清琪	Li Keran	李可染
Fan Zeng	范曾	Huang Rui	黄锐	Li Kuchan	李苦禅

154

PINYIN	CHINESE	PINYIN	CHINESE	PINYIN	CHINESE	PINYIN	CHINESE
Li Miao	李淼	Pan Tianshou	潘天寿	Wang Keping	王克平	Ye Yushan	叶毓山
Li Muer	李默尔	Pei, I.M.		Wang Leifu	王磊夫	Yin Guangzhong	尹光中
Li Shan	李山	(see Bei Yuming)		Wang Shu	王树	Yuan Jia	袁佳
Li Shuang	李爽	Peng Chuanfang	彭传芳	Wang Zhaowen	王朝闻	Yuan Min	袁敏
Li Xiannian	李先念	Qi Baishi	齐白石	Wang Zhiping	王志平	Yuan Yunfu	袁运甫
Li Xiaoke	李小可	Qian Songyan	钱松嵒	Wang Zhongnian	王仲年	Yuan Yunsheng	袁运生
Li Xiaoming	李晓明	Qian Yuehua	钱月华	Wei Jingshan	魏景山	Yuan Zuo	袁佐
Li Xin	李新	Qin Yuanyue	秦元阅	Wu Changshuo	吴昌硕	Zeng Shanqing	曾善庆
Li Zhenpu	李振甫	Qiu Deshu	仇德树	Wu Erlu	吴尔鹿	Zhang Daqian	张大千
Li Zhongliang	李忠良	Qu Leilei	曲磊磊	(Lawrence Wu)		Zhang Ding	张仃
Liang Mingcheng	梁明诚	Qu Qiubai	瞿秋白	Wu Guanzhong	吴冠中	Zhang Ga	张嘎
Lin Biao	林彪	Quan Zhenghuan	权正环	Wu Jian	吴健	Zhang Hongnian	张红年
Lin Fengmian	林风眠	Shao Fei	邵飞	Wu, Lawrence		Zhang Hongtu	张宏图
Lin Jianpu	林剑仆	Shen Congwen	沈从文	(see Wu Erlu)		Zhang Jianjun	张健君
Liu Bingjiang	刘秉江	Shen Ronger	沈蓉尔	Wu Liangyong	吴良镛	Zhang Jianping	张健平
Liu Chunhua	刘春华	Shen Yantai	沈延太	Wu Xiaochang	吴小昌	Zhang Langlang	张朗朗
Liu Danzhai	刘旦宅	Shi Guoliang	史国良	Wu Yi	吴毅	Zhang Meixi	张梅溪
Liu Haisu	刘海粟	Shi Lu	石鲁	Wu Zuoren	吴作人	Zhang Songnan	张颂南
Liu Jilin	刘骥林	Shi Tao	石涛	Xiao Dayuan	肖大元	Zhao Wuji	赵无极
Liu Jirong	刘济荣	Sima Qian	司马迁	Xiao Feng	肖锋	(Zao Wou-ki)	
Liu Shaohui	刘绍荟	(Ssu-ma Ch'ien)		Xiao Huixiang	肖惠祥	Zhao Xiuhuan	赵秀焕
Liu Tianwei	刘天炜	Song Wenzhi	宋文治	Xiao Shufang	肖淑芳	Zhao Yixiong	赵以雄
Liu Xiaodi	刘小弟	Su Dongpo	苏东坡	Xie Lingyun	谢灵运	Zhao Youping	赵友萍
Liu Ziming	刘自鸣	(Su Tong-p'o)		Xu Beihong	徐悲鸿	Zhao Yu	赵域
Lou Jiaben	楼家本	Su Jianghua	苏江华	(Hsu Pei-hung;		Zhong Acheng	钟阿城
Lu Xun	鲁迅	Sun Jingbo	孙景波	Ju Peon)		(Ahcheng)	
(Lu Hsün)		Sun Weimin	孙为民	Xu Jianguo	徐建国	Zhong Ming	钟鸣
Lu Yanshao	陆俨少	Tang Muli	汤沐黎	Xue Mingde	薛明德	(Zhong Myng)	
Luo Zhongli	罗中立	Tang Xiaoming	汤小铭	Ya Ming	亚明	Zhou Enlai	周恩来
Ma Desheng	马德升	Tang Yun	唐云	Yan Jiabao	颜家宝	Zhou Lin	周菱
Ma Hua	马华	Wang Datong	王大同	Yan Li	严力	Zhou Sicong	周恩聪
Mao Lizi	毛栗子	Wang Gang	汪钢	Yang Gang	杨刚	Zhou Yang	周扬
(Zhang Zhunli)	（张准立）	(Peter Wang)		Yang Huangli	杨黄莉	Zhu Da	朱耷
Mao Zedong	毛泽东	Wang Huaiqing	王怀庆	Yang Qixian	杨齐贤	(Ba Da Shan Ren)	（八大山人）
Nie Ou	聂鸥	Wang Jiqian	王己千	(Yang Chih-hsien)		Zhu Danian	祝大年
Pan Chuyang	潘初阳	(C. C. Wang;		Yang Yanping	杨燕屏	Zhu Qizhan	朱屺瞻
Pan He	潘鹤	Wang Chi-ch'ien)		Yao Zhonghua	姚钟华	Zhu Weimin	朱维民
(Pan Ho)				Ye Qianyu	叶浅予	Zhu Xiuli	朱脩立

LIST OF GROUPS AND INSTITUTIONS

ENGLISH	PINYIN	CHINESE
Agricultural Publishing House	Nongye Chubanshe	农业出版社
Anti-Japanese United Front	Kangri Tongyizhanxian	抗日统一戏线
April Society	Siyue Ying Hui	四月影会
Beijing Painting Academy	Beijing Huayuan	北京画院
Beijing Young Artists Association	Beijing Qingnian Hualiui	北京青年画会
Beiping Art College	Beiping Yishu Zhuanke Xuexiao	北平艺术专科学校
Beiping Normal College	Beiping Shifan Zhuanke Xuexiao	北平师范专科学校
Central Academy of Arts and Crafts	Zhongyang Gongyimeishu Xueyuan	中央工艺美术学院
Central Academy of Fine Arts (Design)	Zhongyang Meishu Xueyuan	中央美术学院
Central Institute of Nationalities	Zhongyang Minzu Xueyuan	中央民族学院
Central University (Nanjing)	Zhongyang Daxue (Nanjing)	中央大学（南京）
Chengdu Painting Academy	Chengdu Huayuan	成都画院
Children's Palace	Shaoniangong	少年宫
Chinese Federation of Literary and Art Circles	Zhongguo Wenxue Yishujia Lianhehui	中国文学艺术家联合会
Chinese National Artists Association	Zhongguo Meishujia Xiehui	中国美术家协会
Chinese Photographers Association	Zhongguo Sheyingjia Xiehui	中国摄影家协会
Contemporaries	Tongdairen	同代人
Dunhuang Research Institute	Dunhuang Yanjiusuo	敦煌研究所
Experimental Painting Exhibition (1983)	Basannian Jieduan Huihuashiyan Zhanlan	八三年阶段绘画实验展览
Federation of Artists (1932)	Zuoyi Meishujia Lianmeng	左翼美术家联盟
First Exhibition of Modern Art in Xi'an	Xi'an Diyijie Xiandaihua Zhanlan	西安第一届现代画展览
First Institute of Art and Design (Hong Kong)	Dayi Xueyuan Yishu Sheji Zhongxin (Hong Kong)	大一学院·艺术设计中心（香港）
First National Art Exhibition (Shanghai, 1929)	Shoujie Guojia Huazhan	首届国家画展
Four Modernizations	Sige Xiandaihua	四个现代化
Fourth Congress of Artists and Writers (1979)	Disijie Wenxue Yishujia Daibiao Dahui	第四展文学艺术家代表大会
Fudan University	Fudan Daxue	复旦大学
Gang of Four	Sirenbang	四人帮
Grass Grass	Cao Cao	草草
Great Hall of the People	Renmin Dahuitang	人民大会堂
Green Grass Studio	Chuncaotang	春草堂
Guangzhou Academy of Fine Arts	Guangzhou Meishu Xueyuan	广州美术学院
Guangzhou Fine Arts Studio	Guangzhou Meishu Chuangzuoshi	广州美术创作室
Haizhu Square	Haizu Guangchang	海珠广场
Hangzhou Academy of Fine Arts	Hangzhou Meishu Xueyuan	杭州美术学院
Hefei Painting Academy	Hefei Huayuan	合肥画院
Heilongjiang University	Heilongjiang Daxue	黑龙江大学
Hunan Teachers College	Hunan Shifan Xueyuan	湖南师范学院
Imperial College (Tokyo)	Dongjing Diguo Daxue	东京帝国大学
International Youth Festival	Shijie Qingnianlianhuanjie	世界青年联欢节
Jiangsu Provincial Normal School (Wuxi)	Jiangsusheng Shifan Xueyuan (Wuxi)	江苏省师范学院（无锡）
Jiangsu Traditional Painting Academy	Jiangsu Guohuayuan	江苏国画院
Jiaotong University	Jiaotong Daxue	交通大学
Kunming Enamel Factory	Kunming Tangcichang	昆明搪瓷厂
Kuomintang (KMT)	Guomindang	国民党
Liaoning Provincial Propaganda Artistic Group	Liaoningsheng Xuanchuan Huazu	辽宁省宣传画组
Lu Xun Academy of Fine Arts (Yan'an)	Lu Xun Meishu Xueyuan (Yan'an)	鲁迅美术学院（延安）
Luwan District Cultural	Luwanqu Wenhuaguan	卢湾区文化馆
May Fourth Movement	Wusi Yundong	五·四运动
May Seventh Cadre School	Wuqi Ganxiao	五·七干校
Military Museum (Beijing)	Junshi Bowuguan (Beijing)	军史博物馆（北京）
Modern Heavy Color	Xiandai zhongcai	现代重彩
Monkey-Year Group	Shen She	申 社 重

ENGLISH	PINYIN	CHINESE
Monument to the Martyrs	Renmin Yingxiong Jinianbei	人民英雄纪念碑
Museum of Chinese History and the Revolution	Zhongguo Geming Lishi Bowuguan	中国革命历史博物馆
Nanjing Academy of Art	Nanjing Yishu Xueyuan	南京艺术学院
Nanjing Academy of Traditional Painting and Calligraphy	Nanjing Shuhuayuan	南京书画院
Nanjing Art Gallery	Nanjing Meishuguan	南京美术馆
Nanjing Museum	Nanjing Bowuguan	南京博物馆
Nanjing Normal High School	Nanjing Gaodeng Shifan Xuexiao	南京高等师范学校
Nankai University, Tianjin	Nankai Daxue, Tianjin	南开大学、天津
National Art Exhibition	Quanguo Meishu Zuopin Zhanlan	全国美术作品展览
National Art Gallery	Zhongguo Meishuguan	中国美术馆
National Youth Art Exhibition	Quanguo Qingnian Meizhan	全国青年美展
New Spring Art Exhibition	Xinchun Huazhan	新春画展
Oil Painting Research Association (OPRA)	Youhua Yanjiu Hui	油画研究会
Palace Museum (Beijing)	Gugong Bowuguan	故宫博物院
People's Fine Arts Publishing House	Renmin Meishu Chubanshe	人民美术出版社
People's Literary Publishing House	Renmin Wenxue Chubanshe	人民文学出版社
People's Republic of China (PRC)	Zhonghua Renmin Gongheguo	中华人民共和国
People's University	Renmin Daxue	人民大学
Qinghua University	Qinghua Daxue	清华大学
Quanzhou Cultural Bureau	Quanzhou Wenhuaju	泉州文化局
Quanzhou Cultural Center	Quanzhou Shi Wenhuaguan	泉州市文化馆
Quanzhou Workers Publishing House	Quanzhou Gongren Chubanshe	泉州工人出版社
Shanghai Art College	Shanghai Yishu Zhuanke Xuexiao	上海艺术专科学校
Shanghai Art Gallery	Shanghai Meishuguan	上海美术馆
Shanghai Artists Association	Shanghai Meishujia Xiehui	上海美术家协会
Shanghai Chinese Painting Academy	Shanghai Zhongguo Huayuan	上海中国画院
Shanghai Drama Academy	Shanghai Xiju Xueyuan	上海戏剧学院
Shanghai Fine Art Institute	Shanghai Meishu Zhuangkexuexiao	上海美术专科学校
Shanghai Oil Painting and Sculpture Academy	Shanghai Youhua Didosu Yuan	上海油画雕塑院
Shanghai Painting Academy*	Shanghai Huayuan	上海画院
Shanghai Teachers College	Shanghai Shifan Xueyuan	上海师范学院
Shanghai University Fine Art Department	Shanghai Daxue Meishuxi	上海大学美术系
Shenzhen University Academy of Painting	Shenzhen Daxue Zhongguo Huayuan	深圳大学中国画院
Sichuan Academy of Fine Arts	Sichuan Meishu Xueyuan	四川美术学院
Southern Fujian Art Group	Minnanhuapai	闽南画派
Southwest China Union University	Xinan Lianda	西南联大
Star Star	Xing Xing	星 星
Tokyo Art College	Dongjing Meishu Daxue	东京美术大学
Twenty-eight Painters Association	Erba Huahui	二八画会
West Lake Art School (Hangzhou)	Xihu Meishu Zhuanke Xuexiao (Hangzhou)	西湖美术专科学校 (杭州)
Wild Grass	Ye Cao	野 草
Wuhan Art College	Wuhan Yishu Xueyuan	武汉艺术学院
Wuxi School of Fine Arts	Wuxi Meishu Xuexiao	无锡美术学校
Xi'an Academy of Fine Arts	Xi'an Meishu Xueyuan	西安美术学院
Xinjiang Museum	Xinjiang Bowuguan	新疆博物馆
Yan'an Forum on Arts and Literature	Yan'an Wenyi Zuotanhui	延安文艺座谈会
Yongle Palace	Yongle Gong	永乐宫
Yunnan Art Institute	Yunnan Yishu Xueyuan	云南艺术学院
Yunnan Artists Association	Yunnan Meishujia Xiehui	云南美术家协会
Yunnan Cultural Bureau	Yunnan Wenhuaju	云南文化局
Yunnan Painting Academy	Yunnan Huayuan	云南画院
Yunnan People's Publishing House	Yunnan Renmin Chubanshe	云南人民出版社
Zhejiang Academy of Fine Arts	Zhejiang Meishu Xueyuan	浙江美术学院

*In 1981, the Shanghai Painting Academy was divided into two units, the Shanghai Chinese Painting Academy and the Shanghai Oil Painting and Sculpture Academy.

GLOSSARY

ENGLISH	PINYIN	CHINESE
Graphic arts (literally, woodcut)	Banhua	版画
Wall painting	Bihua	壁画
Zen	Chan	禅
Tz'u-chou ware	Cizhouyao	磁州窑
Tao	Dao	道
Korean paper	Gaolizhi	高丽纸
Precisely outlined style	Gongbihua	工笔画
Chinese ink painting	Guohua	国画
Ching-te-chen ware	Jingdezhenyao	景德镇窑
Internal, classified	Neibu	内部
Chinese meditation exercise	Qigong	气功
Freely brushed, traditional ink technique	Xieyihua	写意画
Rice paper; paper made in Xuancheng, Anhui province	Xuanzhi	宣纸
Western painting; oil painting	Youhua	油画
Seal-style script	Zhuanshu	篆书

Anderson, Ruth S., and Ralph Crozier. *Painting in the People's Republic of China: Heirs to the Great Tradition.* Exhibition Catalogue. Berkeley: University of California Press, 1974.

Art Treasures of Dunhuang. Dunhuang, People's Republic of China: Dunhuang Institute for Cultural Relics; Hong Kong: Joint Publishing Co., 1981.

Cahill, James. *The Art of Southern Sung China.* New York: The Asia Society, 1962.

———. *Chinese Painting.* Geneva: Albert Skira, 1960.

———. *Hills Beyond a River: Chinese Painting of the Yuan Dynasty, 1279–1368.* New York and Tokyo: John Weatherhill, 1976.

———. *Parting at the Shore: Chinese Painting of the Early and Middle Ming Dynasty, 1368–1580.* New York and Tokyo: John Weatherhill, 1978.

Century of Chinese Painting, A. Exhibition Catalogue, the Collection of Mr. and Mrs. Kuo Ven-chi. Hong Kong: City Museum and Art Gallery, 1974.

Chang, Arnold. *Painting in the People's Republic of China: The Politics of Style.* Boulder, Colo.: Westview Special Studies on China and East Asia, 1980.

Chen, Jo-hsi. *The Execution of Mayor Yin and Other Stories from the Great Proletarian Cultural Revolution.* Trans. Nancy Ing and Howard Goldblatt. Bloomington: Indiana University Press, 1978.

Chen Yifei. *Recent Paintings.* Exhibition Catalogue. New York: Hammer Galleries, 1984.

China Council for the Promotion of International Trades (eds.). *Chinese Paintings.* Beijing: The People's Fine Arts Publishing House, 1900.

China Reconstructs. Beijing: People's Republic of China. Published monthly.

Chinese Intellectuals and the CCCP: The Search for a New Relationship. Papers and notes of the New England China Seminar. Cambridge, Mass.: The Fairbank Center, Harvard University, 1984.

Chinese Literature. Beijing: People's Republic of China. Published monthly until 1983; now published quarterly.

Chu, Christina. *Twentieth-Century Painting.* Exhibition Catalogue. Hong Kong: Hong Kong Museum of Art, 1984.

Cohen, Joan Lebold. "Abstract Art Blooms in a Remarkable Year for Chinese Art Groups." *Asian Wall Street Journal,* January 29, 1981.

———. "Abstract Art Is Out and Folk Art Is In as China Readjusts Its Political Line." *Asian Wall Street Journal,* April 15, 1981.

———. "Art in China Today." *ARTnews,* Summer, 1980, pp. 60–68.

———. "Braving the Currents of 'Bourgeois Internationalism.'" *ARTnews,* January, 1984.

———. "Chen Yifei." *ARTnews,* Summer, 1980, p. 71.

———. "China: A Modern Who's Who of Traditional Artists." *Asian Wall Street Journal,* July 21, 1980.

———. "China: From Red Flags to Red Flowering Plums." *Asian Wall Street Journal,* May 31, 1979.

———. "China: Realism Is the Style with a Future." *ARTnews,* November, 1983, pp. 177–78.

———. "China's Artists Testing Wings in the West." *Asian Wall Street Journal,* January 20–21, 1984.

———. "China's Modern Art World: How Far the Current Swing from Relative Freedom?" *Asian Wall Street Journal,* April 10, 1980.

——. "Drawing a Harder Line." *ARTnews*, September, 1981, pp. 188–89.

——. "From Mao to Michelangelo in Chinese Art Education." *Asian Wall Street Journal*, October 11, 1979.

——. "Graduates Herald Freer Chinese Art." *Asian Wall Street Journal*, November 22, 1980.

——. "Hong Kong Shows Ignore China's Most Innovative Art." *Asian Wall Street Journal*, February 24, 1984.

——. "Huang Yongyu." *ARTnews*, Summer, 1980, p. 69.

——. "Learning to Paint in China." *ARTnews*, Summer, 1980, pp. 72–75.

——. "New Year's Art Shows Swing to New Party Line." *Asian Wall Street Journal*, March 25, 1981.

——. *Painting the Chinese Dream: Chinese Art Thirty Years after the Revolution.* Exhibition Catalogue. Northampton, Mass.: Smith College Museum of Art, 1982.

——. "Peking Painting Revives Debate on Abstract Art." *Asian Wall Street Journal*, July 24, 1983.

——. "Yuan Yunsheng." *ARTnews*, Summer, 1980, p. 70.

——, and Jerome Alan Cohen. *China Today and Her Ancient Treasures.* 3rd ed. rev. New York: Harry N. Abrams, 1986.

Contemporary Paintings from the People's Republic of China. Exhibition Catalogue, featuring Geng Yin, Yuan Yunfu, Wang Jiao, Deng Lin and forty Jinshan Peasant Painters. New York: Wally Findlay Galleries, 1981.

Crozier, Ralph C. (ed.). *China's Cultural Legacy and Communism.* New York: Praeger, 1970.

Ecke, Tseng Yu-Ho. *Chinese Folk Art in American Collections.* New York: China Institute of America, 1976.

Exhibition of Works by Chinese Artists in New York. New York: Oriental Gallery, 1983.

Fairbank, John K., and Edwin O. Reischauer. *China: Tradition and Transformation.* Boston: Houghton Mifflin, 1977.

Fan Zeng. "Li Kuchan: Painter of Flowers and Birds," *Chinese Literature*, April, 1979.

Feuerwerker, Albert (ed.). *History in Communist China.* Cambridge, Mass.: MIT Press, 1968.

Goldman, Merle. *Literary Dissent in Communist China.* Cambridge, Mass.: Harvard University Press, 1967.

——. *Modern Chinese Literature in the May 4th Era.* Harvard East Asian Series 89. Cambridge, Mass.: Harvard University Press, 1977.

——. "Culture." *China Briefing.* Boulder, Colo., and London: Westview Press, 1985.

Graphic Art by Workers in Shanghai and Luta. Beijing: Foreign Languages Press, 1976.

Hajek, Lubor, Adolf Hoffmeister, and Eva Rychterova. *Contemporary Chinese Painting.* London: Spring Books, 1961.

Hinton, William. *Fanshen: A Documentary of Revolution in a Chinese Village.* New York and London: Monthly Review Press, 1966.

Hua Junwu (ed.). *Contemporary Chinese Painting.* Beijing: New World Press, 1983.

Isaacs, Harold R. *The Tragedy of the Chinese Revolution.* 2nd ed. rev. Stanford: Stanford University Press, 1961.

Jiang Feng (ed.). *Yan'an Papercuts.* Beijing: The People's Fine Arts Publishing House, n.d.

Kao, Mayching Margaret. *China's Response to the West in Art: 1898–1937.* Ph.D. thesis, Stanford University, 1972.

——. "The Beginning of the Western-style Painting Movement in Relationship to Reforms in Education in Early Twentieth-century China." *New Asia Academic Bulletin* IV, 1983.

Kuo Hsi. *An Essay on Landscape Painting.* Trans. Shio Sakanashi. London: John Murray, 1959.

Laing, Ellen Johnston. "Chinese Peasant Painting, 1958–1976: Amateur and Professional." *Art International*, Vol. XXVII, January–March, 1984.

La Peinture de Xu Beihong. Le Musée Xu Beihong et les Éditions de Beijing. Beijing: Éditions de Beijing, 1979.

Lee, Sherman E. *Chinese Landscape Painting.* New York: Harper & Row, n.d.

Les Beaux-Arts en Chine populaire. Exhibition Catalogue. Paris: Grand Palais, 1982.

Leys, Simon. *Chinese Shadows*. New York: Viking, 1977.

Li, Chu-Tsing. *Trends in Modern Chinese Painting*. Ascona, Switzerland: Artibus Asiae, 1979.

Liang, Heng, and Judith Shapiro. *Son of the Revolution*. New York: Knopf, 1983.

———. *After the Nightmare*. New York: Knopf, 1986.

Lim, Lucy (ed.). *Contemporary Chinese Painting*. Exhibition Catalogue. San Francisco: The Chinese Culture Centre of San Francisco, 1983.

Link, Perry (ed.). *Stubborn Weeds*. Bloomington: Indiana University Press, 1983.

Lu Xinhua, Liu Xinwu, et al. *The Wounded*. Hong Kong: Joint Publishing Co., 1979.

MacFarquhar, Roderick (ed.). *The Hundred Flowers*. London: Stevens & Sons, 1960.

Mao Tse-tung: On Literature and Art. Beijing: Foreign Languages Press, 1977.

Meisner, Maurice. *Mao's China: A History of the People's Republic*. New York: The Free Press, 1977.

Moss, Hugh. *The Experience of Art: Twentieth-Century Chinese Paintings from the Shuisongshi Shanfang Collection*. Hong Kong: Andamans East International Ltd., 1983.

New Year Pictures of Weifang. Shantung: The People's Publishing House of Shantung, 1978.

Paintings: Zao Wou-ki. Exhibition Catalogue. Hong Kong: Hong Kong Arts Centre, 1982.

Peasant Paintings from Huhsien County of China. Beijing: The People's Fine Arts Publishing House, 1976.

Rotondo, Lisa E. *Chinese Revolutionary Woodcuts, 1935–1948*. Hamilton, N.Y.: The Picker Art Gallery, Colgate University, 1984.

Shapiro, Judith, and Heng Liang. *Cold Winds, Warm Winds: Intellectual Life in China Today*. Middletown, Ct.: Wesleyan University Press, 1986.

Sichuan Painting Exhibition. Exhibition Catalogue. Sichuan: Chinese Artists Association, Sichuan Branch; Hong Kong: Hong Kong Arts Centre and Joint Publishing Co., 1984.

Snow, Edgar. *The Other Side of the River*. London: Gollancz, 1963.

Spence, Jonathan. *The Gate of Heavenly Peace*. New York: Viking, 1981.

Sullivan, Michael. *The Arts of China*. rev. ed. Berkeley, Los Angeles, and London: University of California Press, 1977.

———. *Chinese Art in the Twentieth Century*. Berkeley and Los Angeles: University of California Press, 1959.

———. "New Direction in Chinese Art." *Art International*, Vol. XXV, January–March, 1982.

Sun, Shirley. *Modern Chinese Woodcuts*. San Francisco: Chinese Culture Foundation, 1979.

Terrill, Ross. *The White-Boned Demon*. New York: William Morrow, 1984.

Witke, Roxane. *Comrade Chiang Ch'ing*. Boston: Little, Brown, 1977.

Wrath of the Serfs—A Group of Lifesize Clay Sculptures. Beijing: Foreign Languages Press, 1976.

Yue Daiyun and Carolyn Wakeman. *To the Storm*. Berkeley and Los Angeles: University of California Press, 1986.

CHINESE BIBLIOGRAPHY

Cheng Shifa huaniao xizuo 程十发花鸟习作 (Studies on Birds and Flowers by Cheng Shifa). Shanghai: Shanghai People's Fine Arts Publishing House, 1979.

Chòu xiao ya 丑小鸭 (Ugly Duckling). Illustrations by Jiang Tiefeng 蒋铁峰. Beijing: Fine Arts Publishing House, 1982.

Da Yu zhi shui 大禹治水 (Da Yu Controls the Flood). Hong Kong: Kingsway International Publications Ltd., 1982.

Di liu jie quanguo meishu zuopin zhanlan nianhua tu lu 第六届全国美术作品展览年画图录 (Catalogue of the Sixth National Art Exhibition, New Year's Paintings). Hangzhou: Zhejiang Fine Arts Publishing House, 1984.

Di liu jie quanguo meishu zuopin zhanlan xuanchuan hua sumiao tu lu. 第六届全国美术作品展览宣传画素描图录 (Catalogue of the Sixth National Art Exhibition, Propaganda Paintings and Monochrome Drawings). Xi'an: Shaanxi People's Fine Arts Publishing House, 1984.

Di liu jie quanguo meishu zuopin zhanlan youhua tu lu 第六届全国美术作品展览油画图录 (Catalogue of the Sixth National Art Exhibition, Oil Paintings). Shenyang: Liaoning Fine Arts Publishing House, 1984.

Di liu jie quanguo meishu zuopin zhanlan Zhongguo hua tu lu 第六届全国美术作品展览中国画图录 (Catalogue of the Sixth National Art Exhibition, Chinese Paintings). Nanjing: Jiangsu Fine Arts Publishing House, 1984.

Di liu jie quanguo mei zhan diaosu qihua bihua xuan 第六届全国美展雕塑泼画壁画选 (Selections of Sculpture, Lacquer Paintings and Murals from the Sixth National Art Exhibition). Beijing: Chinese Art Gallery, 1984.

Huang Yongyu hua ji 黄永玉画集 (Paintings of Huang Yongyu). Hong Kong: Artist Publishing Co., 1980

Huang Zhou jin zuo zhanlan zhanpin mulu 黄胄近作展览展品目录 (Catalogue of Huang Zhou's Recent Exhibition). Hong Kong: Chinese Resources (Holding) Ltd., 1985.

Meishu congkan 美术丛刊 (Fine Arts Series). Shanghai: Shanghai People's Fine Arts Publishing House, 1984.

Meishu yanjiu 美术研究 (Studies in Art). Quarterly. Beijing: Central Academy of Fine Arts, 1981.

Meishu yuekan 美术月刊 (Fine Arts Monthly). Beijing: People's Fine Arts Publishing House, 1983.

Meishujia 美术家 (Artist). Bimonthly. Hong Kong: Artist Publishing Company, 1982.

Silu hua xing 丝路画行 (Images of the Silk Road). Xinjiang: Xinjiang People's Publishing House, 1983.

Wu yu san shan jingu fengqing: Zhongguo hua shi wu ren lian zhan zuopin xuanji 五岳三山今古风情：中国画十五人联展作品选集 (Landscape, People and Civilization: A Selection of Paintings from the Group Show of 15 Artists). Hong Kong: Tsi Ku Cha Ltd., 1985.

Xiandai zhongcai 现代重彩 (Modern Heavy Color). Hong Kong: First Institute of Art and Design, 1982.

Xiao hong mao 小红帽 (Little Red Riding Hood). Beijing: Children's Publishing House, 1982.

Yuan Yunfu hua ji 袁运甫画集 (Paintings by Yuan Yunfu). Hunan: Hunan Fine Arts Publishing House, 1983.

Zhang Ding hua ji 张仃画集 (Paintings by Zhang Ding). Hong Kong: Han Culture Development Co. Ltd., 1980.

Zhongguo xinxing banhua yundong wu shi nian 中国新兴版画运动五十年 (Fifty Years of the Chinese New Graphic Arts Movement). Liaoning: Liaoning Fine Arts Publishing House, 1981.

CHRONOLOGY

Neolithic period		
Yangshao culture	?4000–?2000 B.C.	
*Xia dynasty	?2000–?1523 B.C.	
Lungshan culture	?2000–?1200 B.C.	
	(with scattered later survivals)	
*Shang dynasty	?1523–?1027 B.C.	
	(traditional ?1766–1122 B.C.)	
*Zhou dynasty	?1027–256 B.C.	
	(traditional ?1122–256 B.C.)	
Western Zhou	?1027–770 B.C.	
	(traditional ?1122–770 B.C.)	
Eastern Zhou	770–256 B.C.	
Spring and Autumn era	770–481 B.C.	
Warring States era	403–221 B.C.	
Qin dynasty	221–206 B.C.	
Han dynasty	206 B.C.–A.D. 220	
Western Han	206 B.C.–A.D. 8	
Wang Mang Interregnum	A.D. 9–23	
Eastern Han	A.D. 25–220	
Six Dynasties	220–587	
Western Jin	265–304	Three Kingdoms 222–264/280
Eastern Jin	317–420	Sixteen Kingdoms 304–386
Liu Song	420–447	Northern Wei (T'o-pa) 386–534
Southern Qi	479–502	
Liang	502–577	
		Western Wei 535–557
		Eastern Wei 534–550
		Northern Zhou 557–581
Chen	557–589	Northern Qi 550–557
Sui dynasty	581–618	
Tang dynasty	618–907	
Ten Kingdoms	907–979	
		Five Dynasties 907–960
		Liao dynasty (Khitan Tartars)
Song dynasty	960–1279	947–1125
Northern Song	960–1127	
		Jin dynasty (Jurchen Tartars)
Southern Song	1127–1279	1115–1234

Yuan dynasty (Mongols)	1279–1368
Ming dynasty	1368–1644
Qing dynasty (Manchus)	1644–1912
Republic	1912–1949
Guomindang (Nationalist Party)	1928– (in Taiwan, 1948–)
People's Republic	1949–
Hundred Flowers movement	1956–1957
Anti-Rightist movement	1957–1958
Great Leap Forward	1958
Great Proletarian Cultural Revolution	1966–1976
Death of Mao Zedong; arrest of Gang of Four	1976
Beijing Spring	1978–1979
Second Hundred Flowers movement	1978–1980
Responsibility system	1980–
Socialist morality 1981	
Anti-Spiritual Pollution	1983–1984
Double Hundred (Third Hundred Flowers movement)	1986

*The dating of the Xia and Shang dynasties and the Zhou invasion has not been indisputably established. Most modern scholars use the dates given first in the chronology and used in the text, rather than the traditional dates shown in parentheses.

INDEX

Pages on which color illustrations appear are in **bold face**; pages on which black-and-white illustrations appear are in *italics*.